Gangs
and Their
Tattoos

Gangs
and Their
Tattoos

Identifying Gangbangers on the Street and in Prison

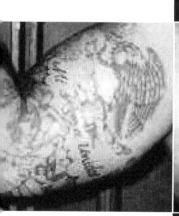
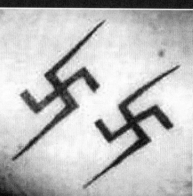
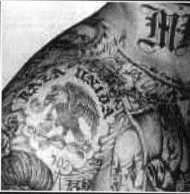

Bill Valentine

Original Artwork by Robert Schober

Paladin Press • Boulder, Colorado

Also by Bill Valentine:
Gang Intelligence Manual: Identifying and Understanding
 Modern-Day Violent Gangs in the United States

Gangs and Their Tattoos:
Identifying Gangbangers on the Street and in Prison
by Bill Valentine
with original artwork by Robert Schober

Copyright © 2000 by Bill Valentine and Robert Schober

ISBN 13: 978-1-58160-099-5
Printed in the United States of America

Published by Paladin Press, a division of
Paladin Enterprises, Inc.,
P.O. Box 1307
Boulder, Colorado 80306 USA
+1.303.443.7250

Direct inquiries and/or orders to the above address.

Visit our website at www.paladin-press.com.

CONTENTS

DISCLAIMER

The views expressed herein are those of the authors and do not necessarily reflect those of the Nevada Department of Prisons.

Neither the authors nor the publisher assume(s) any responsibility for the use or misuse of information contained in this book.

PREFACE

Gang members communicate in many different ways. Speech is the most obvious; however, gang members also make extensive use of nonverbal methods of exchanging thoughts. Graffiti, hand signs, stylized dress, colors, hairstyles, postures, and tattoos effectively announce gang affiliation, issue challenges, and denote rank.

Many law enforcement agencies assign a numerical value to gang membership indicators according to their significance, though this is not absolutely necessary. These indicators include but are not limited to

- tattoos
- self-admission
- documents
- publications
- graffiti
- authorship
- court records
- group photos
- confidential informants
- media accounts
- colors/clothing/hairstyle
- hand signs
- enemies and allies
- intelligence (intel) from other agencies
- involvement in gang crime

Graffiti can be transient and subject to cover-up by civic-minded officials. Hand signs and postures are fleeting, and colors and clothing are subject to normal wear and tear. Tattoos, on the other hand, are relatively permanent. Used in ancient cultures for thousands of years to indicate tribal identity, tattooing is a recognized art form in today's high-tech society. Yet the techniques in use today are nearly identical to those practiced by primitive man. Whether inscribed by a powered tattoo gun or a cluster of piercing thorns, the indelible reagents inscribed subcutaneously bring the same results: intricate designs etched into the skin that the wearer will carry to his grave. Of all the identifiers used to verify gang membership, tattoos are one of the most pervasive and reliable. Not only are they relatively permanent, but they convey a wealth of information about the wearer. Looking past the obvious, the astute reader of gang tattoos may also discern the subject's rank in the gang, his criminal expertise, and, in some cases, the number of hits (murders) he's performed or other peculiarities. These traits are sometimes shown as separate tattoos, or they may be reflected in the gang member's tattooed moniker, e.g., Maton (Killer); Gauge (Shotgun); Sherm (heavy PCP user).

Tattoos can be photographed and cataloged in files of tattoo patterns that become the

foundation of gang membership identification. During law enforcement training seminars, photos and slides of gang member tattoos have proven invaluable when teaching large groups how to identify street and prison gang members. And the thousands of gang tattoo patterns that have been cataloged are now being shared among cooperating departments nationwide, who transmit these images to each other via the Internet.

My first book, *Gang Intelligence Manual*, was published by Paladin Press in September 1995 and was a best-seller in the police science category for many months. It continues to serve as a valuable reference for law enforcement as well as for anyone who is interested in the identification and tracking of criminal gangs.

In February 1998 I produced a two-part video titled *Reading Gang Tattoos*, which is highly acclaimed but available only to law enforcement personnel. Not long after this was released, I began getting inquiries from the general public asking how they could obtain the type of intelligence presented in the video. Attorneys, school teachers, hospital personnel (including those in the pathology labs), workplace supervisors, private security firms, antigang organizations, and people from all different sectors expressed a need to be armed with this type of information.

Responding to this need, I set out to declassify as much of the intel contained in the video as possible so that I could produce a work that could be offered to the general public as well as to the law enforcement community. *Gangs and Their Tattoos*, which is the culmination of two years of research, data compilation, and writing, now fills this void.

A video, which is a valuable training tool, has its limitations. It can only be utilized where proper equipment is in place. A reference book, however, can be carried by the cop on the beat as well as the school master, both of who may be encountering gang members on a daily basis.

Much of the contents of this work was previously confidential and, therefore, necessarily restricted to law enforcement personnel. Now, the material has been declassified and is offered to the public in the hope that it will alert others as to the enormity of the pervasive gang problems throughout the United States.

Every effort has been made to ensure the accuracy of all the information contained within; however, neither the author nor the publisher assumes any responsibility for the use or the misuse of any information contained in this work.

All of the illustrations in this work are either actual photographs of gang member tattoos or sketches made from actual photographs. If the sketch appears crude, that is because the subject's tattoo was crude. Conversely, if the sketch appears finely detailed, it is because the tattoo itself was the work of a very skillful prison tattoo artist.

BILL VALENTINE'S
ACKNOWLEDGMENTS

For gang investigators, sharing intel with each other is essential. This is what members of gang investigator associations do during their frequent seminars and networking. In fact, these seminars have been of inestimable value in helping me put this work together. I am indebted to my coworkers, gang officers from different agencies, and countless gang investigators who gave presentations during seminars and workshops. Here I attempt to recognize them all and offer my sincere thanks. However, I fear that some of the names will have been lost from memory, and for this I offer my sincere regrets.

Gang Investigator Associations that Have Been of Great Value in My Endeavors

- American Society of Law Enforcement Trainers, Lewes, Delaware
- Calibre Press/Street Survival, Northbrook, Illinois
- Midwest Gang Investigator's Association, Des Moines, Iowa
- National Law Enforcement Institute, Santa Rosa, California
- National Major Gang Task Force, Houston, Texas
- Nevada Gang Investigator's Association, Las Vegas and Reno, Nevada
- Northern California Gang Investigator's Association, San Jose, California

Outstanding Gang Investigators

- Correctional Officer (C/O) Ray Ardiles, Nevada State Prison, who was raised in the East L.A. barrios and knows the Sureño gang scene as well as, or better than, any other gang investigator
- Charles Berard, Milwaukee County, Wisconsin, Sheriff's Office and president of the Midwest Gang Investigator's Association
- Loren Christensen, Portland, Oregon, Police Department (Ret.) and author of many police science books
- Chris Cuestas, Tucson Police Department (Ret.)
- Special Agent Ernesto Diaz, United States Treasury Department, BATF
- Officer Rich Duran, LAPD, CRASH
- C/O Catarino Escobar, Nevada State Prison, with whom I've spent countless hours cruising Reno barrios and meeting with active Hispanic gang members face to face
- Officer Marcus Frank, Westminster (California) Police Department, an expert in Asian gangs
- Detective Walt Frazier, Reno Police Department, CAT Team
- Lynn A. Gibson, senior special agent,

United States Customs Service, Reno, Nevada
- Cory Godwin, Florida Department of Corrections
- Deputy Tom Green, Washoe County, Nevada, Sheriff's Office, another close friend with whom I've worked closely and exchanged information for many years
- Sgt. Joe Guzman, Los Angeles County Sheriff's Department
- C/O Gary Hill, Nevada State Prison, who relates exceptionally well with prison gang members and is able to draw out information from them without their ever knowing
- Capt. Jacob Kopylov, Denver County Sheriff's Office, a Russian immigrant, exceptional individual, and close friend who helped me much with information pertaining to Soviet prison camp tattoos and sign language
- Frank "Paco" Marcell, New Mexico Department of Corrections
- Sgt. Wes McBride, Los Angeles County Sheriff's Department
- Gabe Morales, King County Sheriff's Office, Seattle, Washington, author of *Varrio Warfare: Violence in the Latino Community*
- Lt. Charles Muller, Nevada State Prison (Ret.)
- Senior Agent Newton Phillips, United States Customs Office, Reno, Nevada
- C/O Henry Pimentel, Solano County (California) Sheriff's Office, another exceptionally bright gang investigator with whom I've spent hours discussing and exchanging intel on active gang members
- Detective Don Ramsey, Reno Police Department, CAT Team
- Deputy Brent Royle, Washoe County Sheriff's Office, a top-notch gang investigator
- C/O Robert Schober, Nevada State Prison, an outstanding illustrator whose work is featured in this book
- Sgt. Lou Savelli, Gang Squad, New York Police Department, who has impeccable credentials and a track record of smashing illegal gangs on the streets of New York City
- Craig Trout, Federal Bureau of Prisons
- Al Valdez, Orange County (California) District Attorney's Office
- Jim Vepley, Winthrop Harbor Police Department, Winthrop Harbor, Illinois
- Deputy Tobie Weberg, Milwaukee County Sheriff's Office and newsletter coordinator for the *Gangster Gazette* (the top-notch newsletter of the Midwest Gang Investigator's Association) with whom I communicate frequently regarding gangs and gang members
- A. Dale Welling, Federal Bureau of Prisons (Ret.) and executive director of the National Major Gang Task Force
- Senior Trooper Robert Dent, Oregon State Police, a pioneer in developing compassionate support for families of fallen officers who also works tirelessly instructing others in methods of preventing officer tragedies (www.survival-spanish.com)

The Paladin Editorial Staff

I would also like to acknowledge the outstanding work done by my editor at Paladin Press, Karen Petersen, who wouldn't let me coast, and who made me apply myself diligently to this work. In addition, I would like to acknowledge the fine cover design done by Paladin Art Director Fran Milner. Thank you both.

And Most of All . . .

My wife of many, many years, Jessie, who has always been there with support, encouragement, and patience.

—Sgt. Bill Valentine
Carson City, Nevada

ROBERT SCHOBER'S ACKNOWLEDGMENTS

I would like to express my gratitude to my wife, Michelle, and my four sons, Mathew, Nathaniel, Luke, and Benjamin for their support and love.

PRISON GANGS

Intelligence on active gangbangers is derived from many sources. Of all the intel I have gathered throughout my 20-year career with the Nevada Department of Prisons and beyond, none has been more valuable than that given up by prison inmates, either knowingly during debriefing sessions or unwittingly during what they deemed to be nothing more than casual conversations between us.

Validation of prison gang members is a legal procedure that begins during the prison intake process when the C-File is started, comprising the inmate jail reports and other pertinent data. Suspected gang history is documented and sent up the chain of command, passing through various levels of staff members, including the gang intelligence officers who begin a separate gang file and database. Using the various sources of gang intelligence, officers determine the validity of the data and compile documentation, which then becomes part of the gang file. They forward the documentation up the chain of command to the warden, whose job it is to either accept or reject the information. After receiving the warden's seal of approval, the packet leaves the prison walls for its final destination, the attorney general's office, where it will be evaluated. If all criteria have been met, an inmate's gang membership is certified and his name is entered and tracked through the computer database as long as he is incarcerated. Once an inmate is put in lock-up because of gang membership, there are usually only three ways out: debriefing (telling all), expiration of sentence, or death. If and when an inmate is released back to the streets, copies of his gang file are shared with outside law enforcement agencies.

Gang intelligence officers must be thoroughly trained and certified, as should any gang task force if working as a specialized unit. Their work must be accurate, complete, and, above all, court-defensible, since inmates traditionally flood the courts with legal papers. In court these officers will be required to defend their position as it relates to gang member identification and disposition.

Other custody officers share the responsibility of recognizing signs of gang membership and criminal activity. Line officers, even though they lack the specialized training given to the gang officers, are in a position to observe the many different ways gang members communicate.

In addition, officers working housing units should scrutinize cell furnishings, scribbling on the walls, photos, inmate associates, and the demeanor of inmates under their control. Visiting room officers can supply information as to the character of outside visitors. The mail room officers, in addition to inspecting

incoming mail for contraband, should also maintain lists of the people who correspond with inmates. Guntower officers are in a position to describe the types of vehicles visitors drive and their license plate numbers. Property room officers have the opportunity to inspect and track inmate property over a period of time, which may reveal a gang's tactics of pressure and extortion directed against other inmates.

Aside from custody, other departments also have a responsibility to alert staff to unusual circumstances. The medical department, for instance, may be the first to note the presence of fresh tattoos, body piercing, injuries, cigarette burns (pervasive among Asian gang members), evidence of sexual assaults and illegal drug use, and related indicators.

The athletic department staff is also in a position to observe shirtless inmates, which reveals the presence of gang-related tattoos.

PRISON TATTOOS

Prison inmates, whether in Soviet labor camps or state-of-the-art modern penitentiaries, have brought the skill of tattooing to a high degree of design and innovation. The remarkable thing about this is that the practice is outlawed by most holding facilities because of the very real threat of contagion under unsanitary circumstances and conditions. Working secretly, inmates must make their own tattoo guns and inks out of obtainable items and then spend countless hours inscribing the tattoos without being detected by the ever-present prison staff. When caught in the act, both the tattooist and the inmate receiving the work are sent to disciplinary, which usually means confiscation of all paraphernalia and loss of privileges.

Making a prison tattoo gun begins with removing the head from a toothbrush and bending the handle into an offset "L" shape. Next, a cassette motor taken from a Walkman or similar appliance is taped to the angled, short end of the toothbrush handle and the tip of of a ball-point pen is taped to the horizontal portion. Inside this goes the needle, which is

attached to the cassette motor on one end while the other end protrudes through the front of the pen. The needle is usually a rigid piece of wire, such as taken from a disposable cigarette lighter, which is straightened and then sharpened to a fine point on one end. Wire leads run from the motor to either a cassette motor or dry cell batteries. The finished gadget is less than 4 inches long and uses a single needle. In the hands of a skilled artisan, it produces work that will equal or rival any done in a professional tattoo studio.

Inmates may smuggle India ink out of hobbycraft classes or make it themselves. Prison ink is made from the soot created by burning plastic eating utensils mixed with Prell shampoo and water. This mixture is easy to

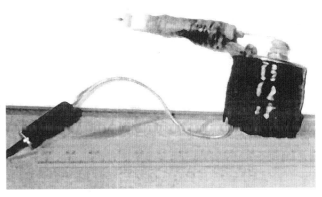

A prison-made tattoo gun. This gadget was made using the small motor from a Walkman cassette player.

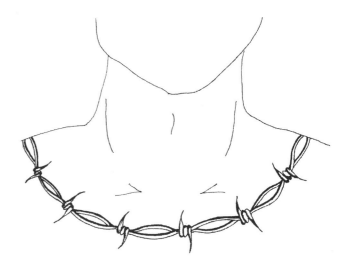

Barbed wire around the neck is a common prison tattoo. It is not gang-specific.

work with, will not overly irritate the skin, and is permanent. Reports from Russian prisons indicate that the inmates there mix the soot with urine. This questionable practice has resulted in some inmates contracting life-threatening infections.

Once the gun and ink have been assembled, a tattoo pattern is applied to the Vaseline-coated skin of the inmate receiving the work. The pattern may be a freehand sketch or a design that is transferred using a carbon-papered stencil. Before starting the tattoo, the artist must place a point out on the tier to watch for approaching officers. When none are near, the tattooing begins. Outlines are usually done first, and the shading follows in a long series of sittings that are interrupted periodically for the skin to heal. Intricate tattoos, such as those that encompass large areas of the skin, may take months to complete.

There are several ways inmates pay to have tattoos inscribed, and most of these are illegal within a prison setting.

- The inmate may have his family send in a money order to the inmate artist's account.
- The inmate may trade something of value (e.g., clothing, electrical appliances, canteen items, toiletries, or contraband such as drugs or weapons).
- The inmate may pay in tobacco, which is the preferred medium of exchange in prison and is used in much the same way as currency is used on the streets.
- The inmate may be forced by the tattoo artist and his friends to go on a mission as a way to repay the debt.
- The inmate may be forced to commit sexual acts.

Each prison gang has its own tattoo artists whose responsibility it is to ink gang members with authorized designs.

RACIAL DYNAMICS OF PRISON GANGS

Most prison systems throughout the nation have spawned prison gangs, and, though there are exceptions, most of these gangs form along racial lines. White supremacist gangs such as the Aryan Brotherhood (AB) and Aryan Warriors (AWs) limit their membership strictly to whites. Groups that espouse a blacks-only membership policy include the Black Guerrilla Family (BGF) and 415—Kumi African Nation, both with headquarters on the West Coast; the Zulu Nation on the East Coast; and the nationwide Black Panthers, among others. Among Hispanics, the Mexican Mafia and most of the Border Brothers groups limit membership to Mexican Americans or Mexican immigrants.

The notable exceptions to this rule are the Folks and People Nations, two large, prison-based umbrella organizations based in the Midwest. These "nations" have under their control many street gangs of mixed-race membership, a feature that is generally predicated upon the racial makeup of the gang's neighborhood. In neighborhoods of mixed races, it is common to find multiethnic street gangs. This may or may not carry over when the individual gang members enter prison.

WHITE PRISON GANGS

During the late 1950s, white prisoners in California prisons were frequently being assaulted and victimized by roving bands of predatory inmates, most of whom were either black or Hispanic. Rapes, beatings, stabbings, cell thefts, and other acts of violence directed against the whites had become rampant, and the administration seemed unable to control them. Some of the stronger white inmates began arming themselves with prison-made weapons and fighting back. Many of these were renegade bikers, some of who had tiny bits of glass embedded in their teeth and called themselves the Diamond Tooth Gang.

Members of the Diamond Tooth encouraged other whites to arm themselves and stick together to put a stop to the attacks once and for all. Other whites joined in, yet the Diamond Tooth still lacked sufficient membership to discourage further attacks. Recruitment stepped up. As more inmates joined, the gang dropped the name Diamond

Tooth in favor of the Blue Bird Gang. Their identifying tattoo, usually inscribed on the neck, was a pair of bluebirds in flight, which symbolized freedom.

The Blue Birds gained strength for a while and then began to falter. During the turbulent 1960s, all-out race wars erupted within the prison system, pitting blacks, Hispanics, and whites against each other. It was during this period of time that several neo-Nazi groups on the yard at San Quentin teamed up with the remnants of the Blue Birds, giving birth to what would become one of the most feared and violent of all prison gangs, the Aryan Brotherhood.

The Aryan Brotherhood

The AB began to structure as a whites-only prison gang and formed its own specific rules. Where the blacks and Hispanics recruited solely to bolster membership, the AB limited membership, accepting only the strongest and most violent white inmates and those who would kill without question. A "blood-in, blood-out" decree was issued for all members: to gain membership, a prospect had to kill whomever the AB targeted. The only way out of the gang was death.

···

Rules of the Aryan Brotherhood

1. After reading these rules and you decide you would like to be in the Brotherhood and you are voted in and accepted, there is only one way out, that is death.
2. Once you enter into the AB, do not try to backslide in any way! You are not being given a free ride thru this prison. If you enter with those thoughts in your mind and we find out, it will be your death!
3. After you are sworn into the AB, you will be advised of the social structure of the AB and will be expected to recognize it and abide by it's decisions and orders.
4. The AB is exactly what it says, "A Brotherhood." When you see a brother involved in any sort of trouble or hassle, you go to his side. You may not be on the best of terms with the man, but he is your brother and will be treated as such. So back him! He is going to do the same for you when you need him!
5. A brother can sometimes be wrong, but in front of a non-brother, he's right! Afterwards when you are alone, his being wrong can be dealt with. But never in front of a non-brother!
6. You will not bullshit or play games with a brother in front of non-brothers. Always show respect to a brother and let everyone around you know that the respect is there!
7. We take care of our own! We don't have time for the games that non-brothers are involved in! You will protect your brother, his property, and the interest of the AB as if it were your own! Your brothers will be doing the same for you.
8. If you are told to do something there is a reason for you being told to do it, so do it!
9. You are in the AB for life! If you hit the streets and come back, you're still in it! You must be willing to do for a brother what you want him to be willing to do for you. No matter where you are!
10. After a certain length of time, it will be necessary to make a donation to a bank account in case any brother is placed on the adjustment center (maximum security detention). A brother is to be taken care of to the fullest of the AB's capacity! The donations will be reasonable.
11. The purpose of the Aryan Brotherhood is to bring back the respect that is long overdue in coming to this prison and to the White Race! At all costs! We will strive to maintain that respect!

···

The AB Brand

A shamrock with the number 666 and the initials AB became the official brand of the Aryan Brotherhood and was tattooed on the bodies of those members who had earned their bones—completed a successful mission. The use of the shamrock symbolized Irish thought and originated with an early founder of the AB, who was Irish. The 666, which is the mark of the beast, was taken from satanism and represented the AB's antiauthoritarian lifestyle.

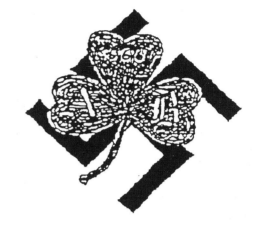

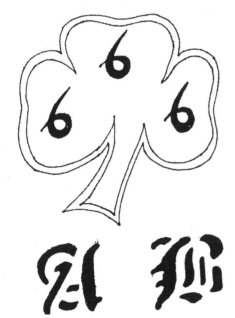

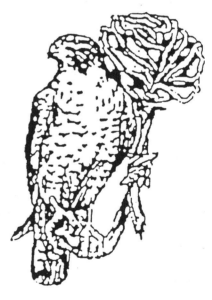

Sinn Fein

Four common symbols of the Aryan Brotherhood.

Supplementary tattoos drew heavily from the World War II Nazis, who, under Hitler's leadership, espoused racial purity. The AB aligned itself philosophically with the Nazi objective of exterminating all non-Aryans and creating a pure Aryan society that would endure for 1,000 years. Tattoo patterns borrowed from Nazi symbolism included the swastika, lightning bolts, runic SS, death's head, iron cross, Nazi war eagle, and other German army themes, including uniformed and helmeted soldiers, armored machinery, and automatic weaponry. The Vikings—the tall, muscular, fierce blond warriors who plundered and terrorized Europe during the 9th and 10th centuries—also served as ideal role models for the AB and other white supremacists, lending them a legacy of strength, courage, and unity. Tattoo patterns taken from the Vikings included Viking ships, sword-wielding mounted warriors, body armor, and especially the horned Viking helmet covering the head of either a warrior or his fair-haired woman.

The AB Seizes Control and Strikes Back

To reinforce their goal of becoming the most feared gang in San Quentin, the AB, which numbered around 100 members, put out the green light (open season to hit) on all blacks, regardless of their gang or political affiliation. AB soldiers eagerly jumped at this opportunity to retaliate for the violence that had been directed against the white inmates previously. Blacks suddenly found themselves being attacked without provocation by soldiers of this newly created white warrior society. In the early 1970s, gang assaults and murders within the California prison system climbed dramatically, and the AB was responsible for many of these.

To show disrespect to the AB meant instant bloody retribution. Not the slightest insult was tolerated. Once its reputation for brutality had been established, the AB moved right on into the control of organized prison rackets. Protection, extortion, narcotics, weapons, and contract hits followed, including the brutal murders of career correctional officers by known AB leaders.

Aryan Brotherhood Identifiers

- *Other names*: The Brand, Alice Baker, The Tip
- *Ideology*: White supremacy. The AB, from its inception, drew from Irish/Celtic history (as attested to by their use of the shamrock in their tattoos), neo-Nazi racist thought, and satanism (shown by their use of the "666," or mark of the beast, in tattoos).
- *Recruitment*: Whites only; no mixed races. A prospect must be sponsored by a confirmed member. An AB member is required to remain active with the gang once he is released from prison. Marching orders are issued, and the inmate is expected to carry them out. A "blood-in-blood-out" requirement is absolute.
- *Appearance*: Good physical conditioning is required, including weight lifting (where available), cardiovascular/endurance exercises, and self-defense training. Shaved heads are common.
- *Criminal activity*: Weapons manufacturing and concealment, drugs, extortion, protection, prostitution, assaults, and murder inside the walls. ABs on the streets are frequently involved in murder-for-hire, drugs, weapons, bank robberies, and related crime.
- *Allies and enemies*: The AB has a long-standing alliance with the Mexican Mafia. The Black Guerrilla Family and the Nuestra Familia (NF) are long-standing enemies. Contrary to popular thought, the AB and Hell's Angels do not get along well.
- *Tattoos*: A shamrock with the numbers 666 affixed; the initials AB; a shamrock affixed to a swastika; and, most recently, a falcon that may be superimposed on a shamrock or in front of prison bars. The slogan *"Sinn Fein"* may also be seen.

The Aryan Brotherhood of Today

As of 1998, AB membership was thought to number no more than a few hundred. This

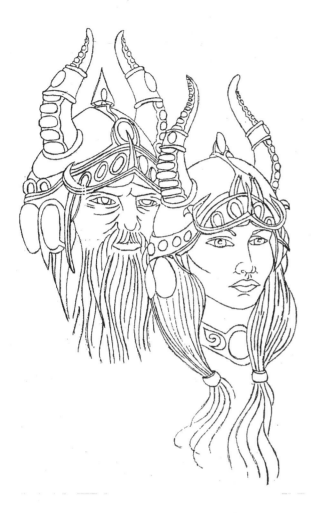

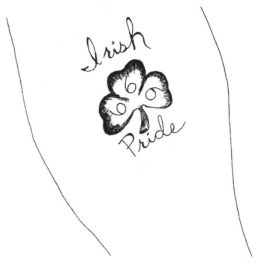

The shamrock and "666" of the Aryan Brotherhood with "Irish Pride."

Viking heads denote a belief in white supremacy and are seen extensively on AB gang members.

The "AB" and shamrock of the Aryan Brotherhood on the left inside biceps.

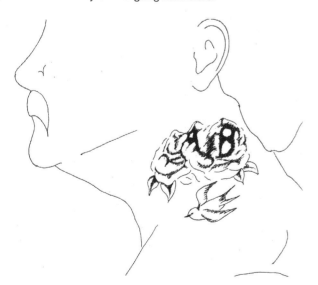

"AB," bluebird, and flowers on the neck of a long-time Aryan Brotherhood member.

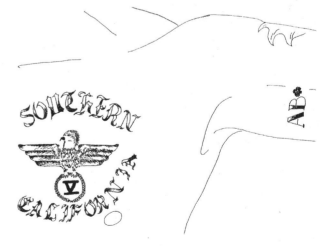

"AB" and small shamrock inside left biceps. The Nazi war eagle on the chest is neo-Nazi. "Southern California" refers to the inmate's home state.

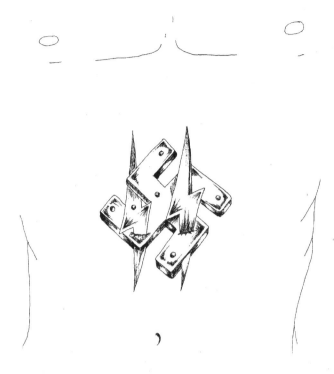

The swastika with lightning bolts on this inmate's abdomen is the brand of the Arizona Aryan Brotherhood.

includes the hard-core members and associates who are housed in California prisons, along with those in the Federal Bureau of Prisons and those who have been released back to the streets. Upon release from prison, AB members are given their marching orders, which may be anything from hitting a snitch to smuggling drugs or weapons back into prison. Inside the prisons, the AB members continue to excel in weapons manufacturing and concealment, drug trafficking, protection, and extortion. They rule by fear, intimidation, and violence.

The structure of the Aryan Brotherhood has changed little since the inception of the gang. At the top sits a three-person commission, and below that a 10- to 12-member council. This hierarchy rules with complete authority. Below this level are the lieutenants and schoolmasters who instruct prospects in self-defense, lethal striking points of the body, handcuff release, baton take-away, weapons, classification manipulation, and other topics deemed necessary inside a prison. Below this level are the soldiers and prospects.

AB membership is limited to whites only.

Prospects are selected on the basis of strength and connections. Prospects are sometimes selected from neo-Nazi groups in prison, such as the Nazi Low Riders (NLR), Skinheads, Dirty White Boys, Co Co County (Contra Costa County), and Peckerwoods. Entry into the Brotherhood is a complicated procedure. To begin with, the recruit must be sponsored by an AB member. His papers and background must be established (the AB family members on the street maintain computerized intelligence on criminals as well as law enforcement personnel). If these are deemed acceptable, the entire AB membership puts it to a vote. Final approval is placed in the hands of the commission.

Once accepted, the prospect is placed on up status, put on probation, and, among other things, given a mission. This will usually be an act of great violence directed against a black or a person regarded as an AB enemy. All this may take as long as two years to complete. By now, the prospect has made a commitment to the Brotherhood. Refusing to obey orders, dropping out of the gang, failing to complete the mission, or showing any sign of disrespect to the AB or its members may result in swift retribution by the Brotherhood. A "blood-in, blood-out" entry requirement is absolute.

Once an inmate has been initiated into the Aryan Brotherhood, he is branded—marked indelibly with the AB tattoo. As explained earlier, a tattoo is relatively permanent, and in prison it leaves no doubt as to the wearer's gang affiliation or lack thereof. This may work as a plus or as a minus. When the inmate is working out on the iron pile or playing handball, or any other time he is shirtless, his prison gang tattoo flashes like a beacon. Other inmates know at once that he is connected, that he is a member of a notorious prison gang and an inmate who is therefore accorded a measure of respect by weaker inmates. But, of course, there are disadvantages to wearing the brand of the AB. Prison administrators, when validating prison gang membership, regard the tattoo as the most irrefutable gang member identifier. And AB enemies, such as the Nuestra Familia and the Black Guerrilla

Family, view the subject who is wearing the AB shamrock as a target to be hit. When away from home base (e.g., while being held in a county jail awaiting court action), the Aryan Brother risks being attacked solely because he is wearing the AB gang tattoo.

Despite these drawbacks, the AB prison gang members have, until recently, worn the tattoo like a badge of honor. It symbolizes the wearer's willingness to follow AB precepts blindly for life and to accept the risk that goes with being a member. Recently, however, since all validated prison gang members are being sent to ultra-maximum security prisons like Pelican Bay or Corcoran, many of the longtime AB members are covering up their identifying tattoos to avoid being slammed in these newer California lock-up facilities.

Recently prison authorities have noted another AB tattoo, again taken from the Irish: a falcon, which may be superimposed on a shamrock or in front of prison bars. The slogan *Sinn Fein* (Gaelic for "we stand alone") may also be seen in more recent AB tattoos, as well as literature. Between 1992 and 1994, two escapees from Northern Ireland's Maze prisons, were apprehended in California and imprisoned at a federal facility in northern California. It is thought that these two prisoners were influential in bringing their *Sinn Fein* ideology to AB gang members (although this has not been confirmed).

The Aryan Brotherhood continues to maintain a shaky alliance with the Mexican Mafia and continues to war with the Black Guerrilla Family and the Nuestra Familia. The AB also has a history of confrontations with the Hell's Angels. This is because the AB is a prison-based gang that extorts taxes from all white inmates in the prisons under their control. The Angels, on the other hand, are essentially an outside organization and refuse to pay taxes when incarcerated.

Most of the hard-core California AB members are imprisoned at Pelican Bay, an ultra-maximum security prison near the Oregon border. Despite the tight security, several inmates have been murdered there during the last few years.

A confidential informant and one-time AB enforcer has told authorities the killings are the result of AB politics gone sour. There appears to be a power struggle going on now between the new generation Aryans and the older established hierarchy. The informant also indicated that several unsolved murders on the streets were the result of orders issued by AB leaders from their SHU (Security Housing Unit) cells. Del Norte County, California, Deputy District Attorney James Fallman has said of the informant, "[His] cooperation may deliver the death penalty to up to 10 AB leaders, some of whom still call 187 [murder] hits from their cells."

Rumors persist that the Aryan Brotherhood is nearing its end, that the Nazi Low Riders are trying to take over. This may or may not be happening. Harsh internal discipline has caused many AB members to drop out. These dropouts sometimes join other groups opposed to the AB. Such inmates refer to themselves as "Brand Busters."

Nazi Low Riders

The NLR have been around since the 1970s when they formed a group within the California Youth Authority (CYA) system. Membership was limited chiefly to whites with a few Hispanics allowed. Blacks were not allowed in. As the group gained strength and its members matured and entered the adult institutions, recruitment was stepped up throughout California prisons. Many of the more violent members went on to hook up with the Aryan Brotherhood, which set the pattern the NLR was to follow.

During the 1980s, when the authorities went after the Aryan Brotherhood in earnest and slammed validated AB members in Pelican Bay and other max lock-up prisons, the NLR filled the void and conducted AB business in several California prisons—as sanctioned by the AB. The NLR was soon validated as a disruptive group (which means the identified members are placed at a higher custody level than the general population but still don't require max lock-up, as do validated prison

gang members).

By early 1999, the NLR was estimated to have upwards of 1,500 members, including those who had returned to the streets. They had become such a problem in the prison system that the California Department of Corrections (DOC) went after them much as they had with the AB. The result was that the DOC validated the Nazi Low Riders as a prison gang (as opposed to a disruptive group). With this new standing, all identified members were to be moved to a prison with max lock-up capabilities, such as Pelican Bay or Corcoran. To avoid the drudgery of 23-hour lock-up, many NLR members started to cover up their identifying tattoos in order to thwart the DOC's intentions.

NLR Tattoos

Because of their white supremacist leanings, NLR gang members also got inked up with Nazi and Viking symbols. However, the specific gang tattoos seen most often are the words "Nazi Low Riders" or the initials "NLR," which may

"NLR" on the subject's upper left chest.

be seen on various parts of the body.

Aryan Warriors

The Aryan gang concept was brought to Nevada in 1973 when a troublesome Nevada prison inmate, whom we will call "McBain,"

was sent to the California DOC. During the inmate's stay in California, he got his first look at the structured, feared Aryan Brotherhood and was swayed by what he saw. When he was sent back to Nevada, he brought with him plans to organize the white inmates at Nevada State Prison (NSP), much as they had been in the California prison.

As you will recall, white inmates at that time were poorly organized and had become the victims of frequent attacks from the blacks. On too many occasions, when a swarm of blacks rolled in on a white inmate, he had little or no help from the other whites. McBain vowed to change all that. He held meetings with some of the stronger whites and began laying the foundation for an Aryan gang at NSP, at that time a maximum-security facility. Other whites, especially those who had been victimized previously by the blacks, eagerly offered their support.

McBain at first sought a charter membership of the California Aryan Brotherhood. He was turned down and told that Nevada would have to form its own tip. The Nevada group then agreed to call themselves the Aryan Warriors. Nevada's Aryan Warriors have never reached the stature or notoriety accorded the AB.

Leadership and Organization

During the first year, the group was beset with indecision and internal strife. For a while it seemed as if it might break up. And then a shrewd inmate called The Pope, who was doing a life term for murder, took over. This influential inmate had done a lot of time in California prisons and began to school the AWs. The Pope was a good 20 years older than the other AWs, and because of his experience in the California system, the Nevada inmates paid attention. Physical conditioning was essential, he told the others. It was imperative that all members drive iron on a regular basis. They had to buff up and get mean. He explained that they, the white gang members, had a responsibility to police the other white inmates. "Baby rapers" (child molesters), snitches, whites associating with blacks, and other undesirables

could no longer live in general population. They had to check in (go into protective custody [PC]) or risk being killed. He also taught the group to get along with the administration. "Don't fight with the guards; we don't need that kind of heat. Our fight is with the blacks," he stressed. "And don't let any insult, no matter how slight, go unanswered."

Under the Pope's leadership, the Aryan Warriors began to structuralize. All members who had been with the group since its inception were regarded as soldiers. As such, each was awarded a pair of lightning bolts tattooed inside the left biceps. White inmates who wanted to tip up with the AWs needed a sponsor. The sponsor had to be at least a bolt-holder. The prospect had to pay homage to the established members and was required to complete a mission, usually a bloody assault of another inmate or, in some instances, a drug rip-off from a person outside of the brotherhood. When the mission had been completed successfully, the prospect was awarded the bolts and became a brother.

Brothers looked out for each other. It was soon known on the yard that if you put a brother in check, you had to answer to the entire brotherhood. The AWs were building a reputation for violence. They had also become excellent weapons manufacturers who didn't hesitate to put their weapons to use when taking care of business. There was a feeling of great camaraderie among the brothers. They paid dues willingly, knowing that if they were moved to lock-up they would be sent tobacco and other canteen items, small luxuries that are so important in prison.

The next step up the ladder was a promotion to horn-holder, a position directly below the leader. Horn-holders wore a tattoo on the left upper chest consisting of a Viking helmet with horns and the letters "AW." To earn the horns, a soldier had to commit an act of great violence, usually the murder of a black or anyone else on the AW hit list. At the top sat The Pope, the acknowledged leader.

The Pope formed a council to sit below him. The council had six members, all of whom had to be horn-holders. Below this level were the soldiers and the prospects. The leader and his council met frequently to decide on all matters important to the gang's well-being and objectives. Plans were laid out and sanctions were imposed on soldiers for rule infractions. At times, fines were levied; serious violations of a rule resulted in serious beatings and expulsion from the gang. Intelligence on other inmates as well as prison staff was discussed. Which staff could be compromised? Which female correctional officers or nurses could be played? These topics were of vital interest to the success of the Aryan Warriors, who were ready to make a play for control of the lucrative prison rackets.

Black Prisoners Respond to the AW Threat

The blacks, who had been monitoring the AWs closely during this period of time, began to restructure themselves. Borrowing from the AWs, the blacks were now organizing under the name the Black Warriors (BWs). And the mimicry didn't stop there. The identifying tattoo they adopted was also a helmet with horns, placed on the upper left chest, and the letters "BW."

The blacks still regarded themselves as the yard bosses, and after running the yard unmolested for so many years, they voted to confront the Aryans. Several skirmishes broke out. Marauding blacks rolled in on weaker white inmates. Beatings, rapes, cell thefts, and other acts of violence followed. It was time for the AWs to put up or shut up. And put up they did.

Showdown: AWs vs. BWs

The Native Americans had also been having problems with the blacks, and a meeting was called between the Natives and the AW power structure. For the first time in the history of the more than 100-year-old prison, the whites and Natives pledged to band together to bloody the blacks. This set the stage. Under cover of darkness, the oldest profession in prison, the manufacture of weapons, was put into high gear. Shards of metal from window frames, doors, and beds disappeared. The tag plant (license plate

factory), reported missing metal. Hidden shanks were retrieved and sharpened. It wasn't long before enough weaponry was available to restart the Crusades.

Veteran officers sniffed the air and sensed trouble. Canteen sales tripled. Whites were seen in quiet conversations with Natives. Newspapers and magazines were becoming scarce (used as body armor by inmates), an inordinate number of inmates was trying to get into PC. Admin was receiving far more snitch kites (notes sent up front to staff when an inmate wants to inform on others). Every max officer worth his salt pressed his informants for information. When the officers compared notes, they all reached the same unequivocal conclusion: everything pointed to an impending racial showdown for control of the yard.

On the fateful day, inmates moved into the culinary with apparent uneasiness. Only half of the usual number came in for the meal. The white inmates all seemed to be wearing padded shirts or bulky jackets. Veteran officers instinctually knew something was coming down.

As if on cue, the culinary exploded. Suddenly shanks, clubs, socks filled with canned goods, and other assorted bludgeons were slicing the air and pounding into black inmates (who, customarily, were gathered together on their side of the eating area). Burly whites and Natives blocked the exits, allowing only the retreating officers to escape. Gas gun ports were rendered ineffective by inmates blocking the outlets with food trays.

The blacks, taken aback by the suddenness of the onslaught upon them, were thrust into disbelief: this couldn't be happening. The whites had no heart. It was they, the blacks, who controlled the yard. The whites were punks. Yet many of the shocked blacks, few of them strapped (armed), now cowered under tables hoping to save their lives. Blood splattered the walls and floors. The noise was deafening. Shrieking voices could be heard pleading and screaming obscenities. Attackers were ducking under hurled food trays that could crack a skull.

And then, just as suddenly as it had erupted, the battleground stilled. The white and Native attackers dumped their weapons and poured out of the culinary, only to be ordered facedown in the dirt by the gun-post officers on the cellhouse roof. Shotgun-toting gun-post officers screamed at the proned inmates through bullhorns to cease their excited chatter. But the adrenaline had yet to subside, and they ignored the orders to shut up. This wasn't a time to be quiet and submissive; no, this moment called for laughter and pompous recanting of what they had just accomplished. The whites and Natives were now running the yard.

Faltering Unity: AWs Begin to Prey on Their Own

During the next few years, the AWs continued to grow in strength and number. But they began to move away from their founding precept, that of protecting white inmates.

Now that they had defeated the blacks, they began to prey on their own kind. Pressure and extortion of white inmates soared. It worked like this: AW soldiers would roll in on a white known to have well-off family members. The victim would be roughed up and told to have his folks send in money orders to gang members. A time frame was allotted, and if the victim failed to meet the deadline, he was savagely beaten or stabbed. If he, instead, checked into PC, a contract was put out on him and, sooner or later, they would get to him. If the victim had no such family contacts, he would be forced to surrender his television, radio, or canteen items. If unable to produce any of these tangibles, he was then violated sexually. He became a punk and was prostituted on the yard. Occasionally, the white power structure gave the blacks permission to victimize a white inmate. Whites targeted for this type of degradation were low-life baby rapers, snitches, or other unworthy vermin. But they weren't given up freely; the whites demanded payment up front from the blacks for the privilege.

The whites and blacks formed a precarious alliance that stayed in effect when both could profit from sales of narcotics or

other prison rackets.

BWs Attempt to Strike Back

The black leaders made one more attempt to regain control of the yard. Having learned from their past experience with the AWs, and having no desire for a repeat of the culinary disaster, they conceived a plan that they thought could restore their status and credibility on the yard. Their plan would catapult the Black Warriors, again, to the top of the hill, their righteous position. They would regain control of the yard. And this time their rivals would be grossly outnumbered. The BWs would go after and kill correctional officers.

One late afternoon, three correctional officers were walking a troublesome black inmate up the gauntlet (a walkway leading to a lock-up unit, and—at that time—devoid of gun coverage) to be placed in administrative segregation pending disposition. As they approached the unit, they were suddenly set upon by a large group of shank-wielding black inmates who had been hiding in an alcove. The blacks surrounded the officers, cutting off any escap;, seized their hand-held radios and keys; and then began to beat and stab the three until the bleeding officers crumpled to the ground. After freeing the prisoner the group hurriedly vanished back into population.

In the ensuing weeks, all suspects in the attack were identified and sent to lock-up. It didn't take long for informants among them to come forward and roll over on the others. Their camp was now divided between those who wanted to cut a deal and testify and those who were going down for the attempted murder of the three correctional officers. Seeking to regain control of the yard had not only been futile but costly. Many of the black gang members would receive lengthy sentences in addition to being locked up in administrative segregation for years. Their days of terrorizing were over.

Because a select few of the BWs had rolled over and testified in court against their former brothers, the once feared prison gang crumbled. A few hard-core members hung tough, however, and vowed revenge against the ones who had testified against them. But for all practical purposes, the BWs were finished as a viable prison gang.

Meanwhile, the AWs' strength continued to soar. Yet, what had happened to the Black Warriors foreshadowed what was to befall the Aryans.

The Decline of the Aryan Warriors

The AWs continued to pressure and extort the other inmates. On November 5, 1980, while driving (lifting weights) on the lower yard, several of the Aryans spotted a white inmate who was carrying a snitch jacket (thought to be an informer) and who was on the AW hit list. Surprised that he had ventured out among them, they offered to share a joint with him in the lower yard bathroom. At first he was distrustful of their intentions, but after they reassured him that they meant no harm, he followed them in. It was a fateful error.

Once inside, the inmate was quickly encircled by the Aryans who began bouncing him from one to the other. He was seized by powerful hands, and a crudely fashioned noose was looped around his neck, choking off his terrorized screams.

Abruptly, the Aryans spilled out onto the yard. "I couldn't believe it," one of them muttered. "It took five of us to kill that mother _____! He damn near bit my finger off! If I hadn't had gloves on, he would have." "Shut up!" another ordered, and the Aryans dispersed into the yard.

As had happened with the Black Warriors, the Aryans began to scheme in an effort to avoid being blamed for the killing, which would have given them additional life sentences. But it wasn't long before informants broke from the AW ranks to tell on others. The attorney general's office, with its corps of neophyte deputies, envisioned easy convictions—convictions that would look good in someone's personnel file. And the man chosen to bring the killers to justice was a young, eager deputy named Robert Manly.

Manly began interviewing the rollovers and slowly put together a credible prosecution, thanks to the AW informants. The prison grapevine works as efficiently as do the network radios, and soon prisoners in other institutions were made aware of the crumbling

of the Nevada Aryan Warriors. The AWs became known by other white gangs as the "Aryan Witnesses." Many of the gang members had their bolts and horn tattoos covered with other, nonspecific tattoos.

The AWs were through as a viable prison gang. Any hope of being sanctioned by the California Aryan Brotherhood had been dashed forever. Three of the Aryan youths were convicted of murder and given additional life sentences. One was able to get his conviction overturned and was eventually released. The other two are still doing time.

The Pope, a self-admitted heroin addict who never rolled over, was always looked up to by the others who hung tough. He died of natural causes in a Nevada prison in 1997, after having served a combined total of more than 40 years in California and Nevada prisons.

As for the Aryans who became state witnesses, several were given early releases from prison, while others received no clemency and are still doing time. Some who hung tough continued to exhibit the AW bolts and horns, proud of what the gang had once achieved. They referred to the AW informers as cheese-eating rats. All of the cheese eaters who didn't gain an early release were forced to serve out the remainder of their sentences in PC, despised by the general population. Occasionally, one would make it out to general population, rationalizing that what happened long ago would be forgotten. One of them was doused with cleaning fluid and set afire several years ago, which served as a notice to the others that it would be best to remain in PC.

The Aryan Warriors Today

As late as 1998, reports from the Ely State Prison, a maximum security prison, indicated that the AW hard-core members continue to believe that the gang will once again rise from the ashes and regain their stature.

The administration continues to monitor all white supremacy activity. A few other white disruptive groups have, at one time or another, tried to pick up where the AWs left off. The Aryan Circle, the Broken Dreams Brotherhood, and the GFBD (God Forgives, Brothers Don't)

are three of these. (Two members of the GFBD were recently convicted of the murder of another inmate who refused to provide them with his prescribed daily methadone.) The Broken Dreams and the GFBD continue to gain strength. They prey on child molesters, informers, and other weak whites. The Aryan Circle crumbled after a few of its members at the Ely State Prison killed a white inmate because of his close association with a black. During the subsequent investigation and trial, three of those involved rolled over. Their testimony convicted a fourth. The Aryan Circle (not to be confused with the Aryan Circle of Texas) was finished.

..

Aryan Warrior Identifiers

- *Other Names:* None.
- *Ideology:* White supremacy. Initially, the gang formed to protect all white inmates. As it gained strength on the yard, this all changed and they began to extort and pressure weaker whites.
- *Recruitment:* Whites only; however, some of the members had Latino or Hispanic names. A "blood-in" mission was required; however, once an AW member was released back to the streets, he could drop out without reprisal.
- *Appearance:* Nonspecific.
- *Criminal activity:* Drugs, weapons, extortion, protection, prostitution, and murder.
- *Allies and enemies:* The AWs got along well with the Native Americans and Hispanics. They never got along well with blacks.
- *Tattoos:* Lightning bolts inside the left biceps and the AW horns on the left upper chest were the only specific tattoos. Other nonspecific tattoos seen frequently were neo-Nazi symbols, the inmate's name and hometown, and the usual prison tattoos: gun towers, spider webs, Vikings, skulls, etc.

..

BLACK PRISON GANGS

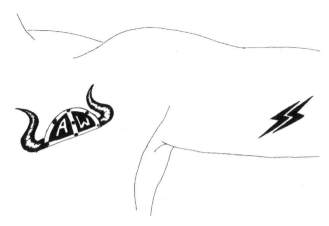

The horns and bolts of the Aryan Warriors.

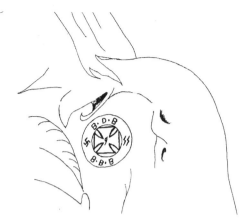

"BDB BBB," which stands for "Broken Dreams Brotherhood, Brothers By Blood." The number "9" inside the Iron Cross denotes the inmate's place in the group.

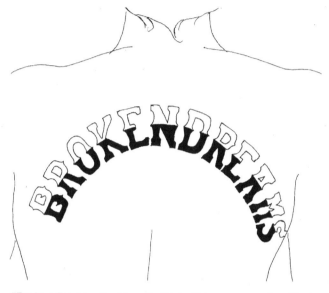

"Broken Dreams," a Nevada State Prison group classified as a security threat.

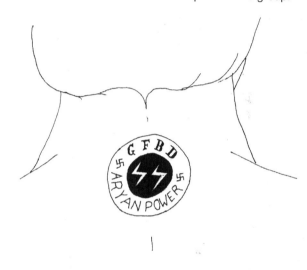

"GFBD," which stands for "God Forgives, Brothers Don't," a Nevada State Prison security threat group.

Prior to the 1960s, most black prison gangs consisted of small, unorganized groups of thugs who engaged in rapes, cell thefts, assaults, and other strong-arm tactics in prison. Few gave much thought to revolutionary ideas. This all changed dramatically in the 1960s with the advent of the Vietnam War. Militant revolutionary ideas seemed to erupt spontaneously on the streets. Blacks, spurred on by pseudointellectuals and Hollywood luminaries, began taking to the streets in record numbers demanding equality. Structured, radical organizations began to appear, two of which were the Black Panther Party (BPP) and the Black Liberation Army

(BLA). A new term, "black militant," was coined by the press to identify these activists.

This idea caught on quickly in the nation's prisons. Some of the better-educated black prisoners grasped the concept and began efforts to unite others into associations dedicated to prison reform and antigovernment ideology. Among the initiates there were those who were sincere in their belief that they could reform the system and were willing to resort to violence to do so. However, there were others who quickly cooled to the political rhetoric espoused by the leaders and convinced others that they should instead throw their resources into an effort to take control of the lucrative

prison rackets. One such group to emerge from this era, and which continues to exist today, is the Black Guerrilla Family.

The Black Guerrilla Family

The BGF, a radical prison security threat group, got its start in San Quentin in 1966. The founder was a former Black Panther Party member, George L. Jackson. Many of the early members had been followers of the Black Liberation Army and the Symbionese Liberation Army, both revolutionary groups from the 1960s. As the BGF began to structure, one of its primary objectives was to "establish the prison gang as one of the most effective and deadly revolutionary forces in society." The BGF, which Jackson initially called the Black Family, appeared to support a violent overthrow of the U.S. government. The group was structured as a paramilitary organization with one leader, the supreme commander; a central committee; and a rigid chain of command. Only blacks were allowed membership, and a lifetime commitment with a death oath was required.

The group drew heavily from Maoist concepts, the expressed purpose of the organization being to "return power to the people." The four rules of discipline are directly from Mao Tse-tung:

- The individual is subordinate to the Family.
- The minority is subordinate to the majority.
- The lower level is subordinate to the higher level.
- The entire membership is subordinate to the Central Committee.

To maintain discipline, the Central Committee could impose sanctions against deviant members. These sanctions ranged from loss of privileges or fines to more serious penalties, up to and including capital punishment.

By 1971, Jackson, who called himself the "Black Dragon," had changed the name of the group to the Black Vanguard. On Saturday, August 21, 1971, a day that would go down as the bloodiest in San Quentin Prison history, Jackson was supplied with a loaded handgun during a visit with his attorney and hurriedly concealed the weapon in his afro. Following the visit, he was being escorted back to his cell when he whirled around, grasped the concealed handgun, and opened fire on nearby correctional officers. As they reeled backward from the impact, Jackson bolted toward a 25-foot-high wall, fantasizing an escape. The startled tower officers quickly opened fire, criss-crossing the battle zone. Jackson was cut down in his tracks, stopped by a high-caliber slug that tore through his back and shattered his spinal cord. Within minutes, responding officers quickly regained their ground, but six lifeless bodies lay in the dirt, including, along with Jackson, two other inmates and three correctional officers who had been caught in the line of fire.

Following Jackson's death, power struggles ensued within the group, which was called the Black Guerrilla Family again. Two factions emerged: the members who wanted to pursue a revolutionary course of action, and others who viewed the organization as a controlling influence over the lucrative prison rackets.

It was agreed that the group needed money, and so the BGF began to sell protection in the prison system. Sales of drugs and weapons were next, followed by extortion, assaults, gambling, prostitution, and hits. Soon, a pact was made with the Nuestra Familia (a Mexican American prison gang based in northern California), in which each organization worked in concert to control prison money-making schemes. They mutually declared Mexican Mafia and Aryan Brotherhood members as hit-on-sight enemies.

The BGF influence was soon felt outside prison walls. Released inmates, following the revolutionary precepts of the BGF, were involved in ambushes, kidnappings of prominent persons, bank and armored car robberies, and wanton murder of police officers. Inside the walls, BGF soldiers were assaulting staff, which resulted in many of the gang members being moved to isolation cells.

By 1983, the declared war against the Mexican Mafia and Aryan Brotherhood was not going well for the BGF. Members were being attacked ruthlessly, and infighting for control of the prison rackets threatened to divide the BGF.

During this period of turmoil, several members broke away to form another association. These breakaways started an affiliate they called "Bay Love" (taken from the San Francisco Bay area). Bay Love was the forerunner of the 415, which later became the 415—Kumi African Nation (see below).

The BGF Today

The Black Guerrilla Family is also known as "Jama," a Swahili word meaning "family." Many BGF members have learned to communicate in Swahili. Other names include Weusi Giadi Jama, which is Swahili for Black Guerrilla Family, and the numbers 276 (representing the numerical order of the letters B, G, and F in the alphabet).

Its stronghold continues to be the San Francisco Bay area; however, the gang is active in other Western states, as well as in the Federal Bureau of Prisons (FBP).

The revolutionary-bent BGF leaders in prison continue to think in terms of anarchy and the formation of the Republic of New Afrika (RNA). New Afrikan Revolutionary Nationalist (NARN) is thought to be the name of a revised BGF constitution. BGF members in prison regard themselves as political prisoners or prisoners of war (POWs) and have a high incidence of assaults against staff.

Black August is an annual celebration to honor those who fell during the first Watts riots. BGF and 415 members are supposed to murder a law enforcement or correctional officer during this month.

The BGF and the Nation of Islam (NOI), and possibly the New Black Panther Party, are sharing intel data. The BGF and the Nuestra Familia are also allies. Their shared enemies are the Aryan Brotherhood and the Mexican Mafia. Intel sources have uncovered ambitious plans of the BGF to unite all 415 members and all members of the Consolidated Crip Organization (CCO) prison gang under BGF, as protection against the burgeoning Hispanic gangs in the California prisons.

415—Kumi African Nation

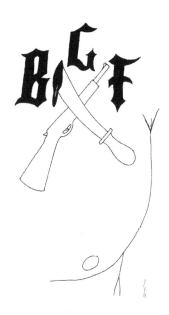

A crossed carbine and machete superimposed over the initials BGF.

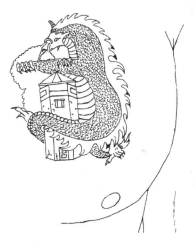

A dragon wrapped around a prison gun tower is a BGF-specific emblem. The dragon represents Asian revolutionary thought, especially that of Mao Tse-tung. A dragon descending on wings signifies an attack. The number of claws or heads may represent the number of hits done by the wearer.

This spin-off from the BGF started as Bay Love in 1983 in the California prison system. The name was soon changed to 415 (the telephone area code of the San Francisco Bay area), and later "Kumi African Nation" was added. Kumi is a Swahili word meaning ten (the total of 4 + 1 + 5). The only members permitted to call themselves Kumi are prison

inmates and ex-inmates. The 415 is also known as "The Big Ten," "The Bleeding Heart," and "DAE" (the alphabetic representation of 415). On the streets of the Bay Area, the 415 and the BGF are known by the name "The Firm."

The 415 started out much the same as the BGF, with whom they shared the concept of uniting all African American gang members into one large umbrella group. (The 415 regard themselves as being head and shoulders above Crips and Bloods, whom they consider to be runaway street gangs tripping on colors and other stupid things. Of the two groups, the 415 get along better with Bloods.)

Protection from other inmates, especially from Mexican Mafia and Aryan Brotherhood members, was a major concern. Control of prison crime, which was regarded as a means of financing their revolutionary ambitions, was another.

The group leaders set their sights on control of the prison rackets, yet they instilled in members the idea that the black man was a political prisoner under white oppression and, as such, had to think in terms of revolution. Many inmates bought into this line of thought, which served to provide a common bond among the members. Still, some of the members were more interested in the power and money-making opportunities available to a strong prison gang.

Recruitment was open to blacks only. A prospect's papers (background) had to be checked and approved by the group's leaders. Once accepted as a prospective member, a recruit was placed on probationary status, at which point he was indoctrinated with the gang's concepts, given preliminary schooling, and tracked. Ultimately, he would be given a mission that would have to be completed before he was granted full membership.

Recruitment continued to expand the ranks of the 415 in the prison system, yet the leadership was wobbly due to petty bickering and arguing among members. Outside, released 415 members grasped the idea of "taking back the streets by whatever means necessary." However, this concept was not necessarily meant in the sense of doing battle with the establishment as revolutionaries, but rather

controlling street crime through intimidation and tax collections. The 415 continued to remain allies with the BGF, and the two groups were responsible for a significant portion of Bay area crime, much of which was done on orders issued from behind prison walls. Still, the 415 was suffering from internal strife and lack of decisive leadership. What was needed was an organizer with unquestioned leadership who could stabilize the entire organization.

In 1985, a former Black Guerrilla Family member, whom we will call "Mickey Green," filled the gap and became the undisputed leader of the 415. Green brought to the organization the leadership and sense of purpose that it had been lacking. Among his accomplishments were revising the group's bylaws and instilling in members the importance of shedding negative habits, improving one's character, and, above all, working together for the benefit of the 415 and supporting New African solidarity. He also attached the title "Kumi African Nation" to the 415 name. The bylaws he revised stressed the legal protection afforded the document under the First Amendment of the U.S. Constitution and became the rules of conduct that all Kumi warriors were expected to live by.

These bylaws ramble on for 22 paragraphs and several subparagraphs, covering everything from the chain of command to the individual's responsibility of self-improvement, the use of drugs (which is left up to the discretion of the member), homosexuality (which is discouraged), mandatory dues, sanctions imposed against those who violate the rules, and what violators can expect as punishment. Cowardice and leaking secrets to "the man" are the most serious violations, either of which may result in the member's being placed on the hit list. The bylaws also outline requirements necessary for promotion to the Kumi Echelon Golden Chain, where the hierarchy resides.

Membership in the 415 is open to blacks only. Intelligent blacks are preferred, as are those who carry themselves with a certain amount of reserve. New arrivals to the prison who are regarded as possible prospects are given a care package and befriended by the

415, who will watch them for 60 to 90 days to make a fair evaluation. When accepted as a prospect, an inmate's initial schooling will consist of learning parts of the Swahili language, which is very useful when communicating in the midst of strangers. The subjects of Mau Mau history and concepts are required reading.

The security arm of the 415, the sergeant at arms, must screen each prospect to detect infiltrators. Papers are checked; references are contacted. When a prospect is given a mission, the sergeant will track the recruit to confirm that he successfully completed it. Refusal to complete the assignment is a very serious offense, which could carry a punishment of death.

Prison inmates nearing release are offered safe housing, a money borrowing plan, weapons, and other amenities. Parolees are enticed by a promise of family assistance in the event that they are returned to prison on a violation.

. .

NOTE: The 415 oath must be learned by all recruits within three days of acceptance. The following oath was confiscated during a cell search.

415 Oath

I, as an active 415 soldier, will come from the bleeding heart of this constitution and flow as a true soldier across the land. I hereby fly the right African solution never before like no other black man, to achieve the goals of African opportunity never before like no African other and embrace "415" African to support the cause of my brothers. And through the years to come I'll honor and do my best by this banner until the job is done. I'll never stop for rest, to be winner is the faithful test, to be a loser is for the African dead. This is why I fight for the real conquest with the faith of my 415 comrades. If ever I should fail my obligated deeds under this banner that I fly, may this oath prevail and punish me for the reasons I did not try. Forever and ever to the 415.

Certain code words are used in an effort to confirm an unfamiliar black's membership in 415 or BGF. A stranger would be asked, "What up love one?" The correct response is, "What up love one?" After this correct response, the quizzer will ask, "Can you sing the song?" The correct response is, "Yes, I can sing the song." The person in question then must begin to recite the 415 oath. After a few passages, he will stop and expect the other to continue. The two will then continue doing this until the oath has reached completion.

If the stranger is not a 415 but a Black Guerrilla Family member, the correct response is, "What up Family?" The two unacquainted inmates then have a common bond.

Other code phrases used by 415 members to check unknowns are

1. "Do you know Billie Jean Foster?" This coded phrase is asking, "Are you 415 or BGF?"
2. "Do you live in the community?" This question asks the same thing.

If the subject answers in the affirmative to either query, he will then be asked, "What's the address?" The correct response is to claim either 415 or BGF. In a prison setting, when a group of 415s are having a meeting and a correctional officer approaches, the one who first sees him will say, "Kill game." The conversation then quickly changes to mundane chatter. The 415 motto is "Forever-Forever." This term is used to close the oath and to open and close serious business meetings.

. .

Some Common Swahili Words Used by BGF and 415

ASKARI	Soldier
BUNDUKI	Gun
JAMA	Family
KUMI	Ten
MKUKI	Spear
SILAHA	Weapon
UASI	Disobedience/

	Revolution
UWEZO/MAMLAKA	Power
WAJINGA	Fool
WETU WATU	Our People
WEUSI GIADA JAMA	Black Guerrilla Family
YERO	Warrior

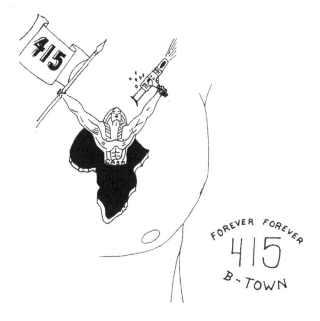

On the left upper chest, a *yero* (warrior) rising out of the African continent. On the inner arm is "Forever-Forever," which is the phrase Kumi use when opening or closing meetings. "B-Town" indicates Berkeley (California).

Tattoos provide 415s with another method of identifying one another. A *yero* (warrior) rising out of the continent of Africa holding an Uzi in the left hand and a banner showing 415 in the right is gang-specific. If the tattoo shows the hands crossed above the head, this signifies slavery; the warrior rising above the continent signifies the black man rising above slavery. Tattoos of dragons (Asian symbols) are worn frequently by BGF and 415 Kumi members, which reflect the Mao Tse-tung philosophy embraced by the two groups. Recent intel suggests Mickey Green has ordered the Uzi to be covered up and replaced with a shield, a spear, or a book. The book represents the 22 bylaws. Other tattoos are the words "Forever-Forever," "Big-10," and bear claws squeezing a bleeding heart.

If a 415 prison informant (who is on the hit list) is held in PC, a trusted 415 member will be given a mission to work his way into PC and make friends with the informer to gain his confidence. Once this is done, the inmate on the mission will wait patiently until the opportunity arises when he can kill the informer with no witnesses present. The successful completion of this type of mission will reward the gang member with a substantial promotion in the 415. Conversely, if the inmate fails in his mission, a contract will be put out on him.

High-ranking leaders of the 415 at one time called a meeting with the mayor of Oakland in an attempt to secure funding for the organization. They tried to make the 415 appear to be a conciliatory organization with no criminal intent. Fortunately, the Oakland city officials didn't buy it. The cloud hanging over the group at that time was a double murder, the suspects of which were thought to be members of the 415.

The 415 and the BGF exchange intelligence, and each may honor the other's hit lists. In addition, manipulation and compromising of prison staff and police officers is practiced. The 415 advocate "taking back the streets by whatever means necessary." Because California has a "three-strikes-you're-out" law (which automatically sends felons to prison for life after three convictions), 415 leaders are looking at other Western states in which to conduct their illegal activities. Fast-paced Nevada, with its casinos and tourists, is a prime target. 415 gang member couriers bring drugs, weapons, and prostitutes in from California regularly. (Many of these couriers have been apprehended and are currently doing time in Nevada prisons.)

HISPANIC PRISON GANGS

In the United States, Hispanic prison gangs have existed in one form or another for the past 80 years or so. The early gangs were, for the most part, small groups of inmates who moved about the yard in numbers for protection

against other ethnic groups. Leadership and structure were transient. And when an inmate was released back to the streets, he took with him few gang obligations. The prison staff of this era attached little significance to these roving yard gangs because the administration still ran things at that time, and to reinforce their positions, they had use of the baton, the "iron claw" (an adjustable metal clamp used to control unruly inmates when secured around their wrists), and bread-and-water rations slung into roach-infested solitary cells.

It wasn't until the 1950s that prison authorities first began to look seriously at Hispanic gangs. On the West Coast, prison investigators began to document their identifying characteristics and activities, along with gang membership validation. On the East Coast, similar procedures soon followed. Though there were similarities between developing gangs on both coasts, there were also striking differences. Today these differences are patently clear.

West Coast Hispanic prison gangs, for the most part, comprise Mexican Americans. This element forms the nucleus of the structured Mexican Mafia, the Nuestra Familia, the Northern Structure/Nuestra Raza, and the Fresno Bulldogs (a street gang with a strong presence inside California's prisons).

By contrast, on the East Coast Hispanic prison gang members are primarily of Puerto Rican heritage. Cuban immigrants, too, have formed their own prison gangs, which are extensions of the Marielitos Bandidos, a name Cuban criminals gave themselves after slipping away from Cuba's Mariel Harbor early in 1980. Comparisons between Caribbean island gang members and Mexican American gang members show few similarities and many differences. Cuban and Puerto Rican immigrants are markedly diverse, since the populations of both countries include blacks, Indians, whites of Spanish descent, and mixtures of all of these. In fact, the only things most share in common with Mexican Americans are a Spanish surname and a familiarity with the Spanish language. The remainder of East Coast prison gang members

are natives of other Caribbean island nations, Mexican and Central American immigrants, or children of these transplants.

Other groups of Hispanics of fairly recent origin, which comprise one of the largest gang recruitment pools, are Mexican immigrants who go by the name "Border Brothers," or "Paisas," from the Spanish noun *paisano*, which translates into "countrymen." The Border Brothers are ganging up nationwide, many branching out to form their own segregated prison and street gangs. Still others are hooking up with burgeoning "hybrid" gangs to profit from the sale of drugs or other criminal activity.

In the Midwest, Mexican immigrant gangs, along with those from El Salvador (e.g., the Mara Salvatrucha) and other Central American countries, are being seen with increasing frequency. Having escaped abject poverty and, in some cases, bloody civil wars in their native countries, these immigrants arrived here with nothing other than the clothes on their backs, and they had a common goal: refuge and realization of the American dream. Regrettably, this dream was all too often attached to drug trafficking and other criminal activity. Though these gangs are essentially street gangs, when members are sent to prison they maintain their identity, their gang names, and their cohesiveness.

Today inside America's prisons, the number of Hispanic gang members far exceeds the number of gang members represented by any other ethnic group. This was not always the case.

Four decades ago, Hispanic inmates, many of who were slight of stature, found themselves far outnumbered and outsized. Consequently, they were frequently victimized by cell thieves, yard bosses, and muscle-bound jockers (predatory homosexuals), many of whom could drive 300 to 400 pounds of iron from the bench. The Hispanics knew that to survive it was imperative to gang up and fight back. Thirteen inmates of Deuel Vocational Institute (DVI), most of whom were veterans of barrio street crime in southern California, designed a plan by which they would form a "gang of gangs" and retaliate viciously against anyone who would dare challenge them.

Thus was born the Mexican Mafia, the prototype of Hispanic prison gangs, which was to be copied by scores of other Hispanic gangs for generations.

The Mexican Mafia

"A member is to share all and everything. To have one leader or boss for all members and to swear their lives to the group with the understanding that death is the failure to comply with the codes of the group. Once an inmate is accepted into the group, he cannot drop out."
— The Mexican Mafia Creed

The Mexican Mafia got its start in the DVI, Department of Corrections, Tracy, California, in 1957. Mexican American prisoners, many of who were being pressured by other, predatory inmates, held a series of meetings to decide how best to protect themselves. A handful of those in attendance were streetwise toughs, *veteranos* of violent gang wars in East Los Angeles. They suggested *unidad*—unity among all Mexican American inmates—and the inception of a prison gang patterned after La Cosa Nostra (LCN) of the Sicilians. The Mexicans chose to name their gang La Mafia Mexicana (The Mexican Mafia) or, more simply, La eMe (Spanish for "The M"). Some gang historians insist the gang was first named El Mexicano Encarcelado (The Incarcerated Mexican—La eMe).

Movidas (rules of conduct) were drawn up and approved by all of these early mafiosos. The first and unwavering rule was a "blood-in, blood-out" oath: All initiates into La eMe had to draw blood—either killing or seriously injuring an enemy singled out by the founding mafiosos. To complete the circle, membership in La eMe was to be a lifetime commitment, whether while doing time or after release. The only way out of the gang was death. Other rules of conduct included the following:

- Membership was open only to Mexican Americans.
- La eMe was to be placed above all else, including family, church, and self.
- The confirmed member had to carry out

orders without question. If a hit was ordered, it must be done. If not, the member assigned the mission would himself be put to death.
- Members were never to snitch to the authorities or trust prison staff members. The Mafia would try to get along with the administration but would take care of Mafia business whenever it was required, regardless of prison rules.
- Any insult or disrespect directed against Mafia members by other inmates was to be avenged swiftly. The prison inmate population would be compelled to respect La eMe.
- Mafia members were to back each other at all times.
- Homosexual activity among members was forbidden.
- Mexican Americans who were imprisoned together but had fought each other during street gang warfare back in East L.A. were given time to settle their past differences and then were required to be supportive of all Mafia members and activities.

One of the more interesting characters associated with the early Mexican Mafia was Joe "Pegleg" Morgan (sometimes called Papa Joe, he was represented by the character called J.D. in the movie *American Me*). Morgan was born in San Pedro of Hungarian parentage. While he was still an infant, his parents moved to East Los Angeles. During his formative years, he ran the streets with the Chicano gangs of the day. Morgan learned to speak street Spanish, or caló, and was accepted by the Mexican Americans as one of them. And for good reason: Morgan was tough, ruthless, and regarded himself as Mexican, with traditional Mexican values and loyalty to *la raza*. Yet, because he was not bonafide Mexican, he could not be granted full membership in La eMe as outlined in the *movidas* of the gang. Even so, in his heart he was a mafioso and, in fact, he sat in on all meetings when Mafia business was discussed.

Morgan was given the name "Pegleg" because of an artificial leg he wore. During the

1950s, Morgan was caught up in a drug sweep in East Los Angeles. Attempting to escape by running away, he took a slug in the leg fired by a Department of Justice narcotics officer. It was alleged that because of his meanness he refused medical treatment until gangrene set in and the leg had to be amputated in order to save his life. He adjusted well to this disability and, after being sent to prison, despite his handicap, became one of La eMe's best handball players.

At DVI, La eMe was becoming a feared prison group, protecting Mexican Americans and directing swift retaliation against other inmates who tested their strength. Soon the mafiosos began selling protection. From this early beginning, La eMe cast an eye upon other lucrative prison rackets and prepared to fight for control of all illegal prison profits.

The formation of this group did not go unnoticed by the administration. In an attempt to break up the gang, the California DOC transferred many of those identified as leaders to other institutions within the state. This maneuver to break up the Mexican Mafia was a dismal failure. Mexican American prisoners in other institutions had been following closely the emergence of La eMe and had been waiting patiently for the opportunity to hook up. Now, with many of the leaders entering other prisons, Mexican Mafia recruitment soared.

By the mid-1960s, the Mexican Mafia had gained control of most of the heroin trafficking inside California's prisons. Also, it was during this period of time that they began to exert influence outside of prison walls, mainly in the East Los Angeles area. Mafia members, when released from prison, were given marching orders along with titles such as "street enforcer" and "tax collector." Their jobs were to compel street gang members to carry out hits, funnel drugs back into the prisons, and carry out other missions decided upon by the imprisoned mafiosos. Street gang members were also expected to hand over a tax of 10 percent of all illegal profits to La eMe. Many of these street gangsters felt honored to be working for the Mexican Mafia—and were also aware that if they refused they would be dealt with severely

if and when they were sent to prison.

Since all of the Mexican Mafia's founders came from East Los (East Los Angeles), and because most of the rank and file were also from that region, they referred to themselves as *Sureños*, which means southerners in Spanish. The word *sur*, which means south, was also used to identify the members' origin. These terms were being seen with greater frequency, thrown up as graffiti throughout California's prisons along with the numeral 13, which signifies the letter M, or, more precisely, La eMe. The gang had also adopted the color blue as its identifier. Blue *moco* (mucus) rags, or bandannas, issued in Los Angeles County Jail, were worn folded and hanging out the back pocket or as headbands.

It should be stressed here that although all Mafia members claimed Sureño, not all Sureños were Mafia members. The gang had reached the point where they were recruiting selectively, admitting only those inmates who were exceptionally mean, resourceful, or had other skills or qualities needed by La eMe. Other Sureños were kept on the sidelines, supportive of La eMe but lacking the qualifications for full membership. Even so, these Mexican American inmates were expected to show support for the gang at all times.

Along with the Sureños, the California DOC was now seeing a great influx of Mexicans from the agricultural areas of northern California. These inmates, many of who had been farm workers, lacked the street savvy shown by the Sureños, who derided them, referring to them as *farmeros*. Right away, friction developed between the southerners and the northerners, or *Norteños*.

Rudy "Cheyenne" Cadena (represented by the character named Santana in the movie *American Me*) attempted to bring both sides together, which would have strengthened the position of all Mexican Americans in prison. Unfortunately, his efforts were met with suspicion from both sides. La eMe, of which he was one of the original founders, regarded his efforts with disdain; the northerners viewed him as a liar. An impending battle between the two groups was inevitable. And it jumped off

in San Quentin in 1968, during an occurrence dubbed "the Shoe Wars."

The Shoe Wars involved three inmates at San Quentin. Two of these—Robert "Robot" Salas, a Sureño from a street gang called Big Hazard, and Hector Padilla, a Norteño—were cellies (housed together in the same cell). Padilla was the owner of a pair of Florsheim shoes, which he prized highly, continually buffing them to a brilliant shine. One day, after shining his Florsheims, he left them on the floor of the cell and walked out.

Another Sureño, Carlos "Pieface" Ortega, from an East L.A. gang called Geraghty Loma, was walking down the tier and spotted the shoes unattended. He quickly scooped them up, stuffed them under his shirt, and hurried back to his cell. There, he tried them on and discovered that they didn't fit. About this time, Salas was seen nearing Ortega's cell. Upon greeting Salas, Ortega asked the unsuspecting Salas to try on the shoes. The highly glossed shoes fit Salas perfectly. A deal was made between the two Sureños for the shoes, and Salas walked back to his cell wearing them. As he neared the cell, he saw Padilla frantically searching for the shoes.

Padilla immediately saw Salas wearing his Florsheims. Not waiting for an explanation, Padilla jumped to his feet, screaming at Salas and calling him a cell thief, one of the lowest forms of life in prison. A vicious fight broke out between the two inmates. Salas had previously concealed a prison-made shank under his bed, which he seized and plunged time and again into his opponent. Padilla crumpled to the floor.

This incident set off a series of retaliatory attacks from both Sureños and Norteños that escalated into an all-out war between the two factions. By now the Norteños, out of necessity, had formed their own prison gang, a paramilitary organization they called Nuestra Familia (Our Family), also known as the "Organization" or, more simply, the "O." La eMe and Nuestra Familia were now locked in an endless war that would bring about hundreds of casualties.

During the 1970s, La eMe had relaxed the rule that admitted only Mexican Americans into the gang. A few Asians and Native Americans had been jumped in. Joe "Pegleg" Morgan was now courted in and assumed a position of leadership. Though not of Mexican parentage, Morgan spoke fluent Spanish and was also studying Nahuatl. Under his direction, many of the gang's more literate members also studied this tongue-twisting Aztec language. This skill became a plus when it was necessary to communicate in the presence of prison guards or other outsiders.

Under Joe Morgan's leadership, La eMe began to structure and solidify in a manner unrealized before. He was a natural leader and had the ability to enforce iron discipline among the ranks. All members were up, out of bed, dressed, and prepared to fight if necessary by 5:00 A.M. In addition to controlling much of the prison crime, La eMe also continued to exert control over much of the street crime back in Los Angeles. Street gang members were pressured to pay the 10-percent taxes, and Mafia street enforcers were ruthless in their positions. Most paid up as a matter of insurance. Yet a few of the gangs told La eMe to go to hell. One called Maravilla, with upwards of a dozen chapters, was among them.

Among the Mafia's major undertakings was to gain control of all drug trafficking in the Los Angeles area. In south central L.A., populated by a preponderance of African Americans, the drug lords viewed the Mexicans' ambitions with skepticism if not outright contempt. African Americans and Mexican Americans appeared to be on a collision course.

As a long-standing northern California prison and street gang, the Black Guerrilla Family declared war on the Mexican Mafia. And the Nuestra Familia joined forces with the BGF. La eMe and the Aryan Brotherhood made a similar alliance.

In addition to drug trafficking, La eMe, under Joe Morgan's guidance, was becoming active in loansharking, prostitution, protection, weapons, robbery, murder for hire, and witness intimidation and jury tampering in the Los Angeles area. To instill fear in the areas under their control, the Mafia enforcers embarked on

a mission of terror. Their murder contracts were exceptionally gruesome. To be killed on a Mexican Mafia contract meant a painful, bloody death. Their reputation for ruthlessness became legendary. During 1976 and 1977, they were suspected of ordering approximately 30 contract killings on the streets of L.A.

In the ensuing paranoia, a few Mafia enforcers who had neglected business and feared the wrath of the Mafia defected and ran over to the side of the law, eager to give up information in exchange for witness protection. One of these defectors was Armando "Mundo" Mendoza, a hard-core mafioso who was regarded as a son by Joe Morgan at one time. By his own admission, Mendoza had committed upwards of a dozen Mafia killings. He was also credited with assisting other Mafiosos in the slaying of another 20 Mafia enemies.

The one-time "son" of Joe Morgan spilled all to the authorities. He revealed the scope of La eMe's activities, and he even went so far as to name Morgan as the one who did a contract hit on a bail bondsman on the streets. In court, Mendoza testified that, as payment for the murder, Morgan received a kilo of heroin, some cash, and a reduction of bail money for members of La eMe. His testimony helped to convict Morgan, who received a life sentence for first-degree murder. Morgan was returned to prison and incarcerated at Pelican Bay, a maximum security prison near the Oregon border.

When the film *American Me* was released in 1992, its depiction of the Mexican Mafia immediately drew the ire of La eMe's mafiosos. The scene that most offended them was the sodomizing of one of their leaders in a prison dormitory. They felt this was untrue and showed unequaled disrespect toward the Mafia. They were also taken aback by the film's depiction of the prison murder of the main character, Santana, played by Edward James Olmos. The film showed him being stabbed repeatedly and then thrown off the fourth floor tier by other members of the Mexican Mafia. The character Santana was a fictional representation of the real-life Cheyenne Cadena, one of the original mafiosos, who, in reality, was killed by

members of the Nuestra Familia.

Rumor had it that La eMe put a contract out on Olmos (who not only starred in but also directed the film), which he allegedly was able to cancel by paying $1 million. Others connected with the movie were not so fortunate. Ana Lizarraga, an East L.A. gang counselor who served as an advisor on the film and had a bit part in it, playing a grandmother, was cut down in a hail of bullets on May 15, 1992, in her driveway. Within minutes, police arrested one suspect, a Folsom Prison parolee and admitted member of Big Hazard, a long-standing East L.A. gang.

Two other California prisoners who also allegedly served as advisors on the movie, Charles "Charlie Brown" Manriquez and "Rocky" Luna, were both shot down not long after being released from prison.

Joe Morgan died of liver cancer in November of 1993 while imprisoned in California, but he had paved the way to organized crime. His method of controlling other gangsters by fear and intimidation was a success. When Morgan died, taxes paid to La eMe from street gangs were estimated to be in excess of $10 million a year. After his death, younger mafiosos expressed a willingness to throw out the "old guard" and create a new hierarchy. Three Pelican Bay inmates, Rene "Boxer" Enriquez, Ruben "Tupi" Hernandez, and Benjamin "Topo" Peters (now in failing health), have been rumored to be possible replacements for the late Joe Morgan.

On May 30, 1997, a federal jury in Los Angeles convicted 12 Mexican Mafia gang members on charges of racketeering, stemming from plots to murder, conspiracy, drug trafficking, and extortion. They were prosecuted under the federal RICO (Racketeer Influenced and Corrupt Organization) act. Defense attorneys had argued that no such gang existed. During sentencing, 10 of the defendants were given life sentences, while two others received 32-year sentences. Others who had been indicted were also tried and convicted of charges ranging from murder to extortion of street gang members (enforcement of taxes). U.S. Attorney Nora Manella called

the convictions and sentencings, "an assurance that 'La Eme' members are not immune from investigation, prosecution, and imprisonment."

In spite of this, drive-by shootings by Chicano gangsters soon reached epidemic proportions, with many innocent people, including children, being gunned down. Feeling the brunt of the public reaction, the Mexican Mafia ordered all street gangs to do walk-ups (walk up and shoot the victim face-to-face) instead of drive-bys. Many gangsters heeded this mandate, and, as a result, even more people were being killed due to the increased accuracy of the shooters.

The Mexican Mafia Today

Today federal authorities estimate that there are perhaps 400 to 600 Mafia members imprisoned in California and the Federal Bureau of Prisons, and possibly twice that many on the streets. But this does not take into account the sympathizers among the thousands of Chicano street gangsters in southern California—gangsters who are not mafiosos but will do business for the Mafia when asked to do so.

Rumors persist of an impending war that will pit all Chicano gangsters against the African American community in a power play for control of all illegal drug trafficking in the Los Angeles area. Several riots between these two groups have erupted in California jails and prisons. These skirmishes followed the Mexican Mafia's insistence that all Hispanic street gangs pay La eMe 10-percent tax on all activities and that all blacks dealing drugs in the Mexican American neighborhoods do the same. Some of these drug dealers complied; others resisted.

Allies of the Mexican Mafia include the Aryan Brotherhood and most Sureño street gang members, with the exception of the Maravillas (see p. 110 for more on the Maravillas) The Fresno Bulldogs (FBD), a Northern California prison and street gang, is said to be working with the Mexican Mafia in drug trafficking. In addition to the African American gangbangers, the Nuestra Familia, the Northern Structure/Nuestra Raza, and all Norteños remain enemies of La eMe.

Ceremonial Aztec war shield on the mafioso's upper chest.

La eMe Indicators

Mexican Mafia members may display the color blue; otherwise, their apparel is nonspecific. During times of war, they will often shave their heads, and since nearly all mafiosos have done time, most are heavily tattooed. A tattoo of a black hand depicting the outline of the letter M that is formed by the creases on the palm when the fingers are outstretched, along with the word "eMe," is specific for Mexican Mafia membership. Other tattoos commonly seen on Mexican Mafia members are taken from the Mexican flag—the eagle and snake, and Aztec symbolism.

Mi Raza Unida—Aguilas

The Nevada Department of Prisons' fastest growing security threat is the MRU—Mi Raza Unida (My United People), also called the Aguilas (Spanish for eagle).

The MRU was conceived in 1984 at the Southern Desert Correctional Center by former Las Vegas street gang member Ernest "Neto" Mercado and six other Mexican Americans from the Las Vegas area. The initial goal of the group was to unite all Hispanic inmates on the yard as a means of protection from other ethnic groups, mainly roving bands of blacks.

These early founders made a bond between themselves granting each member an equal voice when discussing matters of importance. They also swore to assist each other in any

Tattoo on the subject's upper left chest showing the black hand of the Mexican Mafia with the word "EME." They have a saying, "When the hand touches you, you go to work." The "ESBP" on the lower abdomen shows the mafioso's street gang, "East Side Bolen Parque" (Baldwin Park, CA).

The snake and eagle with the words "eMe Mexicana," which is a traditional Mexican Mafia tattoo.

situation. If one were attacked, the others would come to his aid. If one lacked a radio or television, toiletries, tobacco, or other canteen items, the others would share theirs. Any packages sent in from home would be shared by all. They agreed to eat together in the culinary, to work out together on the iron pile or handball court, and to have a weapon within easy reach at all times. If any of the group were sent to lockup, the others would try to get canteen items to him, and would also keep in touch with the inmate's family on the outside.

All seven of these inmates had come to prison with prior street gang experience. They all claimed Sureño. Any hostilities that had occurred between any of them prior to coming to prison had to be put aside. What was of importance now—here in *la pinta* (Chicano slang for prison)—was the success of the MRU. This, they all agreed, was the collective goal. They also agreed to retain the Sureño identity.

Recruitment was essential. This became their number-one priority. All newly arrived Mexican Americans were pulled up, questioned, and, if deemed acceptable, urged to join the MRU. Any inmate with prior Vegas street gang affiliation was obligated—in the eyes of the MRU—to hook up. In most cases, the inmate had no choice. It was either jump into the MRU or be regarded as an enemy. If the latter were to happen, the inmate would be set upon repeatedly, leaving him no choice but to go into PC (and serve his prison time despised by the other inmates in general population).

Even though the early recruitment efforts

Reglas de Los Carnales

Nada atras de otro raza

Nada de jugar sexual

Todos se vistan con estillo

Si uno tiene, todos traen

Todos salen a la yarda

No fumando o comiendo del piso o mesas

No pidan nada prestado, sin decir al nu.1

No jales sin decir al nu.1

Si uno quebra una regla, nu.1 y nu.2
dan el castigo

Si algo pasa al nu.1, nu.2 es el nu.1

En tiempo de pedo, nadien ba solo

Sobre las reglas, se toman una
vote cada 6 meces

So many madres
Sit and cry all day
Wondering why their son was taken away
A true Gangster
Who died for his hood
Layed down his life
Like you knew he would
The days of war
Seem so far behind
But the image of Death
Stays in our mind
Hatred in our hearts
So hard to let go
Because of a pride
Only our people know
Lokos, Two Eight, or Chicos Gang
It's a time of peace
No longer to bang
I'll remember these times
When nobodys life was took
And pray for a firme ending
Of our lifes insane book

Dedicated to all the vatos
living that "Insane Life"

"Mr. Chino" (Frederick Sampson) 3396
M.R.U. "SUR TRECE 6 16 '94

Original bylaws of the MRU prison gang seized in a
Nevada prison cell shakedown.

Poem and drawing by the MRU leader (in 1994) seeking to
unite three Las Vegas street gangs: the Lil' Locos, the
20th Street Gang, and the San Chucos.

"Mi Raza Unida" on the right inner biceps.

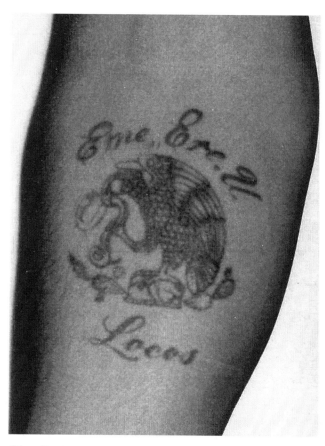

"Eme Ere U," which is Spanish for MRU, along with "Locos." The meaning here is that the MRU gang members are crazy (loco) enough to do anything.

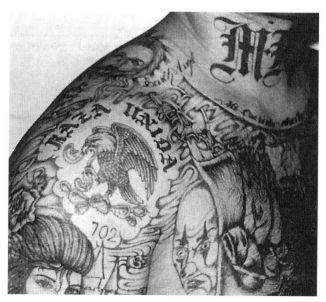

"Raza Unida," along with the Nevada area code "702," on the subject's right deltoid effectively validates the MRU as a Nevada gang.

were vigorous, certain Hispanics were not acceptable. Norteños, long the enemies of the Sureños, had no place in the MRU. Child molesters, some rapists, informants, homosexuals, and other undesirables were refused entry. Initially, only Mexican Americans were admitted; however, this requirement was eventually eased, contingent upon all active members voting the person in. As an example, a white or black inmate who had been a member of a Mexican American street gang in Las Vegas would usually be acceptable.

The identifying emblem of the MRU was taken from the Mexican flag—an eagle perched upon a cactus, clutching a snake in its beak—and included the words "Mi Raza Unida," or simply the initials MRU. This eagle and snake emblem had been in use for years by the Mexican Mafia (who considered it theirs only), who passed the word to the MRU that they considered the use of this emblem without prior permission to be an act of disrespect and would hold the MRU accountable. (Ernest Mercado would eventually be released from prison and return to Las Vegas. One night, while drinking in a local bar, he got into an argument and was killed. The suspect was said to be a member of the Mexican Mafia.)

The MRU did not reverse their decision to use the eagle and snake. They let it be known that they were of Mexican heritage and had as much right to incorporate the emblem into their organization as anyone else. This created several problems for the fledgling gang: Some of the imprisoned Mexican American inmates from the Los Angeles area were reluctant to join the MRU, feeling that to do so could put them in the hat when they returned to L.A. Also, some of these Los Angeles-based gangsters, who had ties to the Mafia, felt obligated to declare war on the Nevadans. An all-out war never materialized, although isolated incidents between the two groups erupted from time to time.

Recruitment faltered for several years, and then, in the early 1990s, Hispanic prisoners began entering the Nevada prisons at an unprecedented rate, many claiming prior street gang affiliation, and nearly all claiming Sur 13.

Las Vegas had exploded with street gang activity during the past decade, and many of these new commitments had been part of the bloody scene. Other Mexican American street gangsters had reached the Nevada prisons from southern California. Together, the new Las Vegas and southern California prisoners formed a ready recruitment pool for the MRU. And having had prior street gang experience, they moved naturally toward the prison gang scene.

The L.A.-based gangsters had an air of haughtiness about them. After all, some of them had been in gangs that were 70 to 80 years old—the same gangs their fathers and grandfathers had served in. They looked upon the Nevada bangers as novices. But despite their differences, they were quick to grasp the advantages of uniting. The MRU was a Nevada-born gang, but since the L.A. gangsters were now in its home state, many were willing to jump in.

During cell searches, some of the southern California imports, as well as those from Las Vegas, were pulled up by investigators and interviewed and photographed. The identifying eagle and snake tattoo of the MRU was being seen with much greater frequency. Officers reported seeing frequent meetings on the yard of groups of inmates previously identified as MRU hard-core members. Informants passed on information to the administration about the group. Assaults against other inmates were on the rise. There was no question: the MRU was evolving into a significant prison security threat group.

During the group's frequent meetings, items of importance were discussed and voted upon. Topics included leadership, the availability of drugs and weapons, enemy hit lists, recruitment policies, staff who could be compromised, and related subjects. Of primary importance was the possibility of being sanctioned by the Mexican Mafia. There were those (mainly from California) who were in favor of sanction, while the other faction wanted to remain self-governing. Prisoners with pipelines to L.A. and the Mexican Mafia relayed this information and other intelligence on the Nevada group back to Los Angeles.

La eMe was not impressed. For one thing, the MRU did not have a "blood-in, blood-out" requirement as did the Mexican Mafia, and for another thing, it was relatively easy to earn the MRU *placa* (gang name or symbol, usually expressed through tattoos, graffiti, and hand signs). All one had to do was complete a mission that may be nothing more than a simple assault. To La eMe, this was absurd. To earn the black hand of the Mexican Mafia, one had to kill or seriously injure the target. The MRU was put on indefinite hold.

Despite their rejection by La eMe, the MRU continued to expand—and to grow increasingly violent—within the prison system. They were policing their own race.

Child molesters, suspected informants, and Hispanics refusing to join the MRU were set upon repeatedly. By the mid- to late 1990s, the gang had been responsible for numerous assaults against other inmates in which shanks and other lethal weapons were used. They were getting drugs into the prison regularly, mainly through the visiting room.

Nevada's prison population was expanding rapidly, resulting in new prisons and conservation camps (prison honor camps for inmates assigned minimum custody and allowed to work outside the walls) opening up statewide. MRU recruitment kept pace. By the late 1990s there was not one institution that did not have an MRU influence inside the walls. And what alarmed law enforcement officers on the streets was that the influence originating inside the prison walls was now contaminating the street gangsters.

MRU gang members being released from prison back to Las Vegas were returning to their former street gangs—and being welcomed as heroes. The contacts they had made in prison, criminal skills they had learned, and prison gang sophistication were now shared with the street gangsters. Unity was stressed. The returning prison gang members admonished the street gangs to quit fighting each other. Most of the Hispanic street gangs were fighting and killing each other over territory, respect, and retribution—certainly not over proceeds from criminal activity. The

MRU tried to instill in them the concept of uniting for control of the profits from the lucrative drug markets now controlled by the blacks in Northtown. But it was difficult for many of these street gangsters to forget about their family members and other homies who had been cut down in street warfare. The machismo concept of retribution was deeply ingrained in these Hispanics, and it seemed to override their cloudy vision of profiteering from street rackets. In the Reno area, much of the same thing was happening, though on a lesser scale. In July 1997, an event alerted the Sparks Police Department that prison activities were infecting street crime. The body of a young Hispanic male who had been savagely beaten was recovered from the Truckee River. He was identified as an ex-con and MRU gang member. Apparently he had been involved in a drug deal gone sour and had been tortured and murdered. Other ex-cons were eventually arrested and convicted of the murder.

During a cell shakedown, an MRU document was seized that appeared to be the group's early rules of conduct and bylaws.

Rules for the Brothers or Associates (English Translation)

- NOTHING BEHIND THE OTHER RACE. (Stick to the race.)
- DON'T PLAY SEXUALLY. (No sexual favors.)
- ALL THE MEMBERS WILL DRESS IN THE SAME STYLE.
- IF ONE MEMBER HAS SOMETHING, THEY WILL ALL HAVE THE SAME THING. (If you need something, then ask a member. If he has it he will give it to you.)
- ALL MEMBERS WILL GO TO THE YARD. (All members will receive yard exercise.)
- NO SMOKING OR EATING ON THE FLOOR OR ON A TABLE.
- DON'T ASK TO USE ANYTHING, WITHOUT TELLING THE NUMBER ONE FIRST. (Don't ask to use anything without telling number one, the leader of the Aguilas.)
- NO JOBS OR INCIDENTS WITHOUT NOTIFYING NUMBER ONE.
- IF ANY MEMBER BREAKS THE RULES, THEN NUMBER ONE OR NUMBER TWO WILL GIVE OUT THE PUNISHMENT.
- IF ANYTHING HAPPENS TO NUMBER ONE, THEN NUMBER TWO WILL BECOME NUMBER ONE. (The second in command will become the leader.)
- IN TIMES OF FIGHTING OR INCIDENTS, NOBODY WILL GO ALONE.
- OVER THE RULES, THERE WILL BE A MEETING EVERY SIX MONTHS. (All members will attend a biannual meeting to vote over the rulings.)
 THE BROTHERHOOD LIVES

Once released from prison, the Aguila may return to his former street gang; however, he is admonished not to gangbang with the street gang, for to do so could place him in a position of doing a drive-by against other Aguilas who have returned to their prospective street gangs. MRU members show a fierce loyalty to the group and, inside the prisons, attack presumed enemies with little fear of the administrative consequences. At the Nevada State Prison in Carson City, where the majority of MRU are housed, most of the gang members are in lock-up. The racial makeup is predominately Mexican American, with a lesser number of Mexican, Guatemalan, El Salvadoran, and Honduran immigrants. There are also a few white and black members. MRU gang members maintain a neat, crisp appearance—shoes shined, and oversized trousers and shirts that are clean and razor-creased. Extra-length blue web belts with the end draped down near the knee are considered *el estillo* (the style). Most favor shaved heads. If a ponytail is worn, it is correct when grown from the base of the skull and reaching to the 13th descending vertebra (T-6).

The MRU prison inmates continue to maintain contact with their former street gangs to update and exchange intelligence data. When released from prison, the MRU members are given marching orders, which are passed on to the street gangs.

The Mexican Mafia has yet to sanction the MRU. Whether or not the MRU would take

care of business for them in Nevada is, at this time, speculative.

As of this writing, the MRU continues to recruit both in and out of prison. It is the fastest-growing illegal security threat group in the state of Nevada. With the new millennium, the Nevada prisons have begun seeing a rapid influx of Hispanic street gangbangers from southern California. Most of these new arrivals come into Las Vegas, where they get into trouble and end up in prison. As they continue to get deeper (grow in numbers) inside the walls, these California transplants are confronting the Nevada gang members with much greater frequency, resulting in bloody fights over control of the yards. To the dismay of the Nevada group, the Border Brothers, who outnumber both the MRU and the Sur Califas in Nevada's prisons, are aligning with the Sur Califas bangers.

If this trend continues, the MRU, being grossly outnumbered, will have to make a truce and, most likely, relinquish control of Nevada's prison yards. To compound the problem, many of the California inmates have close ties to the Mexican Mafia. The administration fears this could open the door to this long-standing ruthless gang's incursion into Nevada's prison system.

Nuestra Familia

If I go forward, follow me
If I hesitate, push me
If they kill me, avenge me
If I am a traitor, kill me
Forward onto victory forever

Following the Shoe Wars in 1968, northern Hispanic inmates at San Quentin understood they were in a fight for survival. All hope of a truce between Norteños and Sureños was dead. The northerners began to structure their group into a paramilitary organization. A constitution was drawn up that placed the leader—a general—at the top. Below him were the captains, lieutenants, squad leaders, squad members (soldiers), and recruits. After experimenting with several names, they selected the title Nuestra Familia (Our Family).

NUESTRA FAMILIA

NUESTRO GENERAL

CAPTAINS OF THE NUESTRA FAMILIA

LA MESA—THE TABLE

CATEGORY III
Rank of Lieutenant or Higher
Regimental Security Department—RSD
Encompasses All of Cat I, and Cat II
The Backbone of the Nuestra Familia

CATEGORY II
Advanced Training
Squad Leaders, Maestros (Teachers)
Experienced Familianos Monitor Activites in Cat I

CATEGORY I
Basic Training Starts Here
Pescados(Fish), Initiates, Recruits, Returning Members
The Entry Level

NORTENOS: BY REGION OR STRUCTURE

Chart showing the category system of the Nuestra Familia.

The NF banner on the subject's neck: a sombrero pierced by a bloody dagger.

Stars on the arms or body of a *familiano* indicate a hitter, also called a cleaner or torpedo. The butterfly is nonspecific.

Among other things, the Nuestra Familia's constitution decreed the following:

- Recruitment was open to northern Hispanics (who identified with the number 14 and the words norte and Norteño) and declared enemies of the Mexican Mafia.
- Members would be referred to as "carnales," "Cs," or "familianos."
- A blood-in, blood-out requirement locked the "carnal" in for life.
- An absolute chain of command had to be adhered to by all members.
- A *carnal* had to be prepared to fight at all times. Ready access to weapons was necessary.
- Every *carnal* had to go to "school" and learn weapons manufacturing and concealment;

defensive tactics, including lethal striking areas of the body, baton take-away, and escape from handcuffs; nonverbal communication; code writing; and related subjects.

- Each *carnal* was required to present a well-groomed appearance, make up his bed in the morning, wear shoes while awake, and not lie down to go to sleep until lockup (following this procedure, he could not be ambushed while sleeping).
- The first and most important rule was to fight to the death if necessary in order to protect other *familianos* and the honor of the Nuestra Familia.
- Red would become their color. A sombrero pierced by a bloody dagger would become their banner.
- The Mexican Mafia was to be a lifetime enemy. Mafia members were to be attacked on sight.
- Dues were to be paid by all *carnales*. Members in lock-up would be sent canteen items, such as tobacco and other small items that make doing time easier.
- A *carnal* in trouble would be assisted immediately by all other *familianos* nearby.
- Any insult or act of aggression directed at a *carnal* would be avenged.
- The penalty for cowardice would be death.
- When given a mission, the *carnal* would carry it out to its fulfillment without question. Not to do so would be punishable by death.

By the mid-1970s, the Nuestra Familia's recruitment policies had resulted in approximately 600 members and associates. And they had been selective, preferring to recruit on the basis of quality rather than quantity. By now, they were deeply involved in many of the usual prison rackets: protection, extortion, prostitution, weapons, and, of course, drugs. The *familianos* showed a fervent loyalty to their gang. They continued their war with the Mexican Mafia; however, they were now fighting for absolute control of the prison rackets. Assaults, stabbings, and killings between the two groups were so uncontrollable that the California Department of Corrections

(CDC) had to separate the groups into different prisons. And this again resulted in increased recruitment on both sides.

By 1976 the Nuestra Familia had elected to expand its criminal endeavors to the streets. The first California city to be affected was Fresno. The NF established a regiment in that locale led by *familianos* recently released from prison. These prison-wise *veteranos* (veterans) enlisted the aid of young Chicano street thugs, most of whom claimed F-14 (Fresno-14) affiliation. These youngsters were put through hurried schooling and instructed to harass and vandalize small business owners throughout the city and put out the word that the NF would be selling protection.

NF enforcers then went after the drug dealers and other big-money crooks. These street people were forced to pay kickbacks (taxes) to the NF. To refuse was not an option; to do so meant being killed. The Nuestra Familia's strength, power, and wealth increased dramatically. Drug routes from the streets back into the prisons were widened, sometimes by compromising prison staff. In the joint, drugs were worth four to five times the amount paid on the street. Business was good for the Nuestra Familia.

But the NF was in for a fall. Had it limited its criminal activities to prison crime, it probably would not have drawn the attention of the federal government. However, the bloody trails this organization was leaving on the streets of Fresno alerted federal investigators to the fact that the Nuestra Familia prison gang was now entering into the realm of organized crime. An intensive federal investigation was begun targeting the gang under the RICO statute.

In January 1982, 25 Nuestra Familia gang members were indicted by a federal grand jury in Fresno, California, charged with extortion, robbery, witness intimidation, and trafficking in drugs. The indictment also accused the gang of committing 22 murders and 6 attempted murders. According to federal investigators, the gang was also responsible for at least 136 killings during the past 5 years. Victims of these slayings were said to have been members of the Nuestra Familia who had gotten out of line, members of rival gangs, prostitutes, and other fringe-element lawbreakers who had neglected to pay taxes to the gang.

The resulting trials pitted hard-core gang members against defectors who knew the scope of the gang's criminal activities (and who were under heavy PC). Scores of guilty verdicts were returned against gang leaders and enforcers. This should have been the end of the Nuestra Familia; however, a few of the leaders emerged unscathed and learned well from this experience. They communicated in secret and vowed to restructure the NF in such a way that the leaders would be insulated from future attacks by the government. The NF now embarked on a plan to regroup, regain strength, and continue their criminal ways both in and out of prison.

A diversionary group was formed to lead the feds away from the Nuestra Familia. In addition to playing the role of a decoy, this group would also serve as a recruitment pool for the NF. Here, a prospect's papers could be checked and he would be evaluated before being introduced to the Nuestra Familia. Any flaws in the prospect's character or background would be uncovered before acceptance into the parent gang. This group was given the name Northern Structure. The Structure opened for business with defined goals, strong leadership, eager recruits, and a constitution called the "Fourteen Bonds."

Meanwhile, under the tutelage of Robert "Black Bob" Vasquez, the Nuestra Familia was restructured. The group revised its constitution, emphasizing the importance of security and isolation of the leadership. This was accomplished by the establishment of the Regimental Security Department (RSD). The RSD would be the security arm of the Nuestra Familia, now sometimes referred to as the "Organization" or, more simply, the "O." Family members on the streets would seek work in places of public domain: telephone companies, water and power, the court system, law enforcement and corrections, departments of motor vehicles, and other intelligence-gathering workplaces. By doing

this, the "O" began to compile a systematic database of sensitive information on individuals—information to be used when checking the papers of prospects or enemies or attempting to compromise or blackmail law enforcement personnel.

The next major modification was the inception of a cell system designed to hide the identity of the higher-echelon members. The Nuestra Familia would establish three separate cells or categories—I, II, and III. Category I would be the entry level for all new recruits being initiated into the gang. Category I gang members would have no knowledge of the activities or identification of persons residing in the higher cells. The gang members who had been promoted into Category II would be knowledgeable of their cell and of the lower cell but would not have knowledge of Category III personnel. The gang's hierarchy would fill the ranks of Category III. Members residing at this higher level would have knowledge of the entire organization. Above this level would be *La Mesa* (The Table), where the highest officers of the gang would sit and direct the operations of all gang activities.

Category I

This is the entry level for all new prospects or inactive NF members returning to the "O." Nobody is admitted here until all papers have been compiled and then sent up the chain of command for clearance. This is where basic training starts for all new recruits, called *pescados*—fish. (Required reading for *pescados* is Sun Tzu's *The Art of War*, a 2,500-year-old Chinese treatise on warfare and conflict.) Also, inactive NF members returning to prison and Northern Structure gang members moving up enter through this level. All members here have an equal opportunity for advancement or specialized training. The personnel and the activities of the higher levels are not revealed to these initiates. Upon successfully completing the requirements of this entry level, the member may advance to Category II.

Category II

The *familianos* admitted to this category have proven their worth and loyalty to the "O." Records outlining the *carnal's* deeds and worth while in Category I are compiled and submitted to the hierarchy for evaluation. When approved, the *carnal* is promoted to this level. This category is the level of the advanced maestros (teachers), squad leaders, experienced soldiers, and overall advisors who supervise and monitor activities in Category I. Advanced training includes weapons, lethal striking areas of the body, concealment of contraband, first aid, and communication between cells, blocks, prisons, etc. Instruction in the manipulation of the classification procedure, methods of compromising staff, and related subjects are also explained at this level. Appointment of squad leaders is handled here. *Familianos* at this level are knowledgeable of the Category I- and Category II-level activities and personnel, but not of those in the higher category.

Category III

This is the backbone of the Nuestra Familia. The Nuestra Familia lieutenants and commanders sit at this level, along with the staff of the Regimental Security Department. A *familiano* reaching this level has to have made at least one kill and reached the rank of lieutenant. Here evaluations on *familianos* at the lower levels are assessed and sent back down for follow-up. Promotions, reprimands, and sanctions against lower-level personnel are processed here. *Familianos* sitting at this level have knowledge of the entire organization.

La Mesa

This is the highest echelon of the Nuestra Familia, where the captains reside. By constitution, the NF is limited to 10 captains. As of this writing, there are eight active captains, leaving two vacancies. All eight of the captains are confined to Pelican Bay Maximum Security Prison.

Nuestro General

At the absolute top of the Nuestra Familia sits the general, Nuestro General. The general is usually appointed by the former general

and must have impeccable credentials in leadership, courage, and related factors. To him is relegated the power to declare war, sign peace treaties, appoint captains, demote, and name disciplinary committees when a commander is brought up on charges. The general himself is subject to impeachment if his commanders unanimously decide his conduct is not in the best interest of the Organization. When the general has one year remaining on his prison term, he must step down and appoint another. This is done to insulate him from further prison criminal activity, thereby ensuring his return to civilian life.

NF soldiers who violate orders from their superiors are written up and may be required to submit a 500-word essay, which is passed up through the chain of command for evaluation, disposition, and punishment. Blunders include allowing someone to disrespect you or your race, falling asleep at post, failure to follow orders, or any number of other infractions. There are three reasons a *familiano* can be put in the box (killed): cowardice, treason, or desertion. When one of La eMe's founders, Rudy "Cheyenne" Cadena, was killed by the Nuestra Familia, "Tiny" Contreras was the *familiano* charged with the murder. Actually, Contreras was only the back-up man for the hit; others implicated were Juan "Apple" Colon and Frank "Joker" Mendoza. Contreras jumped on Cadena after he was dead. Contreras, in fact, stabbed a corpse. Yet he was the one the officers saw doing the stabbing, and he was the one charged. La eMe continues to hold a contract on Contreras, Colon, and Mendoza.*

The arch enemies of the NF are the Mexican Mafia, who are called *moscos* (flies) or hamburgers—because they eat hamburgers like the Americans do, as opposed to the traditional Mexican food eaten by the Nuestra Familianos. Other enemies include all Sureños, the Aryan Brotherhood, and Fresno Bulldogs.

The Black Guerrilla Family and all Norteños are considered allies.

..

NF Indicators

- The original banner of the Nuestra Familia was the Virgin Mary with the words "Nuestra Familia" above and below the figure.*
- The banner of the Nuestra Familia is the sombrero pierced with a bloody dagger. The sombrero represents the Organization—the "O." The stitching represents the tight-knit structure of the "O." The dagger piercing the sombrero represents the constitution, the rules and regulations, and the policies and procedures. The blood on the knife represents the *familianos* who have died in battle; blood dripping from the knife is that of the NF enemies who have been slain.*
- Mongolian ponytail. The base of the tail will be near the top of the head, representing the position of the north star.*
- The *estrella* (star) on the left side of the forehead indicates that the wearer has completed a successful hit.*
- Tiny stars placed on the arm in any fashion indicate that the wearer is a hitter (also known as a "cleaner" or "torpedo").*
- Teardrop not filled in indicates a hitter. If filled in, it confirms the wearer has completed five successful hits.*
- Other confirmatory tattoos include the Nuestra Familia or the letters NF, the words or abbreviations "Ene" (N in Spanish), "XIVER" (XIV=14=N; ER=R; N+R=Nuestra Raza), "Norte," "Norteño," "XIV" (for N, the 14th letter in the alphabet), or "14" (although these tattoos are also used by northern California street gangsters who may have never been to prison).

* This information was given by a Nuestra Familia defector during debriefing. It is thought to be reasonably accurate; however, positive confirmation has not yet been attained.

..

Northern Structure/Nuestra Raza

Following the attempted breakup of the Nuestra Familia (which was in the process of restructuring), a one-time NF general doing

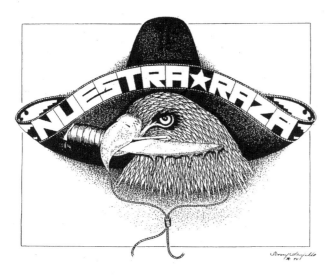

Emblem of the Northern Structure/Nuestra Raza. Note the North Star on the outer brim and the *huelga* birds on the inner brim.

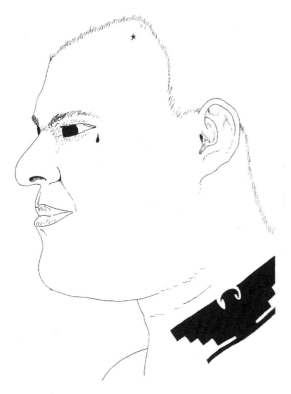

The *huelga* bird tattooed on the subject's neck is the emblem of the Northern Structure/Nuestra Raza. The star on the forehead indicates a successful hit. The teardrop under the eye may be filled in (indicating a hitter) or not (indicating the wearer has completed five successful hits). The teardrop may also be of no relevance; many street thugs, before coming to prison, put on the same tattoo because they think it looks cool.

time at Folsom Prison devised a plan to reassemble a new prison gang made up of remnants of the Nuestra Familia and other hard-core northern Hispanic street gangsters. This new group would serve two purposes: it would divert attention away from the Nuestra Familia (which itself was regrouping) and serve as a recruitment pool and an ally of the NF. This new prison gang took the name Northern Structure.

A category system with three levels, similar to the one adopted by the Nuestra Familia, was implemented. A new constitution was written called The Fourteen Bonds, which would serve as the rules of conduct for all Structure brothers. Among other things, the constitution called for the inmate to take charge of his personal advancement within the prison. He was encouraged to take advantage of the educational opportunities, vocational training, and work assignments. He also was expected to maintain a high level of personal fitness, working out with weights, playing handball, and being active in other athletic programs.

Other conduct outlined by the Fourteen Bonds involved relationships with other brothers. No brother would spread gossip, show disrespect, or in any way denigrate a fellow brother or the brother's *ruca* (girlfriend) or family. A brother was not to lie about his own exploits or status and, if in a position of authority, would not use this position to abuse other brothers. A brother was to have no dealings with Structure enemies or K-9 (correctional officers), unless instructed to do so by the higher-level officers. Acts of favoritism were discouraged. All brothers were encouraged to treat each other equally. Sanctions imposed for violations of these rules could be anything from writing an essay to loss of television privileges to yard restriction or forfeiture of tobacco or other canteen items.

Serious offenses were treated much more harshly. Cowardice, or failure to go to the aid of a brother, could put the offender on the hit list. Leaking Structure business to enemies or K-9 could also place the offender in jeopardy. Once a Structure brother was placed on the hit list, his only hope for survival was to check

in—go into PC. Walking alone on the yard was forbidden. A brother was to have backup with him at all times when vulnerable to attack.

As in the Nuestra Familia, the Structure's Regimental Security Department is at the level of Category III. Squad leaders and other supervisors gather information daily regarding enemies, new arrivals, new prison policies, inmate movement, evidence of weapons manufacturing, rumors of impending fights or hits, and any other sensitive intelligence matters. This is passed on to the RSD on a daily basis.

The RSD was also given the responsibility of screening new recruits. Friends of the prospect who were in prison were interviewed. Others were contacted by mail or telephone. This gathering of gang member intel inevitably became high-tech, and today the information gathered is passed on to security sources outside, who compile all member data on computer disk.

Any Norteño newly arrived at the prison is pulled up by other brothers and questioned about his past. The Structure recruits primarily from the influx of Norteños (northern California Hispanics); however, it has also admitted a few members of other races and from areas other than northern California. If the new arrival appears to be qualified for consideration of recruitment into the Structure, it becomes the job of the RSD to do a background investigation. An interview starts the process. Tattoos are checked. Papers (news clippings, court documents, letters, attorney correspondence, copies of disciplinary hearings, transfer papers, and similar documents held by the prospect) are examined. After this initial screening, The RSD contacts sources in other prisons, on the streets, and, in some instances, within the prospect's family. During this period of time, the new arrival is placed under constant surveillance to learn who he hooks up with, who he appears to be friendly with, which ethnic groups he is seen with, and any other significant associations and behavior. A daily report is done by one of the lower-echelon members and sent on up to one of the squad leaders.

After acceptance into the Structure, the new arrival is given a mission, and when it is successfully completed he is sent to Category I school. The schooling starts with memorizing the Fourteen Bonds and other rules and regulations specific to the housing units and other prison facilities. Lessons in human anatomy, lethal striking areas of the body, basic first aid, and related subjects are next. Basic hands-on defensive tactics and escape from grips and holds are covered. The prospect is required to demonstrate his skill and turn in daily written reports of what he has learned.

When his supervisors are satisfied that he has passed this preliminary training, he is moved forward to Category I-A for advanced training. Here he must learn how to survive in prison by becoming skilled in tier warfare, security procedures, identification of enemies, weapons (shanks, impact weapons, garrotes, poisons) manufacturing and concealment, communication techniques, fishing (passing messages from one cell to another by flushing a line attached to a kite down the toilet, to be retrieved by another inmate housed in another cell), or using a cadillac (a line with the attached message and a weight that is whipped down the tier along the floor from one cell to another), code writing, hand signs, etc.

Training in Category II consists of higher academics: instructor preparation, recruitment, advanced codes used in written communication, intelligence-gathering on enemies and prison staff, manipulation of prison classification, and methods of compromising staff members.

Training in Category III consists of squad leader training and preparation, advanced manipulation of prison staff members (divide and conquer methods, successful methods of interrogation, advanced intelligence gathering and dissemination), and advanced weapons manufacturing: 110-volt booby traps, caustic agents, bombs, and zip guns.

The above Northern Structure category levels of training are quite similar to those of the Nuestra Familia. Higher echelon Structure brothers may sit in on Nuestra Familia meetings. The NF continues to be the parent organization, but during the last few years there

has been increased infighting among the two groups. Many of the Structure brothers continue to push away from the Nuestra Familia, desiring to be free of NF influence. A Nuestra Familia member is not allowed to step down and join the Structure; however, RSD security members have successfully infiltrated the group in order to monitor the group's activities. Inactive NF members who return to prison and are in good standing are sometimes used to do this.

Basic differences exist between the Nuestra Familia and the Northern Structure/Nuestra Raza. These differences include the following:

- The Nuestra Familia has its own constitution; the Northern Structure has its Fourteen Bonds and housing rules.
- The Nuestra Familia has a blood-in, blood-out commitment; the Northern Structure is not a lifetime commitment; however, when a brother returns to prison he is expected to re-enlist and support the Structure.
- To be accepted into Category III, the Nuestra Familia member must have made at least one hit; a Structure member can be accepted into Category III without making a hit.
- Nuestra Familia members refer to each other as *familianos*, *carnales*, or "Cs"; Structure brothers refer to each other as "brother."
- A Structure brother is under no obligation to join the Nuestra Familia and will receive no sanctions for declining entry.
- It is also common to see Norteño tattoos, including the *huelga* bird (Aztec-style eagle taken from the symbol of Cesar Chavez' United Farm Workers Union), which is the emblem of the Structure.

After the Structure solidified, many members wanted a name more aligned with their Mexican heritage. An alternate name was selected and is seen frequently in their graffiti, drawings, and tattoos: Nuestra Raza (Our People, Race). Like the NF and other Norteños, the Structure identifies with the color red. Enemies and allies are the same as those of the Nuestra Familia.

Border Brothers

Border Brothers is a descriptive term adopted by thousands of Mexican nationals, who, after emigrating to the United States, have run afoul of the law and been incarcerated in prisons throughout the country.

The emergence of this new group was first recorded by California prison authorities in the 1980s. Mexican nationals locked up in California prisons lived a fearful existence. They were extorted and made to pay protection by seasoned prison gang members, chiefly those connected to the Mexican Mafia. Back then, the aliens had neither the strength nor the numbers to mount a viable defense. To compound matters, few of the immigrants trusted the prison staff, remembering the stories told back home of the brutal, corrupt Mexican prison guards. In time, however, increased numbers of Mexican nationals were brought into the system, adding to the ranks of the Border Brothers and bolstering their backbone.

At some point the Border Brothers began holding meetings to discuss ways of fighting off their antagonists. The outcome of these meetings was a resolution to resist, with whatever force necessary, attempts by other prisoners to extort them and to retaliate in kind. They vowed to arm themselves, to move around the yard in groups, to protect each other, and to fight back. They were on their way to becoming a structured, tight-knit, disruptive group, held together by common roots, language, customs, family associations, and a dislike of Mexican Americans. They especially scorned the Mexican Mafia's use of the eagle and snake emblem, which was taken from the flag of Mexico and, in the eyes of the Border Brothers, amounted to a flagrant show of disrespect. It was the Border Brothers who were the true Mexicans, certainly not brown-skinned *cholos* (low-life Mexican American gang members) born in the United States. Fights between these two groups of Hispanics were frequent.

In the 1990s, California, Arizona, and Nevada experienced a surge of street gang activity involving immigrants claiming Border

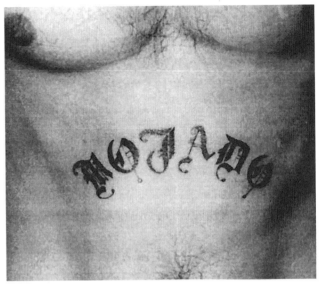

Above: "B.B." with barbed wire tattooed on upper arm.

Top Right: "*Mojado*," which translates roughly into wetback.

Right: Juarez, a city across the border from El Paso, Texas, named after the Mexican national hero Benito Juarez, and PN, which translates into *Puente Negro* (Black Bridge), an illegal street gang in the city of Juarez.

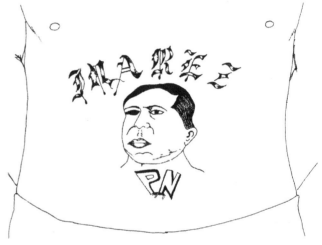

Brother affiliation. Incidents of drive-by shootings, burglaries, robberies, and large-scale drug trafficking rose sharply. Apparently, the immigrants had direct pipelines back to hidden labs in the Mexican jungles where *campesinos* (peasants) toiled around the clock producing black tar heroin and methamphetamine targeted for addicts living in the United States.

In south central Los Angeles, Mexican immigrants began moving into the area in such great numbers that many African Americans, long the dominant ethnic population, began relocating to other adjacent areas. The Mexican Mafia was quick to take notice. Many of these new residents were obviously competing with the blacks in sales of illegal drugs. And many of the Border

Brothers appeared to be working as agents for the newly emerging Mexican drug cartels, something that drew the admiration of La eMe.

The Border Brothers could supply unlimited quantities of black-tar heroin and meth. They could also direct gangsters who were in hiding to safe houses across the border. A truce was in order. The Mexican Mafia had the unlimited distribution networks and the muscle to keep everyone in line. La eMe's reputation for violence and retribution was well known. It was a marriage of expedience. These two diverse factions began working together, at least on the streets. But in the prisons of the Western states, they continued to have problems with

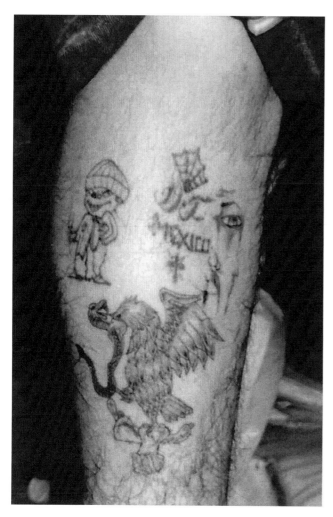

Photo showing "DF Mexico" (*Distrito Federal*, or Federal District of Mexico) and the eagle and snake of the Mexican flag tattooed on the subject's lower leg.

day functioning of the prisons. Group disturbances, assaults, weapons manufacturing and possession, and drug trafficking were all attributed to the group. Validation of Border Brother membership had become relatively easy since they were always seen together in groups and, in the Nevada prisons, were calling each other *paisas*. They had also developed their own distinctive tattoos, which displayed their home states in Mexico, pyramids, Aztec headdresses, the letters BB, and the term *mojado* (wetback).

During a cell search, Arizona Department of Corrections investigators uncovered a document thought to be the "rules of conduct" of the Border Brothers imprisoned there. It is below, as translated into English.

· ·

RULES
(translated version)

RESPECT
Have respect and obedience to all board members and superiors, always.

BROTHERHOOD
You must love, take care, and help out a brother with everything. You must be willing to give your life for a fellow member if it's necessary. Never leave a brother by himself, no matter what.

UNITY
Fighting with a fellow member is not permitted. We must respect each other and conduct ourselves with respect no matter where we're at. We must prevail in all fights with our enemies. Be it as it may we must remain united and remain united forever.

PRIDE
Respect and maintain a good reputation for our cause. Never allow anyone to use the name of our cause without being a member. Do not allow yourself to be put beneath anyone or anything. Do not allow our cause to be put beneath anything. Always maintain a high state of dignity and pride to be a

each other.

In October 1996, a large gang fight between approximately 30 MRU Aguilas and a like number of Border Brothers erupted on the lower yard of the century-old Nevada State Prison in Carson City. Order was not restored until many of the combatants had been shot by birdshot fired from the rooftop gun posts. Arizona and California reported similar disturbances.

The Border Brothers continued to stream into the prisons of Arizona, California, and Nevada, making them one of the fastest-growing security threat groups in the prison system. Their threat index level showed them becoming a major threat to the orderly day-to-

Mexican.

STABILITY

Remember only a board member can decide the membership of a new element. The same rules apply to the termination of a member gone bad or of an enemy.

LOYALTY

Always be cautious when recommending or selecting someone who you think deserves to enter our cause. Teach him well but take into account that you are responsible for his actions and if he betrays or commits an act of treason you will be responsible to take care of the problem by whichever means is necessary.

SOLIDARITY

Consult with the other brothers on your yard all matters or problems that must be dealt with. Find a solution to all matters that all members agree with. Remembering always that all solutions must principally benefit our cause with full respect.

COURAGE/VALOR

To become a member you must first pass a test of valor and loyalty. You must swear to keep in contact with other members. Always obey the rules set forth. Remain faithful to our cause and comply always with the orders that are given to you.

FOR LIFE

Border Brothers Identifiers

The clothing worn by Border Brothers may be wrinkled and unkempt; their style of dress is not as sharp as that seen with Mexican American prison inmates. For instance, a belt may be nothing more than a piece of torn sheet, the shoes may be dirty and scuffed, hair may be long and poorly groomed.

This gang's primary spoken language is Spanish; occasionally an Indian dialect is heard.

The Arizona Border Brothers' tattoo is a circle with a radiating outer flame, an Aztec lion in the center, and the letters BB. In Nevada, the letters BB in Border Brothers' tattoos may be accompanied by strands of barbed wire, the word *Mojado,* or the phrase *Orgullo Mexicano* (Mexican Pride).

Frequently the inmate's name is also inked on the front or back of the torso, along with his home state and a depiction of the patron saint of Mexico, Our Lady of Guadalupe (though this is not limited to Border Brothers). Other tattoos that may be seen are the letters WBP (Wetback Power), MP (Mexican Posse), MB (Mexican Brothers), and BM (Barrio Mexico).

Chilangos

The term *chilango* has various meanings. Mexican Americans use the term to describe people of their race who are fair-skinned and well-off economically. Mexican nationals, however, use the term to describe streetwise inhabitants from the Federal District of Mexico. These *chilango* "city slickers" look down their noses at the unsophisticated *campesinos* from the rural areas of Mexico.

Gang investigators should make this distinction when investigating Mexican nationals. *Campesinos* are quicker to respect authority and generally have a better work ethic. On the other hand, many *chilangos* who have found their way into our prisons come from a background of street violence in their home state and may have been active in the burgeoning Mexican drug cartels. This segment of immigrants appears quite comfortable hooking up with existing prison gangs. This does not mean to exclude the *campesinos* from this activity, only to say that the *chilangos* may be more sophisticated, have better outside contacts, and be more difficult to control.

Common tattoos identified on chilangos are the phrase *Orgullo Chilango,* which translates into "Chilango Pride," and the abbreviation DF (*Distrito Federal,* or the Federal District of Mexico).

Association ÑETA

Carlos Torres Iriarta, aka La Sombra (The Shadow), was born in Myaquez, Puerto Rico,

Tattoo of the ÑETA hand sign over a heart and cross.

on May 26, 1946. As a young man, he moved to San Juan and became active in movements seeking Puerto Rican independence. At age 28, he was jailed on charges he insisted were trumped up and was sent to Los Marbinos Correctional Facility in Rio Piedras. La Sombra regarded himself as a political prisoner.

Los Marbinos, as well as the other prisons during this era, was among the most violent in the Western hemisphere. Rioting, murders, rapes, and beatings were commonplace among the inmates. Prison gangs, whose membership was limited to inmates from the same home towns, fought over control of the yards. As a result, any inmate could be hunted down and killed simply because he came from a different town as the other gang members.

La Sombra, who had an air of sincerity and purpose about him, vowed to put a stop to the violence. He was influential in calling a series of meetings with other prisoners, in which he introduced a new enemy among them: rapists, child molesters, and inmates who'd committed crimes against the elderly. These were the *insectos* (bugs), he said. They had to go. And he exhorted the *respetable* (respectable) prisoners to cease killing each other.

Changing the conversation to the administrative policies, he urged the prisoners to study the rule books and become active in inmates' rights protests, hunger strikes, and other legal maneuvers. He convinced them of the need for an inmate association tasked with contacting newspapers, government agencies, and outside lawyers to get the word out about the deplorable conditions in the Puerto Rican prisons in order to effect a meaningful change.

Many of the prisoners who'd listened were caught up in La Sombra's ideas and began spreading the word, which dispersed throughout the other prisons. La Sombra named his new movement (which he insisted was not a gang but a prison reform organization) ÑETA. (In Puerto Rican culture, when a baby is born, the *abuelo* [grandfather] climbs to the highest point within calling distance and shouts, "ÑETO!" [if male] or "ÑETA!" [if female] three times to announce the child's birth.)

During the next few years, recruitment in ÑETA soared throughout Puerto Rico's prison system. Prospects were required to sit quietly in a circle while confirmed ÑETA leaders interviewed them. The prospects were required to present their judgment of conviction, which verified their crimes and sentences. *Insectos* (rapists, child molesters, abusers of the elderly), when uncovered, had to move to PC or be killed.

Not all of the prison population was eager to join ÑETA. A group of inmates who called themselves Viente Siete (27) grew suspicious of La Sombra's intentions and convinced themselves he was planning to take control of the prison. On March 30, 1981, La Sombra was ambushed by members of Veinte Siete and was stabbed and shot with a .25-caliber handgun that had been smuggled in.

In death, La Sombra became a martyr, and his message of prison reform was grasped throughout Puerto Rico and eventually spread

to prisons in the United States that housed Puerto Ricans. Those responsible for La Sombra's death were labeled *insectos*, and the green light was put out on them. One inmate, Rafael Ayala Ortiz, aka Manota, who was thought to be the person who'd used the gun, was hunted down by ÑETA members and incurred more than 200 lethal stab wounds.

Wherever ÑETA members are confined in large numbers, they assemble to discuss business and pay homage to La Sombra on the 30th day of each month by forming circles and reciting the following prayer:

> *May the spirit of the lord Jesus Christ*
> *and the name of our leader,*
> *Carlos Torres Iriarte,*
> *better known to us as Carlos La Sombra,*
> *and the brothers who died for us in the struggles*
> *be in our hearts and minds forever.*
> *Amen.*

In addition to the monthly meetings, once a year on March 30 an annual celebration is held to honor La Sombra. Investigators who are tracking suspected ÑETA members should be alert to any inmates gathering on this date.

··

ÑETA Identifiers

Beads: A beaded, rosary-like necklace from which dangles a red, heart-shaped pendant and black cross is ÑETA-specific. The main body of the necklace has 78 white beads, terminating at the bottom with 7 black beads forming the letter V. Another ÑETA necklace has alternate groups of beads—3 red, 3 white, and 3 blue strung low around the neck.

- The 78 beads stand for the 78 cities in Puerto Rico.
- The color white stands for peace and harmony.
- The 7 lower beads stand for the seven ÑETA chapters established by La Sombra.
- The V shape stands for victory over enemies.
- The color black is in remembrance of La

Sombra.
- The heart-shaped pendant denotes the blood shed by ÑETA brothers and sisters.
- The cross is symbolic of God's protection of ÑETA members.

Colors: Red, white, and blue, from the Puerto Rican flag.

Hand Sign: The middle finger crossed behind the index finger, both of which are extended together and, in a sweeping motion, are brought from the chest to an upright position.

Ideology: ÑETAs are closely aligned with Los Macheteros, a revolutionary Puerto Rican group committed to gaining independence for the home island of Puerto Rico. Both groups believe they are being oppressed and held in bondage by the U.S. government.

Tattoos: Most Puerto Rican prisoners on the island shun identifying tattoos. In the U.S. prisons, however, a ÑETA-specific tattoo is seen frequently: the hand sign superimposed over a heart and cross. Also commonly seen are the words "*Asociacion Ñeta de la Corazon*" (from the heart) and the word "*Libertad*" (liberty) and "1.50%" (committed 150%). This also contains additional symbolism: the number 1 denotes La Sombra, who was number one; the dot symbolizes the bullet that killed La Sombra; the 5 indicates five stab wounds; and the "0" stands for Oso Blanco, a Puerto Rican prison in which more than 100 inmates were slaughtered during a violent riot in 1975. "PRP" (Puerto Rican Power) emblazoned on the inmate's chest was seen by the author in a Nevada prison housing unit. The Puerto Rican flag is also seen frequently in graffiti and tattoos.

··

Cuban Marielitos

The following assessment of the Cuban Marielitos was given to the warden of the Atlanta Federal Penitentiary by an unnamed Cuban American prisoner who knew the Marielitos well while doing time with them in the 1980s:

> They came originally out of anti-Marxist

Above: This Marielito emblem was drawn by a prison inmate. The dollar sign, the marijuana leaf, and the Turkish pipe (bong) represent the money to be made in trafficking drugs. The skull and dagger are objects used by Palo Mayomberos when invoking the spirits to protect them in their criminal endeavors. The Cuban flag waves in the background to display allegiance to a communist-free Cuba (not to Castro).

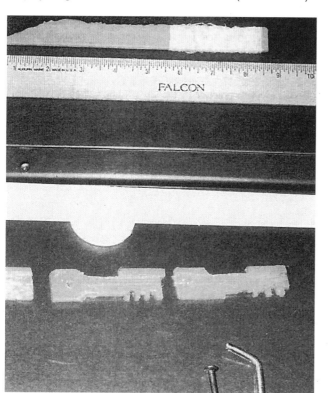

Santa Barbara. This tattoo, one of the most popular worn by the Mariel bandido, tells a lot. The personage is the Catholic Saint, Santa Barbara. The crown on her head is made to resemble the parapet of a castle. On some tattoos, the castle will be seen in the background. The sword in the left hand and the chalice in the right hand symbolize the union between the Catholic Saint and the African deity Changò, patron saint of fire, thunder, and lightning. In the Santeria religion, Changò is a muscular black male with a smiling face who is adorned with gold. The Santa Barbara/Changò deities punish those who have offended them by hurling lightning bolts that strike and destroy them.

Left: The tools of Cuban prisoner craftsmanship: the shank and Folger Adams keys were fashioned from pieces cut from the heavy plastic lid of a footlocker. The Cuban prisoner removed lengths of heavy thread from his mattress and, using this as one would dental floss, was able to cut through the heavy plastic with surprising ease. The finished shank is a deadly weapon equaling those made of metal. The keys were good enough to unlock the cell block gates.

Sources indicate that since Fidel Castro lost financial aid from Russia he has been involved in cocaine trafficking into the United States, working closely with Cuban Marielitos in this country. This photo shows Castro meeting with Panama's Manuel Noriega prior to the Panamanian drug trafficker and money launderer's imprisonment in the United States.

Cuban families and were jailed when very young for minor complaints. But, you must understand that underneath everything with them there is this anti-Americanism of the Marxists. They think they have the right to do anything here. They resent the freedom and they don't know what to do with it.

They call themselves "Marielitos," not Cubans. They identify themselves through the Mariel experience. That gave them their form. They call people outside "civilians"; by inversion, they identify themselves as military. They feel that nobody can touch them—they're "Marielitos."

On April 21, 1980, Fidel Castro allowed 40 Cuban dissidents to sail from Mariel Harbor en route to Key West, Florida, and relocate in the United States. President Jimmy Carter regarded these Cubans as refugees and welcomed them to the United States. This was the beginning of an exodus of approximately 127,000 refugees who would eventually reach our shores, riding the crests on power boats, wind-driven craft, rowboats, rafts, and inner tubes.

Within a week, thousands of these refugees were splashing up onto the Florida Keys, with no money or belongings, no identification, and sketchy details of their backgrounds. Local law enforcement agencies alerted the federal government that the situation was becoming uncontrollable. In an effort to keep abreast of the problem, vacant military bases were quickly reactivated to serve as processing centers for the Cubans.

As processing got under way, it became apparent that some of these new arrivals had questionable backgrounds. Many admitted to having been released from prisons and psychiatric holding facilities, where they were told they would be shipped to the United States—whether they wanted to be or not. Many others had been zealous communists. It now became of vital importance for the U.S. authorities to identify and isolate the criminal misfits and communists from the legitimate refugees and hold the undesirables for deportation.

On June 20, 1980, by presidential order, a special six-month entrant status was granted to all the legitimate Cuban refugees (and some

GANGS AND THEIR TATOOS

Haitians) who had arrived prior to June 19, 1980, allowing them to qualify for work permits, Aid for Dependent Children, Medicaid, Social Security, and other types of welfare and benefits. All of those who had been identified as criminals were ordered held until deportation hearings could be conducted. When this plan was made public, Fidel Castro announced that Cuba would refuse to take back any of these undesirables. In effect, they were now the problem of the United States.

All of the Cubans who could be identified as having prior criminal histories were moved to holding facilities throughout the country until their status could be clarified. However, since they had committed no criminal acts in the United States, the practice of holding them without criminal charges was contested by some of the better-educated prisoners, who filed briefs through the U.S. judicial system.

On January 1, 1981, Judge Richard Rodgers ruled that Cubans with criminal histories could not be held in federal prisons indefinitely without hearings. This ruling effectively transferred the burden of proof from the refugee, who previously had to prove he was admissible, to the U.S. government, who now had to prove the alien was deportable. During this year, hundreds of Cubans who had been held in United States prisons without formal charges were released to the streets of America under the "Sponsorship Program."

This program was enacted to provide a base from which the released Cubans could establish themselves in the United States. A sponsor could be nearly anyone but was generally another Cuban who had been sponsored out of prison. As a result, the Cubans released from various prisons—among them murderers, enforcers, drug and weapons traffickers, and other hard-core criminals—assembled in many of the fast-paced cities of America and entered into organized crime, United States style. Others among them, politically oriented, embarked on the trail of subversion.

Nearly all of the Cubans had set sail from Mariel Harbor. The criminal element took their name from this event and became known as the Marielitos or Marielitos Bandidos.

How many of these Cuban arrivals were hard-core criminals is hard to estimate; however, percentages were calculated by Immigration and Naturalization Service (INS) officials who determined that of the 127,000 refugees, 33 percent had prior criminal histories, which would amount to 41,910 criminals. The percentage of hard-core criminals was determined to be 18 percent, amounting to 22,860.

Today, the Marielitos criminals on the streets are heavily involved in drug trafficking, armed robberies, weapons, murder for hire, auto theft and chop shops, and rip-offs of other street gangsters. In prison, they may behave relatively orderly, or, as in the case of the federal penitentiary in Atlanta, engage in violent rioting and set fires, causing millions of dollars in damages.

Some prison authorities have said the Cubans are unpredictable. However, because I am cognizant of their behavior on a day-to-day basis from observing them in prison, I believe that their behavior can be predicted. They are very loud and profane when together, but with a competent officer who has the ability to listen without being intimidating, they will discuss their adjustment to the prison environment as well as their ability to cope. By following this method, prison staff may increase their competence in predicting Marielito behavior and thereby improve the odds of diverting occurrences of impending violence.

The Cubans compare U.S. prisons with those back in their native country and regard ours as a cakewalk. Here they are not brutalized, nor are they starved, as happens so often in Cuba. They get medical and dental care, legal assistance, schooling, good food and clothing, well-equipped athletic facilities, adequate cell space, and myriad other benefits unheard of in Cuban prisons. (Several years ago, I learned of a plot by six Cuban prisoners to murder a correctional officer in one of our prisons in order to remain in the United States. They had heard a rumor they were going to be deported and elected to kill an officer to ensure that they would not be returned to Cuba. The plot was uncovered in time to prevent the murder.)

Identification of Marielitos

- They are Cubans with skin color ranging from white to brown to black.
- When in a group they yell and scream at each other and play their radios and televisions on high volume. This is unsettling to some detention facilities.
- Many follow the Santeria religion, which practices animal sacrifice.
- They generally have poor dental hygiene.
- They are clannish, but will cling together in groups and fight among themselves. However, when threatened by non-Cubans or prison staff, they may instantly unite and react with the mob mentality.
- Many have had military training in Cuba and are proficient with firearms (in Cuba, military service is compulsory for three years; following this, membership in the militia is required until age 62).
- They are skillful in making improvised weapons and wise to conning prison officials in order to obtain the needed materials to make shanks and other weapons.
- They place a high priority on revenge and retribution.
- Criminal activity: Trafficking in cocaine appears to be the Marielito mainstay (with suspected drug routes back to communist Cuba), but they are also involved in weapons, murder for hire, extortion, protection, auto theft and chop shops, and run-of-the-mill street robberies and burglaries. They have used crash cars against pursuing police vehicles when trying to evade arrest following armed robberies.

Santeria and Palo Mayombe

A large percentage of the Cuban Marielitos arriving on our shores brought with them peculiar religious practices, namely, Santeria and Palo Mayombe. These occult religions, which incorporate the beliefs of Catholicism and African voodoo, are characterized by animal sacrifices, blood letting, spells, and ritual ceremonies that sometimes include the use of human body parts.

Practitioners of these religions number into the millions and are not limited to the uneducated and impoverished. Scholars, professionals, and many of the wealthy elite throughout Latin America are devout Santeros and Paleros. Drug lords also engage in Santeria ceremonies, pleading to the saints for protection from their enemies and from law enforcement. Other Santeros believe that through their rituals they are able to enter a trance state where they are possessed by the spirits of the dead.

Investigating Santeria and Palo Mayombe crime scenes, officers should look for suggestive evidence such as

- desecrated graves, mutilated corpses, human skulls, and other body parts
- animal or reptile body parts (e.g., snakes and roosters), some of which may be displayed, nailed to trees and existing structures
- large metal cauldrons used in black magic rituals where a human head, knives, guns, and animal parts are stewed together in an attempt to contact the departed spirit, which, it is believed, will assist those in attendance with earthly pursuits
- shells from the cowrie tree, many of which are cast in bunches during a ritual, and, depending on the way they land, denote certain code offerings to the gods
- blood-stained gourd bowls
- coconut rinds
- candles
- rag dolls
- objects colored red and white (colors that symbolize the Afro-Cubano deity, Changò)
- grave-robbing; possession of human skulls, and other body parts
- powders made from animals and birds, for which Palo Mayombe high priests have been arrested for trafficking (powders derived from the panther, for instance, are said to imbue the recipient with strength and stealth; powders from the owl restore wisdom)
- altars set up in prison cells for observing religious rites

Tattoos

The Cuban government and law-abiding society generally look down upon tattooed individuals as being rebels and criminals. And rightly so, because in the Cuban prisons, tattooing among inmates is an ongoing practice. The tattoos, though crude by American standards, may reflect the person's criminal expertise and gang membership, as well as religious beliefs. Figures of Christ and African deities are common, as are figures of Santeria saints. American Indian heads are also very common. If the Indian is shown with a peace pipe, the meaning is a desire for peace; if shown with a bow and arrow, hatchet, or spear, it indicates a warrior spirit is present to protect the wearer.

Criminal prowess is usually shown by tattoos on the web of the hand. Examples include

- executioner: a heart pierced by an arrow
- kidnapper: a five-point star below three divergent vertical rays
- enforcer: an upright trident
- drug dealer: three divergent vertical rays above two horizontal lines
- money launderer/counterfeiter: three vertical divergent rays
- weapons supplier: a cross lying horizontally

In addition, dots corresponding to numbers may be seen on the web of the hand. The arrangement and number of dots describe the wearer's criminal expertise. Examples include

- larceny: three dots forming a triangle
- robbery: three dots forming a vertical line
- murder: four dots in a square pattern
- habitual criminal: five dots as seen on the face of a die

FOLKS AND PEOPLE

Although they originally formed along racial lines, today the Folks and the People represent a diversion from the racial dynamics that typify most prison gangs. These two Chicago-based "nations" can trace their origins back to the 1960s, when two violent African American street gangs, the Blackstone Rangers and the Disciples, fought savage battles in the streets over control of turf, crime, and money. Under threats of death, lesser gangs adjacent to the battle zones were compelled to support the dominant gang in their neighborhood.

When Jeff Fort, the leader of the Blackstone Rangers, heard rumors of an impending crackdown on the street gangs, he changed the name of the gang to the Black-P-Stone Nation and tried to pass it off as a community-oriented organization.

During the early 1970s, through a combined effort of local and federal law enforcement agencies, new laws were enacted that targeted these Chicago street gangsters. Multi-agency task forces were formed with the objective of ridding the city's streets of gang crime once and for all. As a result, hundreds of these violent gang members were caught up in sweeps, indicted, and sent to prison.

Initially, it appeared the task forces had succeeded in breaking up the gangs. However, this "victory" was to be short-lived. Inside prison, these rival gang members continued to battle. And other gangsters, fewer in number than the Black-P-Stones or Disciples, came under attack. For protection, they gladly jumped into one or the other of the two dominant gangs.

During this era, new leaders emerged on the streets who remained loyal to those in prison, which established a direct connection between the prison and the street gangs. And the gang leaders doing time enjoyed a new sense of identity. Inside the walls, where gang requirements are far more stringent than those on the outside, the inmate could build up his body and his reputation. When he'd served his time and was released back to the streets, he'd bring with him marching orders for the street gangsters to work with. Events like these effectively reinforced the credibility of the prison gangs and left no doubt that the prison gang leaders were calling the shots.

By the early 1980s, the Black-P-Stones were claiming a coalition of thousands of

Gangs Riding Under the Folks Nation

AMBROSE	BLACK DISCIPLES
BLACK GANGSTER DISCIPLES	BLACK SOUL
CAMPBELL BOYS	GANGSTER DISCIPLES
HARRISON GENTS	IMPERIAL GANGSTERS
INSANE DEUCES	INSANE POPES
LA RAZA	LATIN DISCIPLES
LATIN DRAGONS	LATIN EAGLES
LATIN JIVERS	LATIN LOVERS
LATIN SOULS	ORCHESTRA ALBANY
PARTY PEOPLE	SATAN DISCIPLES
SIMON CITY ROYALS	SPANISH COBRAS
SPANISH GANGSTER DISCIPLES	SPANISH GANGSTERS
TWO BOYS	TWO-SIXERS

Gangs Riding Under the People Nation

BISHOPS	BLACK-P-STONES
COBRA STONES	(AKA BLACK STONES)
(AKA MICKEY COBRAS, ROCK BOYS)	CULLERTON DEUCES
EL RUKNS	FREAKS
GAYLORDS	INSANE POPES
INSANE UNKNOWNS	JOUSTERS
KENMORE BOYS	KENTS
KING COBRAS	LATIN BROTHERS
LATIN COUNTS	LATIN DRAGONS
LATIN KINGS	LATIN PACHUCOS
LATIN SAINTS	NOBLE KNIGHTS
PARTY GENTS	PARTY PLAYERS
PUERTO RICAN STONES	SPANISH LORDS
12 STREET PLAYERS	VICE LORDS
VILLA LOBOS (AKA VILLAGE WOLVES)	WARLORDS

members both in and out of prison. Under this new coalition, the previous name was dropped and was replaced by the "People Nation." Not to be outdone, the Disciples had been forming their own burgeoning coalition of gangsters under the heading "Folks Nation." These two newly founded "nations" continued their bitter rivalry, which spread to the streets, where virtually every street gang in Chicago was claiming either People or Folks. The scattered few who resisted were looked upon with disdain by the gangs of the two nations, who referred to them as "renegades" or

"independents." These holdouts could expect little help if sent to prison.

Most of the gangs and their members continued to display their specific street gang names in their graffiti and tattoos; however, they also adopted the identifying emblems of one or the other of the two large coalitions they had elected to ride under: the five-point star of the People Nation or the 6-point star of the Folks Nation.

As thousands of new gang members came to align with either the Folks or People, previous racial restrictions were tossed out. Street gangs that had developed with mixed-race memberships were readily accepted by Folks and People. The Latin Disciples, a large Hispanic street gang based in the Midwest, aligned under Folks. Soon race was no longer a factor when it came to affiliating with either nation.

(NOTE: The chapters that follow discuss a sampling of street gangs affiliated with the two nations.)

WHITE HATE GROUPS, GANGS, AND OTHER GROUPS

WHITE SUPREMACIST ORGANIZATIONS

White supremacist groups are spread throughout North America, Europe, Australia, and Africa. Some of these groups claim to be followers of Christianity; others disclaim Christianity; still others disavow any organized religion. Despite their differences, they all have a common goal: furthering the ideal of white racial purity. Some seek change through the political process, others take a more direct approach: vandalism and violence directed against blacks, Jews, immigrants, homosexuals, and others deemed undesirable by the groups' leaders. A few of these groups are described here.

Ku Klux Klan (KKK)

The oldest and best known white supremacist group in the United States is the Ku Klux Klan, which was founded in 1866 in Pulaski, Tennessee, by a half dozen combat-hardened former Confederate soldiers who wanted to continue raising hell. At times, they would go into town draped in white sheets and play jokes on the townsfolk. Their antics attracted the attention of other ex-soldiers, who wanted to join in the joviality. It wasn't long before the group had strengthened its ranks considerably. Recruits brought with them new

ideas, some borrowed from the secret societies of the day, others from their wartime experiences. Nathan B. Forest, a former slave trader and Confederate general, took over the Klan's leadership and began to pattern the organization after the military.

The sight of freed slaves and northern carpetbaggers swaggering about town was becoming a bitter pill for many of the Klansmen, as well as the local citizenry. Klansmen began referring to their organization as a vigilante army. The idea spread like wildfire and took hold throughout the South. Within two years, the group that had been started by a handful of men bragged of having a membership of upwards of half a million men throughout the southern United States. With this explosive growth, all hopes of a central leadership were abandoned. The Klan embarked on a mission of search and destroy, its targets being the freed slaves, Yankees, Jews, and Catholics.

Hooded night riders with their flowing white robes first went after the blacks to whip and terrorize them. This was followed by violent kidnappings and lynchings. In Washington, D.C., Congress passed laws making night riding a crime. Still, the lynchings continued to gain momentum. In 1871, President Ulysses S. Grant withdrew troops fighting on the Indian front in the Western

plains and sent them to South Carolina to put down Klan violence. Mass arrests followed, and the Klan vigilante army was nearly abolished. It remained unseen until the period following World War I, when it rose again on a platform of anti-immigration. *Birth of a Nation*, a film released in 1915, presented the Klan in a favorable light. Recruitment intensified.

During the roaring twenties, bootlegging and related crime skyrocketed. Morals were tossed out the window. Church attendance slackened. The Klan took notice and regrouped under the leadership of William Joseph "Doc" Simmons, a bible-thumping evangelist. Simmons' message appealed to the clergy as well as to the law-abiding citizenry: a return to Christianity was the only way the nation could be salvaged. And the Klan was closely aligned with Christian fundamentalism. Ministers clamored for membership.

Upwards of 40,000 fundamentalist church authorities were accepted, many to be named to the First Exalted Cyclops of their local communities. Many others went on to become Grand Dragons of their respective states. Sermons from the pulpits encouraged Klan membership, and nationwide, total Klan membership during this perios soared to 4 million. But a backlash was on the horizon.

David C. Stephenson, one of the nation's most powerful Klan leaders, was convicted of the murder of a young white woman in Indiana. Nationwide, the front pages of newspapers were emblazoned with the details of this grisly Klan-connected murder. Newspaper editorials disclosing other acts of Klan terrorism were syndicated nationally. Politicians in state after state, reacting to their constituents' ire, began enacting laws aimed at "demasking" Klan members. Diverse organizations with strong membership, such as the American Legion and the American Federation of Labor, publicly denounced Klan membership.

Stephenson, languishing in prison, also turned against his former accomplices. In a series of interviews, he revealed the Klan's scope of criminal activity, including their

The emblem of the Ku Klux Klan tattooed under the subject's right biceps. The encircled cross with the flame at the center, as seen in KKK literature, posters, and tattoos, is the confirmed symbol of the Klan and validates membership. The flame at the center of the white cross symbolizes destruction; the cross symbolizes purity. A hooded figure along with the letters KKK is another common Klan tattoo.

involvement with graft, bribery, and other corruption on a political level.

Public opinion of the Klan was crumbling. And then came the Scopes Monkey trial in 1925, in which a Tennessee schoolteacher was put on trial for teaching Darwinism. This trial became a national topic of debate, sharply dividing proponents of each side.

The fundamentalist churches, pillars of support for Creationism, were also known as long-time supporters of the Klan. Nationally, the public could accept the churches' stance on Creationism; however, they could no longer accept their association with the Klan. Since the nation's eyes were focused on the events in Tennessee, which put the churches' beliefs in question, the churches felt compelled to distance themselves from the Klan, at least on the surface. Klan membership plummeted. By the end of the decade, the Klan could claim no more than 40,000 members.

During the civil rights movement of the

Emblem of the Aryan Nations, which is replete with symbolism: 1) the crown—the Father's complete and immutable sovereignty over all things; 2) the three jewels of the crown—the divine and complete perfection of the triune of the Father, Son, and Holy Spirit; 3) the shield—Christian faith and trust in God's perfect law and covenants to them that keep the faith; 4) the two-edged sword—truth that proceeds solely from God and the instrument of His vengeance upon all that hate Him; 5) the revolving resurrection cross centered on the sword of truth—the return of the white race to righteousness; 6) the cross of David—the blessings to Israel (the three bars on each of the four corners symbolize the 12 tribes of God's racial nations and inheritance of His kingdom); 7) the square—the divinely appointed four-square formation and order commanded by Yahweh of hosts for the armies of the tribes of Israel in the beginning as His nation and the symbol of the four-square city of his new Jerusalem with 12 gates for the tribes of Israel, the Adamic Aryan Race of God.

1960s, far right groups like the Minute Men, the American Nazis, Soldiers of the Cross, and others rose to prominence. Along with them, the Klan experienced another resurgence. The KKK was at the front of many anti-civil rights marches. Again membership soared, and not just in the South. There were also active chapters in large northern cities. As the furor of the Civil Rights Movement began to die down in the early 1970s, the Klan experienced another decline in membership.

In 1979, the Klan again gained notoriety in Greensboro, North Carolina, when members of the organization, supported by American Nazis, opened fire on members of the Communist Workers Party, killing five and wounding nine others. This event, which became known as the Greensboro Massacre, signaled the beginning of organized attacks against nonwhites that would be referred to as "white resistance." What was significant here was that other white supremacist groups that had a history of feuding were now helping each other in attacks against blacks, Jews, immigrants, and other minorities. And the white groups had by now attached another group to their list of enemies: agents of the U.S. government. This prevails today.

Aryan Nations

The Aryan Nations, a Christian Identity organization also known as the Church of Aryan Nations and the Church of Jesus Christ Christian, traces its roots back through 60 years of white supremacy ideology, having been affiliated at times with the KKK.

Members of the Aryan Nations advocate the elimination of Jews and all minorities and believe that Europeans are the lost tribe of Israel, Jews are Satanic, blacks are subhuman, and the U.S. federal government is illegal. They refer to the U.S. government as the "Zionist Occupational Government," or "ZOG," and, following the tenets of the Christian Identity philosophy, believe it is controlled by the state of Israel. The Aryan Nations acts as an umbrella movement for many other white supremacist organizations and hopes to create a white homeland in five Northwestern states.

Under the leadership of Richard Butler, the group's current director, a 20-acre compound was set up in Hayden Lake, Idaho, in the 1960s and became the group's headquarters.

In 1982, the Nation hosted the first World Aryan Congress in Hayden Lake, where white supremacists from around the nation met to exchange ideas on government conspiracy, the World Bank, racial hatred, weapons, and Aryan unity. The success of this first congress so pleased the organizers that they decided to

make it a yearly event. By the 1990s, representatives from most major white supremacist groups were journeying to the compound each year for the festivities. Loosely organized skinheads, neo-Nazis, and ex-convicts, along with other white malcontents, were also present.

In a 1998 Internet announcement, "Pastor" Butler offered the tree-studded encampment with all of its facilities to followers and families of the Aryan principles. Campsites, a bunkhouse, showers and rest room facilities, and two full-sized kitchens capable of accommodating 500 persons were featured in the global invitation.

..

Aryan Nations Oath of Allegiance

I, as an Aryan man, hereby swear an unrelenting oath upon the green graves of our sires, upon the children in the wombs of our wives, upon the throne of God almighty, sacred in His name, to join together in holy union with those brothers in this circle and to declare forthright that from this moment on I have no fear of death, no fear of foe, that I have a sacred duty to do whatever is necessary to deliver our people from the Jew and bring total victory to the Aryan race.

I as an Aryan warrior, swear myself to complete secrecy to the Order and total loyalty to my comrades.

Let me bear witness to you my brothers, that should one of you fall in battle, I will see to the welfare and well being of your family.

Let me bear witness to you my brothers, that should one of you be taken prisoner, I will do whatever is necessary to regain your freedom.

Let me bear witness to you my brothers, that should an enemy agent hurt you, I will chase him to the ends of the earth and remove his head from his body.

And furthermore, let me bear witness to

you my brothers, that if I break this oath, let me be forever cursed upon the lips of our people as a coward and as an oath breaker.

My brothers, let us be His battle ax and weapon of war. Let us go forth by ones and twos, by scores and by legions, and as true Aryan men with pure hearts and strong minds face the enemies of our faith and our race with courage and determination.

We hereby invoke the blood covenant and declare that we are in a full state of war and will not lay down our weapons until we have driven the enemy into the sea and reclaimed the land which was promised of our fathers of old, and through our blood and His will, becomes the land of our children to be.

..

The Aryan Nations recruits extensively through the Internet, at gun shows, around schools, and in prisons. Ex-prisoners, indoctrinated in white supremacy, are actively recruited and may serve as intelligence and security forces throughout the organization, helping to uncover government infiltrators and other informers.

Aryan Nations shield on the subject's lower back.

Top: Shoulder patch worn by members of the AWB while in uniform. Center: The flag of the AWB. Bottom: A uniform patch showing the swastika-like emblem and Nazi war eagle.

The organization itself apparently does not endorse criminal activity; however, individual members have been implicated in crimes involving explosives, weapons, and vandalism, as well as hate crimes and related activities. Also, members are very active in prison outreach programs in order to recruit members.

Publications such as *Calling Our Nation*, *National Chronicle*, and *The Way* (a prison outreach newsletter) also serve as promotional vehicles.

Here AWB 777, representing the organization's seven original founders, is tattooed above a prison inmate's left eyebrow.

The official Aryan Nations tattoo is the same as the emblem: a three-point crown atop a downward-pointing sword with the letter N superimposed on a shield which is affixed to a square with rays radiating to each corner. Other tattoos seen frequently are the usual white supremacist tattoos.

Afrikaner Weerstandsbeweging (AWB)

The AWB, or Afrikaner Resistance Movement, is a South African neo-Nazi organization that was founded in 1970 by Eugene Terre'Blanche and six others. This committee of seven chose as its symbol the number 777, as opposed to the number 666 of the satanic forces. The flag of the AWB displays this 777 as a triskele, the three-legged symbol of ancient Greece that signified progress and competition as well as the sun. With a triskele on a white disk in its center, along with the red and black colors of Nazism, the AWB flag is highly suggestive of the Nazi swastika.

From its early beginnings, the AWB found thousands of willing recruits who shared a common interest in establishing a whites-only sovereign republic within the Republic of South Africa. They boast of unmatched achievements in South Africa under white rule:

- Mining—77 percent of the world's steel, 72 percent of the world's uranium, 66 percent of the world's gold, and the largest diamond yields in the world
- Transformation of petroleum products and coal into oil
- Advanced medical technology in the field of organ transplants
- Military— development of the G5 and G6 artillery pieces, the Rooivalk attack helicopter, the Cheetah supersonic jet fighter plane, long-range missiles, and nuclear weapons technology
- The development of nuclear power stations at Koeberg and Pelindaba.
- Abundant food production providing for 40 million people in South Africa as well as inhabitants of adjoining countries

Today, Terre'Blanche and his followers—among them many youthful skinheads and armed supporters—stage frequent protest rallies and marches recruiting new members and sympathizers. The African National Congress (ANC), the black ruling majority, has been at odds with the AWB, which it says has disrupted the political climate of Johannesburg and is responsible for isolated bombings.

Because many of the established white settlements have come under violent attack by Zulu tribesmen and other militant blacks, many whites who at one time shied away from the AWB have joined up as a matter of self-protection. Homes and farms occupied by whites have become armed encampments replete with barbed wire-topped block walls, gun ports, and guard dogs. Armed whites go out nightly on jeep patrols. It is estimated that upwards of 500,000 whites have emigrated out of the country to escape this forced imprisonment, settling in Australia, Canada, and various European countries.

In Johannesburg today, black terrorist gangs armed with AK-47s are indiscriminately slaughtering other gangsters as well as innocent civilians during firefights over control of street rackets. This splendid city, once a tourist mecca, has become one of the most violent and dangerous cities in the world.

Skinheads

The skinhead phenomenon started during the late 1960s in England. This was a period of worldwide economic and political change, in part due to the war in Vietnam. Globe-trotting, stringy-haired hippies, the offspring of apparently wealthy families, were entering Britain in abundance, many drawn there by musical groups such as the Beatles. Other homegrown, youthful subcultures began appearing, some identifying with the hippies, others taking different routes.

Resentment of the hippie invasion by many of the working class Brits was apparent from the start. At times, the tension caused by the disparate ideologies of these two groups resulted in furious clashes that spilled out into the streets. During these clashes, the Brits were quick to grab fistfuls of unkempt hair in taking down the unwashed hippies. These confrontations motivated the Brits to keep their own hair short, the accepted style being close cropped or shaved.

Along with the Brits' identifying hairstyle, other characteristics of dress began to emerge: tight-fitting blue or white jeans or Sta-Prest trousers, American-style button-down shirts (Ben Shermans), flight jackets or Wrangler jean jackets, and very narrow suspenders (braces) to hold up the pants. The most sought-after article of clothing, though, was the steelies, 12- to 14-hole, calf-high, steel-toed Doc Marten boots also called DMs or Docs, the colors of choice being cherry red and black (Nazi colors) or black with red laces. And in order to show off the highly polished boots, the tight-fitting trousers had to be hemmed short or rolled up. The steelies were also regarded by many as lethal weapons when used to stomp an opponent during a fight.

Based on their close-cropped hairstyles, these angry Brits began to refer to each other as skinheads, and specific emotional characteristics began to appear among them: an increased feeling of nationalism along with a hatred of foreigners—especially those of color (who they felt were taking British jobs)—was becoming ingrained in their logic. Attacks against Pakistani immigrants (Paki-bashing) and other foreigners were becoming all-too-frequent occurrences throughout London. Jews, blacks, homosexuals, and other minorities were soon added to the skinhead roster of hated groups. The skinhead movement was speeding ahead into Nazi ideology and white supremacy.

From England, the movement began to appear in Denmark, Switzerland, West Germany, and other European countries. Even Spain and France saw the emergence of skinheads during the 1970s. Following the tearing down of the Berlin wall, the movement erupted in East Germany. Throughout Europe, skinheads espoused trying to rid their countries of Asians, black Africans, Pakistanis, Turks, Jews, and other minorities.

During the 1980s skinhead ideology (i.e., Hitler was right; the Holocaust is a lie) appeared in the United States and was readily adopted by many anti-authoritarian youths in this country. The movement was fueled here in part by radical racist musical groups such as the English import Skrewdriver, grinding out racist themes like "Hail the New Dawn," "The Klansman," "Boots and Braces," and "Fetch the Rope." Today, the skinhead movement is pervasive throughout the United States, where blacks, Hispanics, Jews, homosexuals, and Asians are all targeted.

Skinheads are loosely organized but can be found in industrialized countries in many parts of the world. Criminal activity is focused on violence directed against nonwhites and homosexuals, including assault, vandalism (e.g., desecration of Jewish synagogues and cemeteries), and dealing in explosives and weapons. Skinheads get along with most white supremacists. Minorities, homosexuals, and skinheads against Racial Prejudice (SHARPS) are their avowed enemies.

Most of the youths attracted to the movement are between the ages of 13 and 25, mainly of European stock. Females are also part of the movement. Being a skinhead in no way implies a lifetime commitment; skinheads appear, disappear, and resurface on a whim. Many drop out and rejoin mainstream society. Others, though, move on to hook up with established white supremacy organizations like the Aryan Nations and White Aryan Resistance (WAR). In the United States, many others make their way into the nation's prisons, where, if they carry themselves well, they become members of existing white prison gangs.

Today, most skinheads continue to wear close-cropped hair; however, there are long-haired skinheads who are referred to as "cornheads." Tight jeans held up by thin suspenders and button-down shirts are still the style. Frequently, tank tops are worn, as are bomber-style or jean jackets, which may be emblazoned with Nazi symbols. Camouflage

Skinhead with swastika tattooed on scalp. When he needs to cover this up, the subject merely has to let his hair grow in.

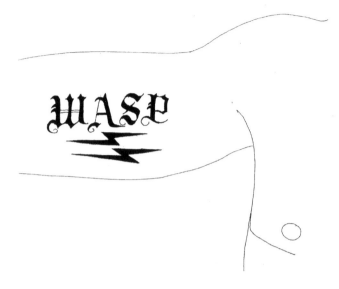

"WASP" (White Anglo-Saxon Protestant) with lightning bolts. This tattoo is not limited to skinheads; many other white supremacists use it.

Skinhead tattoo featuring the word "skin" on the knuckles. The knuckles of the other hand would show "head."

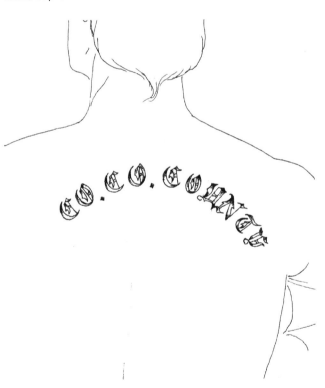

"Torrance So. Cal" on this inmate's abdomen indicates his hometown and is nonspecific for gang affiliation.

"Co Co County" refers to Contra Costa County (California) Boys, a disruptive group within the prison system.

clothing is being seen with greater frequency, as are long overcoats. Still, the Doc Marten-type steel-toed boots are the most identifying item of clothing. When correct, these boots will be polished to a high luster. Black boots with white laces denote white pride; black boots with red laces denote Nazism. The Nazi salute (right arm upraised and extended) is used as a greeting and following meetings.

In skinhead posters and graffiti, red and black always signify Nazism, and white indicates white power or white pride. Drawings depicting Hitler or swastikas, Nazi storm troopers, or hooded KKK figures, or posters advancing whites-only organizations, all indicate white supremacy, but are not necessarily confined to skinheads.

Skinhead Tattoos

The skinheads of the 1960s were identified with a star tattooed on the left palm and four dots in the shape of a square tattooed on the skin of the hand between the thumb and index finger. The four dots stand for "ACAB" (All Cops Are Bastards). Today's skinheads prefer Nazi-oriented ink: swastikas, iron crosses, lightning bolts, "SWP" (Supreme White Power) "FTW" (F—- The World), "Blitzkrieg" (Lightning War), "88" (the eighth letter of the alphabet—HH, or Heil Hitler), Viking helmets with horns, and similar Aryan themes.

Peckerwoods

Imprisoned Peckerwoods regard blacks as the number-one enemy. They get along fairly well with the Hispanics. Groups such as the Peckerwoods, the Co Co County Boys, and other white supremacist prison groups serve as recruitment pools for organized prison gangs like the Aryan Brotherhood.

The term "peckerwood" was first used to denote white inmates who were down for (supportive of) the white race in prison. As the term Peckerwood became known outside prison walls, other disgruntled white youths in many cities began calling themselves Peckerwoods and joined others who had similar racist beliefs. Like the skinheads,

these Woods lacked a unified organization and still do. However, white supremacists have well-funded national newsletters and Web sites through which they share beliefs and intelligence.

Peckerwood Tattoos

Like most white supremacists, Peckerwoods make liberal use of Nazi and Viking symbols. The words "Peckerwood," "Pure Wood," "Real Wood," "Down Wood," and "100% Wood" are common. A bird's head and beak also denote affiliation with the Peckerwoods. Other tattoos common to Peckerwoods include the customary white prison tattoos: prison walls and gun towers, spider webs, skulls, and mythical beasts.

Neo-Nazis

At 11:30 A.M. on April 20, 1999 (Hitler was born April 20, 1889), normalcy and decency were shattered at Columbine High School in Littleton, Colorado, as two students wearing fatigues and black trench coats began firing high-powered weapons indiscriminately on the school grounds. From there, the two made their way into the school cafeteria and up the stairs to the school library, all the time firing their weapons point-blank at terrorized faculty and students. Adding to the carnage were pipe bombs and other incendiary devices that sent shrapnel flying into the bodies of panic-stricken students who were blindly trying to escape. Scores were injured and, tragically, 15 others died, including one teacher. The two shooters, who had apparently been on a suicide mission, were also among the dead.

Responding emergency personnel were quick to learn that unexploded bombs were strewn about the scene. This problem was compounded with the realization that the killers' bodies had been booby-trapped, which necessitated sweeping the entire area using sophisticated electronic sensing devices. Tragically, the dead could not be removed until the following day.

The scenario had been well thought out, as evidenced by the stockpile of explosive devices the two killers had assembled in the weeks or

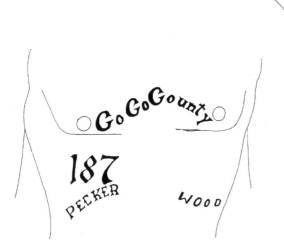

"Co Co County," "Peckerwood," and "187" (the California penal code for murder).

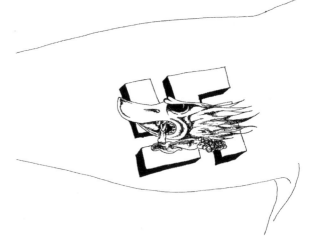

A woodpecker superimposed on a swastika is Peckerwood-specific.

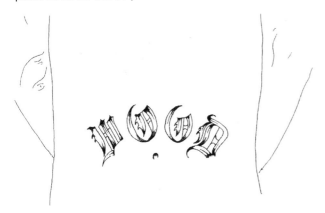

"Wood," which stands for Peckerwood.

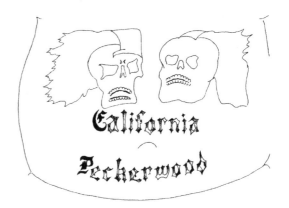

"California Peckerwood" on abdomen.

months prior to the event. Police later found a diary that had also laid out plans to hijack an airplane and force it to crash into a populated area of New York City.

Could this tragedy have been prevented? Had the school officials monitored and tracked the behavior of the shooters prior to the event? Had there been warning signs? Could the parents have been alerted to the intentions of their children in time to head off the massacre? The questions are many, the answers few.

Trying to put the pieces of the puzzle together, the authorities learned that the two shooters had been associated with a group of a dozen or so students known as the Trench Coat Mafia. They were distinguished by the long black trench coats they wore, which they thought gave

them a sinister appearance. In various reports the group's members were said to have had a hatred for blacks, Hispanics, and school athletes.

The two dead shooters were variously labeled as neo-Nazis, Satanists, and goths. The neo-Nazis, who are well known to most people, have been around for decades, as have Satanists, whereas the goths are a relatively recent phenomenon. Followers of these subculture groups display specific characteristics that can be discerned by informed adults.

The concept of neo-Nazism appeals to many of today's white rebellious youths. Hitler, who boasted of a Third Reich of Aryan superiority that would endure for 1,000 years, was himself an avowed occultist, a practitioner of the black arts who also delved into satanic

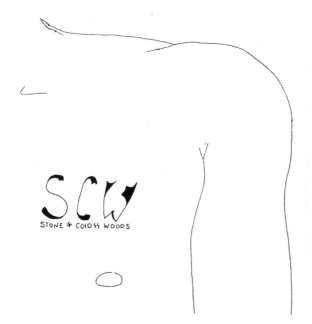

"SCW," which stands for "Stone Cold Woods."

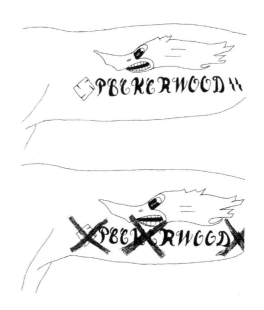

In the upper sketch, the word "Peckerwood" with bird's head has been tattooed under the inmate's left biceps. In the lower sketch, the tattoo has been crossed out by other white supremacists because of the wearer's inability to fight well against minorities. This subject, if imprisoned, must now do his time in protective custody or risk being victimized on a daily basis by white supremacist inmates.

rituals along with members of his inner circle. The feared Gestapo, called the Order of the Deathhead, was Hitler's personal armed guard. Gestapo officers—dressed in razor-creased black uniforms and adorned with symbols of the occult, including the deathhead, lightning bolts, and runic SS—evoked terror in others by their sinister appearance and reputation. Gestapo officers were selected on the basis of their Aryan lineage and willingness to follow orders blindly. The concept of racial superiority was ingrained within them, and they regarded non-Aryans as subhumans. The Gestapo along with Hitler's black guard, the Waffen-SS, were fanatical warriors. In battle they showed no conscience and fought gallantly, granting no mercy to the adversary.

In today's affluent America, tens of thousands of our citizens have bought into the Aryan precepts as defined by Hitler more than a half century ago. Identifying such leanings in their own children should be the responsibility of caring parents. The following are some red flags that provide strong indications of neo-Nazi tendencies:

- Wall decorations with posters of Hitler, the Gestapo, SS soldiers, and swastikas
- Military insignia: SS deathhead, Nazi iron cross, runic SS or lightning bolts, Nazi war eagle, and related items
- Surplus German army clothing, uniform patches, military weapons or equipment (SS ritual daggers are prized)
- Nazi colors: red and black. This may be seen in room decorations, graffiti, clothing (i.e., red shirt/black pants, black boots/red boot laces, black shirt/red suspenders), lunch pails, backpacks, notebooks, or other personal items
- Secret handshakes or hand signs, passwords, greetings, or spoken phrases
- Nazi salute with the right arm extended and angled upward
- Stockpiling weapons and ammunition, explosives, and demolition devices
- Literature such as *Mein Kampf* and biographies of Hitler or German military histories, especially pertaining to the Gestapo, the Waffen-SS, and the SS Panzer divisions
- Wall graffiti incorporating

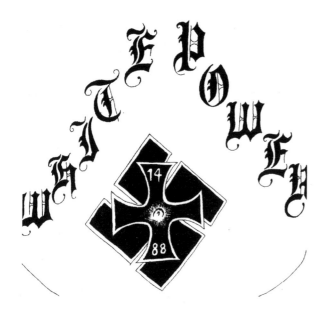

Runic SS. This is a Gestapo symbol, often mistakenly thought to be lightning bolts. Runic Ss have blunt ends, while bolts have pointed ends. Many fringe element persons have their tattoos on the neck so that others may see them.

"White Power" with a Nazi iron cross superimposed on a swastika. The number 88 stands for HH, or Heil Hitler. The number 14 refers to the 14 words that form the slogan used by white supremacists: "We must secure the existence of our people and a future for white children."

Nazi war eagle holding lightning bolts and arrows. The barbed wire is a characteristic of prison incarceration.

Swastikas trailing lightning bolts used to be an emblem of the Silent Brotherhood. The design is now being used by various white supremacist groups.

Swastika riding atop "WP."

"White Power" and "White Pride World Wide" are carried by many white supremacists. The Chinese writing, which means "Trust No Man," is a nonspecific tattoo used by all ethnic groups.

Nazi war eagle, "SWP," and swastika.

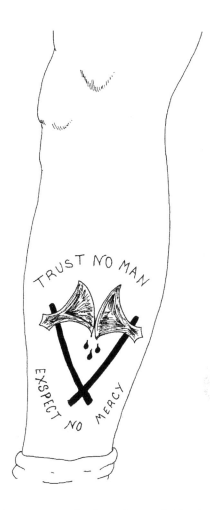

Crossed war axes on the lower leg are indicative of, but not specific to, white supremacy.

"Aryan Power" on abdomen.

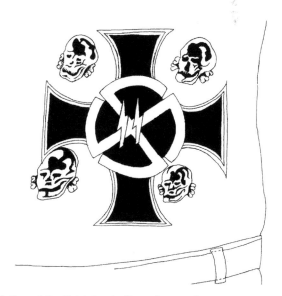

Variation of the lightning bolts and swastika superimposed on the iron cross. The four deathheads are copied from Waffen-SS insignia.

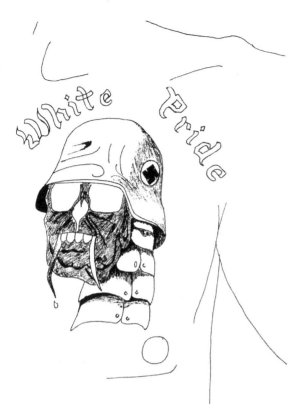

"White Pride" with the Nazi helmet and fanged soldier.

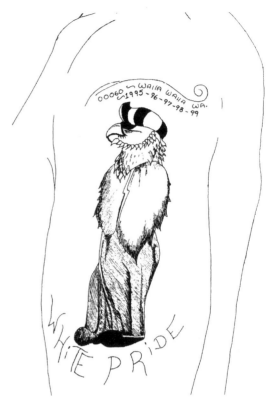

"White Pride" may denote only a belief in racial pride and, without Nazi symbolism, may not qualify as a gang validator.

"Blitz Krieg" is a German phrase that means "Lightning War."

Spider webs are common among prison inmates and are not gang-specific.

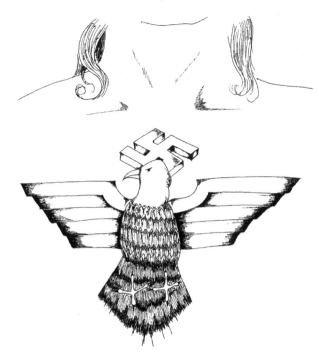

The all-seeing eye of Horus. Horus was the falcon god, lord of the skies. The right eye was the eye of Re (the sun god), the left eye symbolic of the moon. When depicted as an eye and eyebrow, as in this tattoo, it denotes strength and power. This Egyptian symbol has been adopted by many prison and street persons.

The Nazi war eagle and swastika of a neo-Nazi.

Tattoo of a male and female Viking on the lower inner arm of a white supremacist.

The hammer of Thor on chest, which imbues the subject with superhuman powers, according to Viking mythology: "Whosoever holds this hammer, if he be worthy, shall possess the power of Thor."

WHITE HATE GROUPS, GANGS, AND OTHER GROUPS

Thor, the Viking god of thunder.

- 88 (the eighth letter of the alphabet—HH, for Heil Hitler)
- 18 (AH, for Adolph Hitler)
- Blitzkrieg (Lightning War)
- Weiss Macht (White Power)
- Bruderschaft (Fraternity/Brotherhood)
- Bruder Schweigen (Silent Brotherhood), also called The Order, an antigovernment white supremacist gang formed in 1983 by a scholarly-appearing white racist, Bob Mathews. The Order was responsible for a series of armored car and bank robberies in the Pacific Northwest and California during the 1980s. In June 1984, members of the group shot and killed left-wing radio talk show host Alan Berg in Denver, Colorado. Mathews was hunted down by the FBI, and on December 8, 1984, on Whidbey Island in Puget Sound, he perished in a fire when the house he was barricaded in was lit up by federal officers.

NONTRADITIONAL GROUPS

Goths

The gothic movement is generally thought to have originated in the United Kingdom around 1979 with the release of a song by Bauhaus titled "Bela Lugosi's Dead." The song had its own unique identity with words that reflected on the unearthly deeds of Count Dracula, the vampire character portrayed on the screen by Bela Lugosi in the 1940s and 1950s.

Punk rockers in the United Kingdom, tiring of the spiked hairstyles and worn out punk music, were quick to move on to a new craze. Following the lyrics of this new song, the punk defectors began to create and adopt a new vampire-style appearance. Jet black hair and a pasty white pallor to the skin did much to establish an identity. Black lipstick, heavy eye shadow, and black nails added to the effect. Some went so far as to clamp fang-like dentures on their teeth and add drops of blood to their chins. Clothing and boots were jet

Tattoo of a bat on the chest of a goth.

black. Capes, sometimes worn, could be all black or black with a white or red lining.

This new craze soon caught on in Germany and other European countries, and the term "gothic" caught on. The origin of the term is murky at best, but most early followers say the term was coined by the British music press. Many rock bands were quick to cash in on the gothic movement and tailored their moody presentations to include immersion in the supernatural, vampires, death, bloodletting, drinking blood, and other somber subjects. The goths began to shun other subcultures and mingled together, drinking and feeling moody while smoking clove cigarettes in pubs and other meeting areas referred to as bat caves.

Sometime in the late 1980s and early 1990s, the gothic scene took hold in the United States. Adolescent followers of other counterculture movements jumped on the gothic merry-go-round. Around this time, bands such as The Shroud, Rosetta Stone, and London After Midnight became favorites of the goths.

Second-generation goths brought with them new ideas and rituals. Some of the more curious engaged in group role-playing as vampires, which led into bloodletting and tasting of each other's blood. Variations of

gothic rituals are seen from time to time. Genito-erotic activities may be combined with drinking of another's blood (to bond with someone special). Graveyards are a favorite meeting place. Many nightclubs in San Francisco (and probably elsewhere) that cater to goths charge patrons twice as much cover if they come in wearing street clothes.

Alcohol and drug usage is customary; however, it is not a requirement for acceptance. Some goths adhere to neo-Nazi concepts, while others deplore racism. Satanism may also be part of the gothic scene but is not necessarily obligatory.

Gothic Indicators

- Preoccupation with death, suicide, graveyards, Frankenstein, Count Dracula, and Halloween (goth Christmas)
- Black hair, nails, capes, and clothing
- Heavy use of black lipstick and eye shadow over a pasty complexion
- A gaunt look, including a physique that is as thin as possible
- Body piercing with silver studs depicting caskets, vampires, bats, and items regarded as supernatural
- Black tattoos depicting the signs and symbols of Dracula and vampirism in general—graveyards, bloodletting, and Halloween items (goths usually shun multicolored tattoos)
- Literature by Edgar Allen Poe, Charles Adams, and related authors
- Use of drugs ranging from pot to LSD to cocaine and heroin
- Tobacco use, especially clove cigarettes
- Bloodletting and bite marks

Straight Edge

On Halloween night, 1998, in Salt Lake City, a group of about 30 youths gathered near downtown and began hurling insults and soda bottles at passing motorists. The boisterous gathering consisted mostly of white, middle-class teenagers. A number of other youths, including some Hispanic and African Americans who were out celebrating Halloween and cruising State Street, drove into the rumpus by chance.

What happened next is sketchy; however, a few eyewitnesses said the two groups began exchanging insults and challenges, and some of the youths jumped out of their cars ready to fight. Weapons were produced, and the street corner erupted into violence. The melee spilled over into a parking lot. One African American was beaten on the head and stabbed in the leg. A 15-year-old Hispanic youth was bludgeoned across the head and face and then ripped open by a white youth wielding an eight-inch combat knife. The Hispanic youth crumpled to the ground and died.

When police arrived, they confiscated numerous weapons, including pipes and baseball bats. Apparently both sides had been armed and were out looking for trouble. Witnesses insisted they had seen a gun; however, none could be found. Two white teens, both with juvenile records, were arrested and charged with first-degree murder.

Identification confirmed the white youths were associated with a disruptive element known as Straight Edge, which has thousands of followers nationwide. During the last few years, crimes in Salt Lake City, including firebombings, vandalism, and fighting, have been attributed to Straight Edge members. Because of the criminal activity ascribed to Straight Edge, the Salt Lake City police have classified the entire group as a street gang. Members insist they are not a gang and do not condone violence.

Straight Edge traces its lineage back to the 1980s, when Minor Threat, a Washington, D.C.-based rock group, came out with a song titled "Straight Edge." The lyrics, by Ian MacKaye, were said to have been written in memory of one of his friends who had died of a heroin overdose. The message of this tune ran counter to what other rock groups were singing at the time. It promoted the idea of a person abstaining from drugs and alcohol, tobacco, and promiscuous sex in order to more

"Straight Edge" tattooed on subject's chest.

easily control his or her own life by ridding the body of negative addiction.

The song caught on rapidly and probably served as an influence to help some young people recover from addiction and to steer others away from it. Many youngsters had seen firsthand what drugs, alcohol, and tobacco were doing to their friends and members of their families and welcomed the opportunity to join peers who wanted to avoid these same pitfalls.

In looking for a specific identity, Edgers copied from the practice of youth clubs that marked an X on the hands of underage patrons to prevent the bartenders from selling them alcoholic drinks. "StraightXedge" or, more simply, "sXe" became one of their first identifying emblems and tattoos.

Taking charge of one's own life—exercising self-control and refusing to pollute one's body with harmful substances—is the group's avowed goal. In fact, sXe is probably the only youth subculture that actively denounces the use of alcohol, tobacco, and illegal drugs. Although initially there were no restrictions on meat consumption, which is not generally associated with addiction, now some Straight

Edge members with close ties to the Animal Liberation Front (ALF) discourage the consumption or use of animal products by other members.

Casual sex is unacceptable because of the chance of contracting sexually transmitted diseases.

Because of the restrictions placed on members, there is a lot of transient movement among the followers. Many youths are attracted to sXe for varied reasons but, after a while, tire of the restrictions and move on to other pursuits. Some sXe members are atheists because they regard religion as a controlling influence, which they denounce. Others may be active church members. Some sXe members are neo-Nazi racists, while others denounce racism.

In the United States, and to a lesser extent in Europe, sXe followers have physically attacked others because they were smoking tobacco, drinking, or using illegal drugs. This practice is not condoned by many other Straight Edgers. They refer to the violence-prone individuals as "Hate Edge." Other reported criminal activity includes firebombings and destruction directed against fast food restaurants, meat packers, and furriers (usually involving Animal Liberation Front followers), vandalism, and the murder that occurred on Halloween night in Salt Lake City in 1998.

..

Characteristics of Straight Edge

- Oversized clothing
- Shaved head or close-cropped hair
- Prominent body piercing
- Ornamental chains, which may also be used as weapons
- Crossing of the lower arms to form an X as a hand sign
- Tattoos, most commonly "Straight Edge," "sXe," "XXX," "Drug Free," "Hardline," and a stylized X

..

AFRICAN AMERICAN GANGS

The roots of African American gangs can be traced back to the turn of the century, when the United States experienced a dramatic shift from an agrarian society into a sweeping industrial nation. Illiterate farm workers, many of them descendants of slaves, trekked northward and, along with European immigrants, poured into the urban areas of America seeking factory work, which was paying as high as $5 a day.

Irish, Polish, Hungarian, Italian, and Jewish laborers, each held together by their own specific language and culture, blended in along factory assembly lines with America's white and black unskilled work forces. At the end of the workday, having little in common with each other, workers of each ethnic group moved naturally toward fellowship and housing with people of similar origins. As a result, neighborhoods developed that consistently housed persons of the same racial, religious, or ethnic background. And each retained its own culture, language, and specific identity. Boundaries, though invisible, were set in place. And when these invisible boundaries were crossed by outsiders, suspicion and contempt followed. At times, challenges to the outsiders to keep out were hurled from tenement housing windows.

Perhaps because of their different skin color or their curious customs and language, or perhaps reacting to the challenges, young

toughs inevitably began to venture into other neighborhoods to provoke fights and vandalize. Italians were fighting Irish gangs and black gangs; other whites were fighting the blacks along with the Jews and other European immigrants. It wasn't long before each neighborhood could boast of its own identifiable gang, which served to protect its territory and was expected to make payback forays into neighboring areas to retaliate against other gangs' misadventures.

Inevitably, the more aggressive gangs began to build on their reputations by engaging in more serious crimes during their incursions into other neighborhoods. Strong-arm robberies of pedestrians and extortion, robbery, and burglary of merchants and small businessmen began to draw the attention of the police who, during this period of time, pounded foot beats in most of the large industrialized eastern cities.

The economy took a nosedive during the 1930s, when the Great Depression enveloped the nation like a black cloud and tossed millions out of work. Thousands of unskilled blacks abandoned their southern shanties and immigrated to California in search of work. The majority of these émigrés settled in the Watts and Willowbrook areas of south Los Angeles. Whites and Hispanics, who had been the previous occupants of the region, began trickling out. The early youth gangs of this era began forming in the junior high and high

schools and reflected the ethnicity of the schools, which at that time were multiracial. Skipping school, drinking, fighting, and engaging in petty crimes represented the extent of these novice gangs' criminal activity. One of the earliest recorded gangs during this era, which had its beginning in the early 1930s, was called the Clanton Street Gang, named after Clanton Street (now renamed 14th Place), a four-block-long street just south of 14th Street in downtown Los Angeles. The Clanton Street's membership included blacks, whites, and a few Asians, all of whom lived close by and attended the same schools. Some of the more prosperous Clanton gang members wore all-black clothing and double-soled leather shoes with a horseshoe tacked to the heel.

By the time World War II broke out, many of the whites had moved out of the area, and a lot of the blacks had dropped out of Clanton. Nevertheless, the Clanton Street Gang had grown to more than 100 members, most of which at this time were Hispanic.

During the war, hundreds of thousands more blacks came to the Los Angeles area to work in the defense plants. Many of them settled in the south Los Angeles area. At the close of the war, an unprecedented housing boom erupted, which witnessed a mass exodus of whites from the greater Los Angeles area into the suburbs. South central L.A., at this time, became a mecca for African Americans. Public housing projects sprang up like mushrooms. And the first of the organized black gangs appeared.

Long before the emergence of the Crips and Bloods, African American gangs in Watts were building their own ferocious reputations. The Slausons, the Huns, the Mongolians, the Majestics, the Farmers (so named because of the bib overalls they wore), and a few others were locked in nightly battle. How they differed from the next-generation Crips and Bloods was in the absence of heavy weaponry when they fought. Many of these gangsters worked out daily in the gym and were very good with their fists and feet.

During the late 1950s, the Businessmen, a coalition of individuals from several other gangs centered around 51st Street and Avalon, appeared on the scene. To the west, in the area of the Coliseum and the University of Southern California, the Gladiators, another coalition of African American gang members, was formed. These two got along fairly well, but isolated members were sometimes beaten by white gang members belonging to the Spook Hunters, a deteriorating group of whites that was trying to hold the line against a steady influx of blacks to the area.

Following the first Watts riots that started on August 11, 1965, blacks living in south central Los Angeles began arming themselves with added firepower, and within the next few years the Crips and Bloods exploded onto the scene. The glory days of fighting with fists were over. Rapid-fire weapons were now standard issue. And even though this scene was being replayed in most of the nation's largest cities, Los Angeles was given the questionable distinction of replacing both New York City and Chicago as the gang capitol of the nation.

CRIPS AND BLOODS

For the past three decades, media attention given to the Crips and Bloods of south central Los Angeles has been abundant. Newspapers, magazines, the entertainment industry, and trade journals have supplied vast amounts of information on the topic. Much of what has been doled out is fairly accurate; other data is questionable at best.

Even the origin of the Crip name has been the subject of continual debate. Indeed, the gangbangers themselves often differ on the name's origin. Several theories have been put forth to explain the name, and not everybody agrees with any one explanation.

One of the accounts has the name coming from a Vincent Price horror movie, *Tales from the Crypt*, in which dead people were deposited in a crypt; if you messed with this gang, that's where you would be put. During a gang seminar, Ken Bell, a gang investigator with the Los Angeles County District Attorney's office who carries impressive credentials, upheld this version.

Another version has the name taken from

the one substance that is stronger than Superman: kryptonite. The gangbangers were looking for a name that would instill fear into other bangers in the area, and since they professed to be stronger than the popular comic book hero, they coined the word "crip," taken phonetically from the word kryptonite.

A former Los Angeles street gang that predates the Crips was a roving band of blacks from an area near Slauson Avenue who called themselves "The Cribs." One of their chief rivals was "The Slausons," another marauding street gang in the area. So yet another version has the Cribs evolving into the Crips.

When I was employed as an ambulance driver in Los Angeles during this period of notoriety, we were advised of a gang of blacks in south central Los Angeles and the Willowbrook area known as the Crips. We were told the leader had to use a cane because he was crippled and that many of the other gang members also carried canes, which they used as weapons when fighting enemy gang members, attempting to cripple them. This to me is the most believable origin of the Crip name. Raymond "Truck" Washington, a streetwise high school dropout who is generally accepted as being one of the original founders of the Crips, indeed used a cane to walk and was known as a cripple—or a Crip. It would appear that as the gang developed, the name Crip stuck.

Second-generation gang members whom I've interviewed have given another version of the name's origin, insisting that the organization is politically oriented. To them, the name CRIP is an acronym for Common Revolution In Progress. (I encourage readers to select whichever version they prefer or to please share with me any information they possess that would clarify this.)

Besides Raymond Washington, other founders of the Crips included Anglo "Barefoot-Pookie" White, Michael "Shaft" Concepcion, Melvin "Skull" Hardy, Bennie Simpson, Mack Thomas, and Raymond Cook. This nucleus of what was to become the infamous Crips recruited others from the neighborhood and engaged in strong-arm robberies, assaults, burglaries, car theft, and extortion. Many of the victims were middle- and high-school-aged children who were beaten and robbed of their lunch money, jackets, and shoes. To prevent further attacks, many of these youngsters were compelled to gang up themselves, if not with the Crips then with another gang active in the area.

Two of these other gangs were the Pirus, centered along Piru Street in Compton (an incorporated city adjacent to the area), and the Brims, another south central street gang. The Pirus and Brims, who had once been rivals, formed an alliance to counteract the threat posed by the Crips. Members of these two gangs addressed each other as "Blood," and their group soon became known as the Bloods.

One of the Crips named Cunningham had been tagged with the moniker "Young Cousin." This was subsequently shortened to "Young Cuzz," and then to, "Cuzz." Many of the other Crips started calling each other Cuzz, and it wasn't long before the Crips began using this expression in their slang, drawings, and graffiti. The words Cuzz and Crips became synonymous. In addition to the designated names, specific colors became absolute identifiers: Crips were blue; Bloods were red.

The Bloods and Crips began staking out their own territory and moved in on any intruders who looked like bangers from a different hood. Gunfights erupted spontaneously, and when casualties resulted, drive-by retribution usually followed. Both gangs recruited vigorously, and as their ranks swelled, other subgroups broke off from the parent gangs to form their own sets. By the mid-1970s, Blood and Crip sets dotted the entire area. The East Coast Crips (ECC), so named because their hood lies east of the Harbor Freeway, began to spread their influence throughout the entire area. A myriad of ECC sets evolved, which would eventually extend from downtown L.A. all the way down to the L.A. harbor area.

At first, all Crip sets got along with each other and regarded only the Bloods as the enemy. This was short-lived, however, as disputes between gang members from different

Crip sets began to surface. Fighting over women, reefer rip-offs, and the usual conflicts common among law breakers worsened. Gunfights became commonplace.

Two Crip sets, the Eight Tray (sic) Gangsters and the Rollin' Sixties, went to war in the 1970s. This war, which has claimed hundreds of victims over the past three decades, resulted in a split of the Crip community, with most other Crip sets choosing sides and, in so doing, declaring war on opposing Crips. By the late 1990s, more Crip casualties had been inflicted by other Crips than by Bloods.

Crack cocaine appeared on the scene during the 1980s, and this product provided the driving force that would embroil south central Los Angeles in a money-grabbing frenzy that turned the area into a battle zone, claiming thousands of lives in less than two decades. No longer did Crips and Bloods have to battle solely on the basis of turf or colors, they now had a highly addictive drug and a multitude of eager addicts, a combination that promised to bring unheard of riches to those in control. And control could only be achieved through violence.

It had been learned that freebasing cocaine with common baking soda produced small rocks that could be smoked, rewarding the user with an instant feeling of euphoria and omnipotence. This instant high was the gratification that quickly hooked the user, but it was offset by the short-lived duration of the high, which lasted merely 20 to 30 minutes. To stay high long term, the addict was compelled to keep smoking rock after rock. And even though the individual rock could be purchased relatively inexpensively, a day's or week's supply could not. Burglary, robbery, fencing of stolen property, and similar crimes skyrocketed throughout the area.

Crips and Bloods became the controlling distributors of the drug, staking out their individual territory with wallbangin' (graffiti) and fortifying their hoods, some of which took on the look of armed encampments. Rapid-fire weapons replaced cheap handguns. Underground armies developed their own supply routes along with street level dealers, soldiers, runners, informers, collectors, enforcers, and counterintelligence people. Nighttime was for "puttin' in work, bangin', slangin' (drug dealing), and killin'."

As the riches poured in, every neighborhood gang became embroiled in a war for control of the drug traffic. It was all about "clockin' dollars," or stockpiling vast sums of money; acquiring flashy cars and women, jewelry, high-tech weapons, and new homes reinforced with steel panels and wrought iron; and living life in the fast lane. The lifestyle gave rise to Crip and Blood godfathers—millionaires before they turned 30. Some of these Original Gangsters (OGs) became so powerful that they dealt directly with the Colombian drug cartels. One of these godfathers, at the time of his arrest, was alleged to be distributing up to one ton of crack cocaine a week out of his Los Angeles operation.

Countless numbers of gang members were killed, injured, or ended up in prison. Crips in California prisons eventually hooked up for protection, in either the Consolidated Crip Organization or the Hoover Connect (HC). Past enemy situations between various Crip sets on the streets were set aside behind the walls, yet most of these gangsters continued to wear their specific street gang tattoos. The Bloods, who traditionally had much less infighting among their own sets, hooked up with the United Blood Nation (UBN) in West Coast prisons.

The Crips and Bloods Today

Third-generation black gang members are now emerging as today's lil' gangsters. Peewees start out before their teenage years. These up-and-coming bangers are often used as mules or shooters or assigned other duties in order to insulate the OGs from California's "three-strikes-you're-out" law.

Black females in south central are now forming their own gangs and are becoming as violent as the males. The Crip and Blood notoriety has spread to other U.S.-based ethnic gangs, who use the name thinking it will intimidate their enemies.

Crips and Bloods continue to kill each other over colors and encroachment of each other's

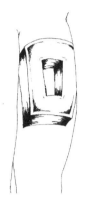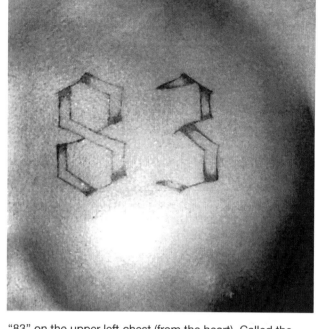

"60" on the back of the upper arms stands for. The Rollin' 60s Crips, a long-standing enemy of the Eight-Tray Gangsters. The Sixties (called the Sissies by their enemies) claim a large territory west of Western Avenue, stretching roughly from 52nd Street on the south up to 10th Avenue. To the west their turf ends near Crenshaw Boulevard. The reader should be advised that the 60s are not confined to California. Las Vegas and many other Western states are also home to the 60s.

"83" on the upper left chest (from the heart). Called the Eight-Tray (sic) Gangster Crips, this set holds down (claims) a large area of south central L.A., extending roughly from 67th Street on the north side down past 83rd Street and terminating at Century Boulevard to the south. To the east their turf stops around Vermont Avenue; to the west, Western Avenue. Across Western Avenue, which is termed the First Parallel, lies enemy territory, turf held down by the Rollin' 60s.

territory; however, most killing now appears to be behind drug sales, rip-offs, and retribution. There are no limits to the violent street crime Crips and Bloods engage in.

Some sources indicate Crips are trying to hook up with the Gangster Disciples, while the Bloods are hooking up with sets from the People Nation. The Crips and Bloods have a long history of crossing over (set jumping) when beneficial. (Set jumping among black gangbangers is not uncommon. This can occur within the Crip and Blood communities, as well as between them. This may happen when the banger is "slangin'"—or selling dope—or when he has been forced to move into enemy territory and agrees to "put in work" for the local gang.)

A gangster's affiliation with the Crips or the Bloods or a specific set thereof is generally shown in some obvious way, such as a red or blue bandanna hanging from the rear pocket.

However, not all Crips and Bloods identify with the colors blue and red. For example, the Lime Hood Pirus identify themselves with green and red, and the Watts Varrio Grape set identifies with purple. Other indicators of gang affiliation include articles of clothing, hair ties, or a pick (comb) protruding from a pocket, and specific brands of shoes, i.e., British Knights (BK—Blood Killer) and Calvin Klein (CK—Crip Killer). Tattoos are specific to the knowledgeable gang investigator. The name of the specific set is seen most often, as is the wearer's moniker.

There are scores of Los Angeles-based Crip and Blood sets. Some have been around since the inception of the phenomenon. Others have appeared, banged for a while, and then faded out of the picture. The following illustrations are only a small sampling of the sets that have survived to this date.

"RSC" for Rollin' 60s Crips.

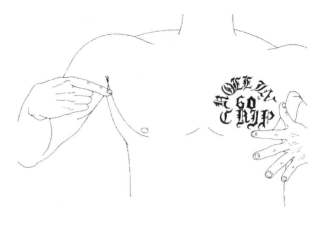

Rollin' 60s hand sign (5–1) and "Rollin' 60 Crip" tattoo.

"43—L.A. 213" on the subject's upper back. The Four-Trey Gangster crips hold down an area neighboring 43rd Street in south central L.A. Seen often with L.A. gangbangers, 213 is a Los Angeles telephone area code.

"Compton" and "ES"—Compton Corner Pocket Crip. Compton is an incorporated city adjacent to south central L.A. The "ES" stands for East Side.

This tattoo of Grape St. and a clump of grapes is specific for "Watts Varrio Grape"; "LA" is for Los Angeles.

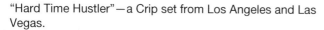

"Hard Time Hustler"—a Crip set from Los Angeles and Las Vegas.

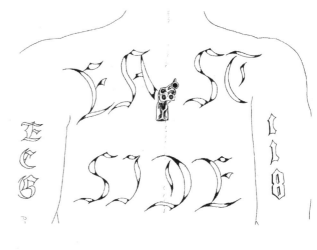

"EAST SIDE" on the upper back with "ECG" (East Coast Gang) and "118" on the back of the upper arms announces that the subject is a member of the Eleven-Eight Gangster Crips. The Eleven-Eight (118th Street) is one of the most pervasive sets in south central L.A., holding down turf from 1st Street in downtown Los Angeles extending as far south as 225th Street in the harbor area. The Eleven-Eight is an "East Coast" Crip set. (In south central L.A., Crip sets located east of the Harbor Freeway claim East Coast; those west of the freeway claim

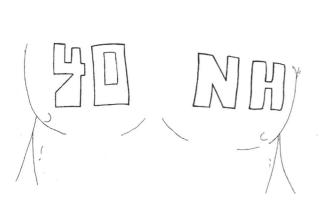

"40" and "NH"—Rollin' 40 Neighborhood Crips, San

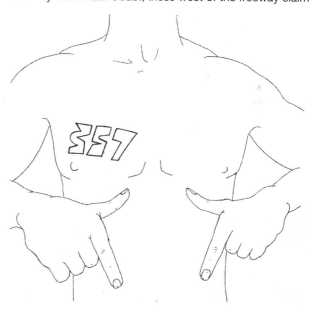

Many sets identify with a number as well as a name. Most of these numbers are taken from street addresses, mainly in housing projects. The "357" on the right chest identifies the wearer as a member of the "Sin Town Crips," Pomona, California. The hand sign is two sevens.

"Dub Life" translates into White Street Mob (Dub=W), an African American Crip set based in and around White Street in Las Vegas. The right hand is throwing up a W; the left hand, an M.

"BTD"—Bite the Dust Crips, Las Vegas. The "101" stands for fighting one on one.

Fruit Town Piru is a Los Angeles Blood set.

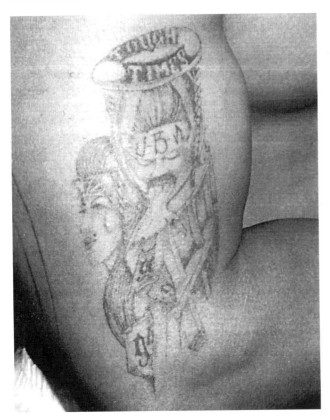

"UBN" (United Blood Nation) tattoo on the upper arm of a prisoner.

"GBC"—Garden Block Crips, Sacramento.

UBN (United Blood Nation) and "PIRU," for the street gang, tattooed on the abdomen.

FOLKS NATION AFFILIATES

Black Gangster Disciples (BGD)

The largest and most notorious gang of the two "nations" is the Black Gangster Disciples of the Folk Nation, which was formed in the early 1960s by David "King" Barksdale. The BGDs were arch-rivals of the Blackstone Rangers, a violent Chicago street gang. Barksdale was ultimately shot to death in a fight over control of drugs. During the preburial rites, one of his followers cried out in a last show of respect, "King David!" This moniker took hold, and the group subsequently adopted the 6-point Star of David, from the Hebrew religion, as a primary indicator.

Several factions broke off from the main group after Barksdale's death, and the parent gang was allegedly taken over by another "king," Larry Hoover. Hoover put the pieces together and is generally given credit for molding the gang into a structured organization. But his freedom was short-lived. Getting deeply involved in criminal matters, he was subsequently convicted of murder and sent to prison. As of this writing, he has been confined for more than 20 years. Despite the long prison tenure, he has allegedly continued to run the Disciple empire.

By the late 1990s, Disciple membership had grown in number, and by the turn of the century authorities estimated its strength to be in excess of 30,000 members (other sources estimated membership nationwide at closer to 100,000 in 2000). The BGDs are regarded as one of the most sophisticated gangs in the United States, with drug sales estimated to be in excess of $100 million a year. In contrast to the loosely structured Crips and Bloods of the West Coast, the BGDs are rigidly organized, well disciplined, and loyal.

Larry Hoover allegedly sits at the head of the BGDs as chairman. Below him are two "boards of directors," one of which controls all street operations while the other oversees the equally lucrative prison rackets. Below the directors are about 15 "governors," who are charged with overseeing the regional operations in hundreds of franchised territories. These regional bosses are further subdivided into "regents" and "coordinators" who, at the street level, distribute drugs and weapons, command the security forces, and ensure all taxes are duly collected and forwarded up the chain of command. Under their command are the "enforcers" and "shorties." The enforcers are there to ensure discipline and impose fines against disciples who break the rules. Punishment may be anything from fines on up through beatings and murder. Shorties set up drug deals and configure armed posts to fortify strategic gang turf.

On May 9, 1997, Larry Hoover and six members of the BGDs were convicted in federal court of running a nationwide drug ring. Many of Hoover's trusted aids, including a former girlfriend, testified against him, helping the feds secure the conviction. Other evidence was gathered when authorities placed

paper-thin microphones inside visitor passes, which picked up conversations during routine prison visits with Hoover and some of his henchmen. With the additional sentence, Hoover, who has been incarcerated for more than half of his life, should remain imprisoned well into the 21st century.

While Hoover continues to run things from inside prison, his right-hand man on the outside, Wallace "Gator" Bradley, allegedly supervises street operations. Bradley may best be known for his attendance, along with Jesse Jackson, at an amiable meeting chaired by President Bill Clinton in the Oval Office.

Black Gangster Disciple Bylaws

1. All members shall abide by the code of secrecy and silence.
2. Every member should believe in respect and no disrespect to every member and non standing members.
3. No member shall take any property from any other member or non standing member.
4. No member shall take any addictive drug.
5. No member shall break and enter any building which may cause institutionalization.
6. All confrontations with any other members or non standing members will be reported through the proper chain of command whether major or minor.
7. No member will argue with any officers or guards.
8. No member shall gamble unless all merchandise is up front.
9. All members must pay dues.
10. All members are requested to have personal hygiene.
11. All members are required to exercise daily.
12. All members are required to aid and assist when asked to.
13. All members must participate in all meetings and gatherings.
14. No member shall participate in homosexuality.
15. All members are required to be on the money.
16. All members are required to uphold all laws set forth.

Recent Intelligence on the Gangster Disciples

- *Leadership:* Hoover continues to maintain shaky control over the organization, but since January 1997 more than a dozen murders and other shootings have erupted as Gangster Disciples battle over leadership.
- *Political clout:* Twenty First Century VOTE (Voices Of Total Empowerment) is a voter-registration effort directed by the Gangster Disciples. It has been instrumental in adding thousands of youthful black men and women to the voter rolls. Voting blocs like this have been a source of support for local ward-level politicians.
- *Other names:* "BGDN" stands for Black Gangster Disciple Nation, although Bradley insists that "BGD" stands for "Better Growth and Development," a civic organization. Tens of thousands of Gangster Disciples on Chicago's South Side go under the name Brothers of the Struggle (BOS). "KD" (King David [Barsdale]) and "KH" (King Hoover) are also common.
- *Ideology:* They try to project a legitimate image of speaking for the masses; however, the GDs have left a great deal of violence and bloodshed in their wake throughout their long-standing history of criminal activity.
- *Recruitment:* At one time, the Black Gangster Disciples admitted only African Americans. They have since relaxed this requirement; white and Hispanic youths are now part of the nationwide Gangster Disciples.
- *Colors:* Blue and black.
- *Criminal activity:* No criminal act is exempt, but drug trafficking, weapons, and money laundering are at the top of the list. The GDs have one of the largest networks of franchised criminal territories in the nation.
- *Allies and enemies:* Gangster Disciples get along well with most other Folks Nation sets and are generally enemies with People Nation sets (although at times the GDs cooperate with these "off brands" when it

A Gangster Disciple tattoo. The heart, wings, upright pitchfork, crown, and devil's horns and tail in this configuration, placed on the subject's right chest along with the six-point star, strongly suggest gang membership. The heart stands for the love of the Folks Nation; the wings, the lifting up of the nation; the pitchfork, the nation's ability to overcome oppression; the crown, the leadership and acknowledgment of the nation's chairman, or king; the devil's tail, the oppression that all nonwhite people suffer; and the devil's horns, the Disciples' determination to overcome all obstacles. The six-point star, which is also seen as a single tattoo, represents the concept that there are six sides to everything, instead of two sides, as is generally believed. It represents the members working up and down, two and from, and within and without. It also stands for "organization within our nation." Starting from the uppermost point and working clockwise, the six points stand for life, loyalty, knowledge, wisdom, understanding, and love.

The heavy BGD on the abdomen, along with the upright pitchfork, is highly suggestive of Black Gangster Disciple membership. The six-point star with the letters BOS below and the number 720 above further corroborate validation. The 720, a BGD identifier, covertly doubles the circumference of a circle. And the circle, which has mystical powers, holds dual meanings for the BGDs: it denotes 360 degrees of available knowledge, and it foretells that black people, who once ruled the earth, will do so again. The 720 also stands for the third world, six-point organization, and, borrowing from the six-point star, stands for love, life, loyalty, and educational, economical, political, and social development.

promises to be advantageous in money-making situations).

- *Tattoos and other identifiers:* Six-point star, a heart with wings, upright pitchforks, the initials BGD, GD, BGDN, or BOS and the numbers 360 and 720. In general, any tattoo or graffiti that displays a gang symbol upside down, broken, or backwards is a statement that shows contempt and disrespect to whoever rides under that symbol. All Folks Nation gangsters identify with the right side of the body: the right hand is raised in greetings, an earring is worn in right ear, tattoos are inscribed on the right side and suspenders or overalls are worn with the right strap over the shoulder and the left strap hanging down (which disrespects the People Nation, whose members identify with the left side). Gang designs cut in the right side of the hair or slits cut in the right eyebrow are also seen. Colors are predominately black and blue.

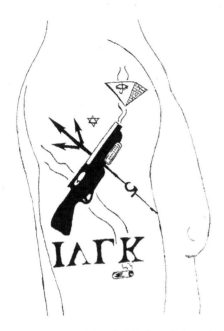

In this tattoo, the upright pitchfork and six-point star indicate a BGD gang member. Further corroboration is gleaned from the put-down of an enemy, the Insane Vice Lords (IVL) of the People Nation. This is evidenced by the upside-down pyramid, which has been smoked by the shotgun, and the inverted IVLK, which stands for Insane Vice Lord Killers. The upside-down 5 on the lower shaft is another put-down. A smoking cartridge is seen below.

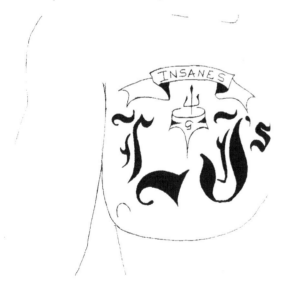

This tattoo belongs to a gangster from the Latin Jivers. The Latin Jivers are a Chicago-area gang riding under the Folks Nation. This is evidenced by the upright pitchfork. In this tattoo, the Jivers are putting down their enemy, the Latin Kings (LKs), by inverting the three-point crown (a Latin King symbol) and the 5 (another LK and People Nation symbol). "Insanes," which is used by many gangs, means "we're crazy enough to do anything."

The El Rukns

The El Rukns date back to the 1960s, when they were known as the Blackstone Rangers, a marauding Chicago street gang from the area of 65th Street and Blackstone Avenue. The gang was led by an elementary school dropout, Jeff Fort. After several years of street crime and bloody gang fighting, Fort emerged as a natural born leader. He was able to convince other street gangs in the area to form into one large criminal organization. The end result was the Almighty Black-P-Stone Nation, an expansive brotherhood comprising gang members from scores of Chicago street gangs.

Under Fort's direction, this new organization developed a rank system and a "commission" known as the Main-21. Its function was to supervise the gang's activities. The Black-P-Stones soon grew to become the most pervasive crime group on the south side of Chicago.

Shifting into the realm of politics, the Black-P-Stones sought and received a charter sanctioned by the state of Illinois as the Grassroots Independent Voters. Next, the group received a $1 million grant from the Office of Economic Opportunity as a pseudo grassroots learning program. This questionable grant became so malodorous that in 1968 a senate investigation into the gang's operation followed. Subsequently, Fort was convicted of contempt of congress and embezzlement and sent to prison.

In prison, Fort continued his organizing skills and founded the El Rukns, which he claimed was a Moorish religion, and took the title Prince Malik. His cohorts outside the walls renovated a former theater on Drexel Avenue in Chicago and established the group's headquarters, known as the Grand Major Temple. After two years, Fort was released from prison and returned to his old ways.

In 1982, Fort was convicted of conspiracy to distribute cocaine and went back to prison to do 13 years. There, he continued to run the El Rukns.

In late 1985, the El Rukns made an attempt to legitimize many of their soldiers as security personnel, which would have allowed them to

carry concealed weapons. They set up a dummy corporation named Security and Maintenance Services (SMS). This caught the attention of the FBI and the Bureau of Alcohol, Tobacco, and Firearms (BATF), which formed a task force along with officers from several local jurisdictions to set up a sting operation. On June 19, 1986, the task force rolled in on the SMS offices and arrested 18 followers for various gun violations. Meanwhile, Fort had been monitoring other happenings in the Muslim world. Word on the street was that Louis Farrakhan, leader of the Nation of Islam, received $5 million from Libya's Moammar Gadhafi. And Gadhafi was also said to be recruiting U.S. citizens, specifically Black Muslims, to commit acts of domestic terrorism in the United States. Fort ordered a few select members of the El Rukns to travel to Libya and meet with Libyan military officials.

The actions of the El Rukns had been well monitored by the FBI, and in 1987, Jeff Fort and several of his "generals" were indicted by the federal government on charges of conspiracy to commit terrorist acts in the United States. Some within the El Rukns rolled over and became witnesses for the state. Fort was found guilty and sentenced to 80 years in federal prison. The ones who didn't roll over were given sentences similar to Fort's.

One of those indicted, Edward Mays, had purchased a LAW (light anti-tank weapon) from an FBI undercover agent but managed to elude the police dragnet and vanish into the underworld. On February 7, 1989, he was placed on the FBI's Top Ten Most Wanted List. He hid out until March 9, 1995, when he was apprehended by members of the FBI's Chicago Joint Terrorism Task Force and charged with 40 federal counts of conspiring to commit domestic terrorism on behalf of the Libyan government.

By the late 1980s, the El Rukns had begun to crumble. Their religious temple on Drexel Avenue was torn down by the city; most of its hierarchy had been sent to prison, and informers from within had created an air of suspicion and distrust among the other members. Today, the El Rukns have lost most of their power, and only a few diehards remain. (*United States v.*

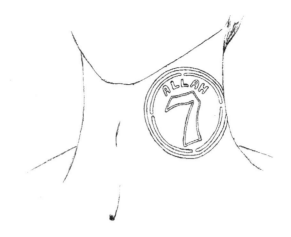

This tattoo is specific to El Rukns. Allah, the Muslim god, watches over the number seven, which stands for the seven acts/prayers of the holy Quran (Koran). The circle, which has no beginning and no ending, signifies 360 degrees of knowledge, wisdom, and the understanding that black people once ruled the earth and will do so

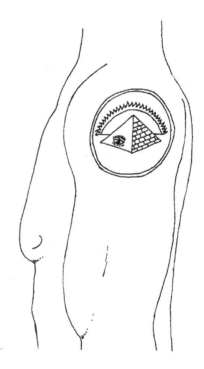

The encircled pyramid showing the eye of Allah and the blazing sun is another El Rukn symbol (also adopted by the Vice Lords and other People Nation gangs). The pyramid is said to have been built by black people under the watchful eye of Allah and is shown here to puzzle the white man, who has never been able to adequately duplicate or explain its construction. The sun symbolizes the rising of truth in the black nation, as well as freedom, reality, strength, energy, and growth.

McAnderson, 914 F2d 934, 7th Cir., 1990.)

In 1988, Fort and three of his followers were convicted of the 1981 murder of a rival gang member, Willie "Dollar Bill" Bibbs, over drugs.

El Rukns today identify with the colors black, red, green, and gold. Common tattoos are a five-point star (which translates into "Five alive, six must die," a reference to Folks Nation gang members who use the six-point star as their chief identifier), the number 5, a pyramid, the eye of Allah, a crescent moon, the number 7, the sun, and a circle.

The Vice Lords

The oldest of Chicago's street gangs is the Vice Lords, having formed in the late 1950s. Today, there are about 20 separate factions, the largest being the Conservative Vice Lords. Others include the Cicero Insane Vice Lords and the Unknown Vice Lords. The Vice Lords are strongly allied with the Latin Kings, as well as some of the other gangs that ride under the People Nation. They regard the Gangster Disciples and other Folk Nations gangs as the enemy.

Vice Lord identifiers include the colors black and gold and any of the following tattoos: a five-point star (which represents the Vice Lord Nation and its affiliates and stands for their belief in love, truth, peace, freedom, and justice), a top hat (which represents shelter for the Vice Lords), opposing crescent moons (which represent the splitting of the black nation into two halves, the east and the west), a pyramid (which represents the mystery of the construction of the pyramids, which were built by African people and have three points, representing mental, physical, and spiritual strength), a champagne glass (which stands for celebration and class), a staff or cane (which stands for strength and, if shown protruding from the top hat in graffiti, means the Vice Lords control the area), a Playboy bunny with straight ears (which represents awareness and quickness as Vice Lords), 312 (the Chicago area code), and inverted pitchforks (a putdown of Folks Nation gangsters).

NONAFFILIATED BLACK STREET AND PRISON GANGS

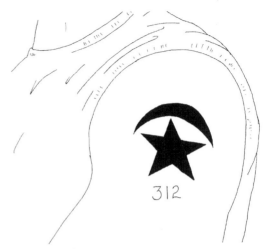

The crescent moon and five-point star and "312" (the area code of Chicago) are all Vice Lord indicators.

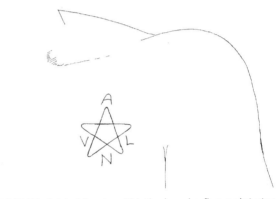

AVLN (Almighty Vice Lord Nation) and a five-point star.

The sideburn shaped like a crescent moon on the left side of the face is a specific Vice Lord indicator.

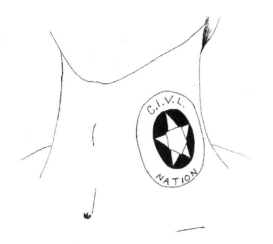

A specific tattoo of the Cicero Insane Vice Lords—an offshoot and ally of the original Vice Lords.

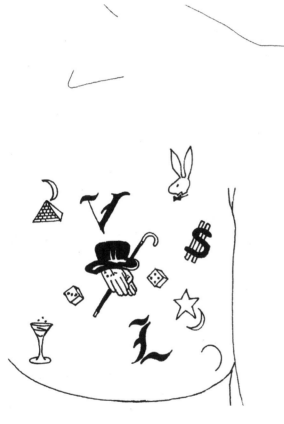

This tattoo on the left chest of a Vice Lord gangster displays most of the gang's symbols. Among them, the number seven displayed on the dice represents the seven acts/prayers in the Koran, and the dollar symbol represents the wealth to be accumulated by the Vice Lords.

NOTE: The above tattoos are not specific to the Vice Lords; they were also used by the El Rukns. When the feds busted up the El Rukns, many of the members who wished to remain active hooked up with their staunchest

Some of the Las Vegas-based street and prison gangs do not affiliate with the Crips or the Bloods. Others have a history of crossing over repeatedly, alternately aligning with one or the other.

The Anybody's Murderer (ABM) claim neither Crip nor Blood. They profess to be hired killers, willing to take a contract on anybody if the money is right. They have come under close scrutiny by the federal authorities many times because of drug trafficking, gun running, and money laundering.

The Gerson Park Kingsmen (GPK) are the oldest established black gang in the Las Vegas area. Their history goes back nearly three decades to when they were known as the Ace of Spades, which, at the time, was also an amateur basketball team. They have been aligned with both Crips and Bloods during their tenure. The most recent affiliation has been with the Bloods during the West Side vs. Northtown gang war. Once a member has put in the required work (drive-by shootings, etc.), he is awarded the GPK crown (a tattoo of a 3-point or 5-point crown). They have a saying, "Stay down and earn your crown."

As mentioned in Chapter 1, the Black Warriors were a violent Nevada prison gang during the 1970s and 1980s. They were housed mostly at the Nevada State Prison in Carson City, which was at that time a maximum security facility. Many of their original members had been affiliated with the GPKs on the Las Vegas streets. They self-destructed in

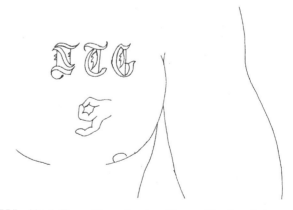

"NTG"—North Town Gangster, Las Vegas. The hand sign tattoo shows a "G," which is NTG specific.

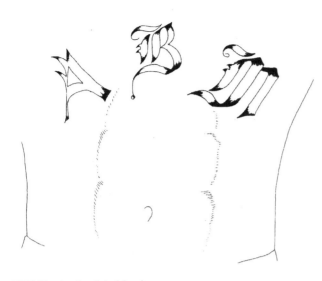

"ABM"—Anybody's Murderer.

A GPK gang member throwing up a "K" for Kingsman and a "W" for Westside. The "369" is taken from the street address of a housing project where many Gerson Park Kingsmen reside and is often used as an identifier in their graffiti and tattoos.

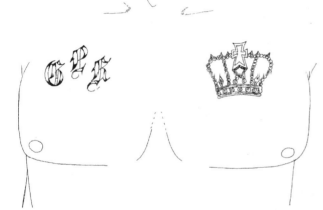

The crown on the left chest of a GPK member, which confirms he has put in work and has been awarded the

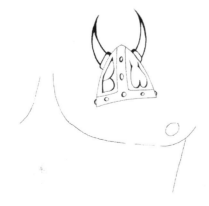

Horns of the Black Warriors on the upper left chest.

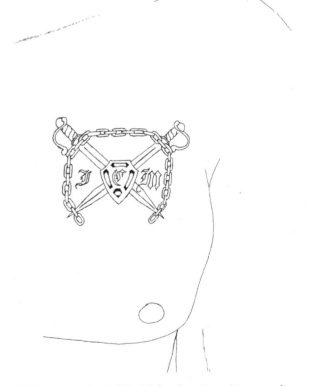

"ICM"—International Crip Mafia. An attempt to organize Nevada State Prison Crips under ICM started during the mid-1980s but failed. Only a handful remain.

CHAPTER 4
HISPANIC GANGS

Hispanic gangs, at one time found only in the southwest and in California, can today be found in virtually every major city across the United States. Diversity abounds.

In East Los Angeles, many Mexican American street gangsters proudly boast of a family lineage in the same gang (e.g., Temple Street) that dates back at least 80 years. On the East Coast, the prison-based gang ÑETA, whose outside tentacles now stretch from New Hampshire down to Florida, has a membership consisting primarily of Puerto Ricans, with scattered Cubans and other Caribbean island immigrants.

ÑETA and Temple Street, both of which are classified as Hispanic gangs, have little in common. The Temple Street Gang, named after an East L.A. street around 1920, has never expanded far beyond its origins. ÑETA, on the other hand, which was formed in Los Marbinos Prison in Puerto Rico in the mid-1970s, has now reached into prisons and cities along the entire East Coast shoreline. (For more on ÑETA, refer to Chapter 1: Prison Gangs.)

In the Midwest, with the exception of the Latin Kings, the Hispanic gangs are primarily street gangs comprised mostly of Mexican and other Central American immigrants.

Unlike most white gangs, the Hispanic gangs (and, to a lesser degree, the blacks) have histories of violent inter-gang wars that go back decades, e.g., the 40-year-old war between California's northern and southern Hispanics. And there seems to be no end to this bloody conflict. Gangsters from both regions continue to perpetuate this war and brazenly show loyalty to their chosen gang by the tattoos they proudly display.

HISPANIC GANG TATTOOS

Many Hispanic gangbangers have a flair for artistry. This is evident in their street graffiti, pen-and-ink drawings (*dibujos*), script lettering, and tattoos. Street tattoos in the Hispanic barrios, as well as in prison, rival any of those done in licensed parlors.

After being jumped in, the Hispanic gang initiate takes great pride in enduring the painful process of having the gang's name tattooed in shaded script somewhere on his or her body. (In many instances, the gang tattoo is inscribed on the head or neck as a show of courage, since the wearer knows that, in addition to drawing admiration from fellow gang members, it will also serve to challenge and provoke enemy gangsters into battle.)

And since all gang members are known by their monikers, the initiate will also take pride in having his or her moniker tattooed along with the gang name, hometown, and indication of loyalty to northern or southern California.

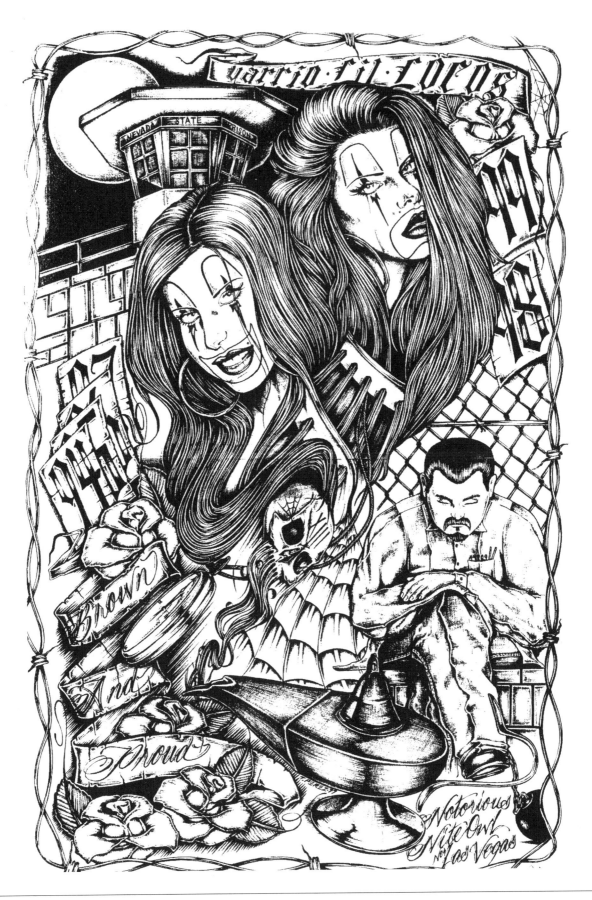

One or two generations ago, Hispanic gang members usually included tattoos of religious figures, such as Jesus on the cross, along with their gang-affiliated ink. With the exception of Our Lady of Guadalupe (the patron saint of Mexico), which is seen frequently on the backs and chest of Border Brothers, tattoos of religious figures have declined in recent years.

Today most Hispanic gangsters favor the pyramid-shaped three dots (signifying the phrase *mi vida loca*, or "my crazy life"), happy/sad faces ("mess with me now, be sorry later"), teardrops, spider webs, prison walls and gun towers, barbed-wire fences, flowers, butterflies, RIPs, and a girlfriend's or mother's name. Tattoos of low-rider cars and *vatos* (dudes with snap brim hats), the Mexican flag, and Aztec symbolism are also common among Hispanic gangsters. The arms of long-term prison inmates may be covered with overlapping tattoos (referred to as being "sleeved").

WEST COAST HISPANIC GANGS

Following the Mexican American War of 1846–1848, the Treaty of Guadalupe Hidalgo was formally drawn up, ratified, and signed by both nations. This controversial document effectively served to slash the Mexican nation in half. The vast expanse of land that now includes Texas, New Mexico, California, Arizona, Nevada, Utah, and half of Colorado, once under Mexican sovereignty, was handed over to the United States. Mexican citizens living in this newly ceded U.S. territory were given a year to decide whether they wanted to remain where they were and become U.S. citizens or move southward below the Rio Grande and retain Mexican citizenship. The majority of these people had been in place for generations, and leaving their homes was unthinkable. Upwards of 80,000 elected to stay and accept U.S. citizenship.

The land acquired by the Americans included immense, untouched gold fields, which also contained other rich mineral deposits, the finest agricultural land, hundreds of miles of coastline, and mountains abundant with timber and water. The Treaty of Guadalupe Hidalgo specified that property rights of the new U.S. citizens were to be honored, along with rights of worship and protection. However, when many of these Mexican American early settlers stood in the way of development or progressive expansion, they were forced to relocate. In their eyes, their land was now being overrun by foreigners speaking an uncommon language and quoting obscure laws. And worse yet, these pale foreigners were forcing them off their property, apparently with the full consent of the U.S. government.

While all of this was going on, the relocated border separating the two countries was left unattended. There was no police presence. The Mexicans were able to cross back and forth with complete freedom; papers were unnecessary. It soon became impossible to

Left: Many Hispanic prison inmates have an exceptional talent for doing pen-and-ink drawings (*dibujos*). This artwork was done by a Nevada State Prison inmate in his max lock-up cell. In the drawing, the artist pays respect to his Las Vegas street gang, the Lil' Locos. It also depicts the negatives of incarceration: idleness coupled with loss of freedom and a longing for women. Much information can be gleaned from carefully scrutinizing *dibujos* such as these. "Varrio Lil' Locos," the artist's street gang, is prominent at the top of the drawing. In the upper left corner, a Nevada State Prison gun tower is silhouetted against the full moon. The happy-sad expressions on the faces of the two women is a theme illustrated repeatedly in prison graffiti and tattoos. The meaning here is "smile now, cry later," or "mess with me now and be sorry later." Strands of the women's hair suggest prison bars. The numbers 94 through 99 indicate the years the inmate has been locked up. The number 13, which is a Sureño (southern California Hispanic) gang indicator, is shown on the face of the skull in Roman numerals (XIII) and also on the face of the clock, the hands of which point to 12 and 1. The placement of the roses on the lower left side (one above the other three) also indicates the number 13. "Brown and Proud" reflects racial pride. Spider webs in the lower center of the drawing symbolize being "caught in the web" (of prison). The inmate, who's back number (prison ID number) is shown above the shirt pocket, is seated in front of a prison fence, deep in thought, trying to deny the existence of the ball and chain attached to his right ankle. Aladdin's lamp is full of dreams of escape from the confines. Barbed wire rings the drawing, as it does the prison.
"Notorious Nite Owl" is the signature of the artist.

distinguish legal citizens from illegal aliens. To compound the problem, most of the migrants made no attempt to learn the English language, preferring instead to retain their native tongue. This migratory existence, coupled with the peculiar actions of the unpredictable Anglos, resulted in tight-knit families and acquaintances isolating themselves from others and grouping together in shared communities that were known as *colonias* (colonies). Each *colonia* developed its own personality and character, including descriptive names. Immigrants with common roots were made welcome. Outsiders with opposing views were not. Suspicion and, at times, outright hostility between *colonias* resulted.

By this time, gold had been discovered in California, and swarms of adventurers advanced upon the gold fields in the Sacramento valley. Many Mexican Americans, as well as other Spanish-speaking immigrants from Central and South America, followed. Opportunities abounded. Farm and ranch workers were in demand, as were railway laborers and skilled craftsmen.

San Diego and Los Angeles, with their orange groves and missions, had been the birthplace of generations of Mexicans who now viewed the invading migrants with apprehension and alarm. More *colonias* followed. Skirmishes between *colonias* increased. Most of the citizenry were peaceful people who wanted to avoid trouble. But others, chronic troublemakers ganging up in groups, frequently assailed members of other *colonias*. To protect themselves, the victimized people had to gather support from their neighbors and retaliate. And so in order to ensure the security of any particular *colonia*, acts of aggression, disrespect, or insults from residents of a different *colonia* had to be avenged. Thus, a pattern of abuse and retribution was established. This concept became ingrained in the Mexican American culture and was passed down through generations and ultimately grasped by today's ganged-up descendants. Also, certain codes or unwritten barrio laws were established:

- Do not trust the police; take care of business yourselves.
- Maintain a code of silence; do not inform on others.
- Any criminal behavior or insult directed against members of the *colonia* must be avenged.

All of the inhabitants of any particular *colonia* respected one basic precept: they could travel to other areas and raise havoc but could commit no criminal acts within their own districts. Their *colonias* had to be protected and made safe for all who lived there. This scenario gave birth to today's Hispanic gang scene in the western United States.

Colonias with a large number of youthful troublemakers became known by names usually taken from a geographical or other noticeable feature (e.g., La Loma, Las Llanas, etc.). Stylized dress of the inhabitants also served to identify specific neighborhoods. Gradually, these *colonias* became known as *barrios*, which means "districts" or "neighborhoods." Early attempts at marking off territory (using graffiti) were beginning to surface, serving as a warning to others to stay away.

In 1910, Mexico was again thrust into a period of warfare and bloodshed. The Mexican Revolution erupted, pitting peasants, natives, mestizos, and others against wealthy landowners and government officials. Thousands of refugees fleeing this conflict streamed northward and into the area now occupied by hundreds of established barrios. Ranchers, farmers, and wealthy railroad and shipping magnates welcomed them as a source of cheap labor. But to the established Mexican American barrio inhabitants, these ragged newcomers were nothing more than *mojados*— wetbacks. Thus, the *mojados* were greeted with discrimination, derision, and hostility by people with whom they shared common roots. They soon shied away from the locals and banded together with those who had emigrated with them, forming their own makeshift barrios.

Early in the 1920s, Los Angeles developers and city officials prepared to develop a large plot of land in greater L.A. The only thing

Tattoo of an H and M on the chest of a prison inmate from Hoyo Maravilla.

This tattoo on the back of a prison inmate pays homage to one of his ancestors who fought with Francisco "Pancho Villa" during the Mexican Revolution of 1910–1911. (Thanks to Lo from Diamond Street.)

standing in the way were hordes of immigrants encamped in shabby huts that dotted the entire area. These *ocupantes ilegales* (squatters) were offered their own land for next to nothing in a less desirable part of the city as an enticement to relocate. They gladly accepted the offer and exclaimed, *"Que maravilla!"* ("What a marvel!"). "We can own our own land!" Thus, the relocation area became known as Maravilla and became the birthplace of the Maravilla gangs, which eventually would claim more than a dozen chapters. Jose "Sluggo" Pineda, a street gang member from Hoyo Maravilla who was incarcerated at Deuel Vocational Institute in California during the late 1950s, is alleged to have been one of the original founders of the Mexican Mafia.

Pachucos, Zoot Suits, and the Sleepy Lagoon Murder

The 38th Street Gang had been well established by August 2, 1942, the date a young lad named Jose Diaz got drunk in East L.A. and ostensibly fell asleep on a road adjacent to a water reservoir referred to as the Sleepy Lagoon. What happened after that remains unclear, but the next morning Diaz was found dead on the road. He had suffered serious internal injuries and many broken bones. He had either been run over by a truck, or, as the investigation concluded, beaten to death. Confidential informants came forward and told the police that Diaz had been caught up in a gang war and had been murdered by members of the 38th Street Gang.

The ensuing investigation became something of a witch hunt. When it was over, 300 Mexican Americans had been arrested as suspects. Twelve were subsequently found guilty of murder; five others were convicted of assault (all verdicts were overturned on appeal). The notoriety given this case did two things:

1. Anglos came to regard most Mexican Americans as lawbreakers, which furthered discrimination.
2. Gang members strengthened their barrios and membership through vigorous

recruiting. Barrios previously devoid of graffiti were now staked out by gang *placas*. Many times the graffiti would also display a roll call, listing all the troublemakers' pet names (monikers). *Placas* were tattooed on hard-core gang members, ensuring a lifetime commitment.

The events of this period effected an accelerated increase in the number of Hispanic gangs in the L.A. area that lasted for decades to come.

During World War II, despite an enforced dim-out and severe rationing of gasoline and other commodities, Los Angeles came alive at night with vehicle and pedestrian traffic. U.S. servicemen, who were required to be in uniform at all times, crowded the area looking for women and excitement. And one didn't have to look far. It was all there: nightclubs, bar-and-grills, tattoo parlors, wax museums, theaters, dime-a-dance joints, pawnshops, sidewalk vendors, and mobs of civilians, including pachucos with their pretty women dressed in tight skirts and sporting beehive hairstyles. Free-lance hookers abounded, ready to offer the servicemen a brief respite from the uncertainties of what lay ahead in the war zones.

The term *pachuco*, taken from El Chuco, which is a slang term for El Paso (Texas), described the Mexican American youth of the day, who effected a style of dress and manner that conflicted sharply with the accepted fashion. Dark hair, greased and gathered in back with a vertical part, duck-tail style, was one of their identifiers. Their clothing was strikingly oversized but clean and well pressed. Shoes were shined to a high gloss. Many also wore the identifying pachuco tattoo: a cross radiating three upward rays, usually seen on the web of the hand between the thumb and forefinger. For the pachuco who could afford it, a zoot suit was the ultimate form of expression. Fabric was in short supply and expensive, and the appropriate zoot suit required about three times the material necessary to make traditional clothing. To cover the head, a fedora (a felt hat with a lengthwise crease and a wide brim) could be purchased at specialty shops.

The oversized but well pressed long-sleeved shirts provided a backdrop for brightly colored wide ties. Baggy, well-creased pin-striped trousers were held high by wide suspenders while the bottom cuffs hugged the ankles (pegged pants). A matching suit coat reaching beyond the knees completed the array. Key chains, one end attached to a belt loop, reached down searching for the ankles and looped back up to terminate in one of the front pockets. What were not visible were the *fileros*—ice picks, switchblade knives (which at that time could be purchased legally in L.A.), and other homemade stabbing weapons—that were carried by many, concealed inside the baggy clothing. To the pachucos, the zoot suit provided a sense of admiration and identification and was symbolic of the wearer's rebellious expression.

At the other end of the spectrum were the well-conditioned military personnel with their close-cropped hair, razor-creased uniforms, and regimented lifestyle—including thousands of Mexican Americans who served with distinction during the war. Service personnel attired in the regulation uniform looked down upon the pachucos and zoot-suiters. To the squared-away military personnel, the baggy-clothed Mexican Americans were draft dodgers and thugs. And most of the civilian populace felt the same way. Civilians were 100-percent behind the servicemen and women and the war effort. Everybody was making sacrifices. Why should these draped-dressed thugs wear expensive, oversized clothing on the streets of L.A. when some of that material, in such short supply, could be used to shelter a desolate GI crouched down in a squalid fox-hole in some godforsaken foreign country?

As far as the citizens were concerned, the accepted uniform of the day was that worn by service personnel from all branches of the military. Nothing else was viable. After all, they reasoned, the men and women wearing the uniform of the United States were prepared to fight and die on foreign soil to save the world— and they expected others to do the same or at least make sacrifices. Support for the military ran high. Theaters, restaurants, and many other

sources of entertainment offered uniformed personnel discounted prices. Many families invited servicemen and women into their homes for meals and a back-home hiatus.

The only common denominator between the pachucos and service personnel was the wearing of highly polished shoes—an invariable mandated by the hierarchy of both sides. Everything else was a study in contrasts. Animosity boiled over into rage. Something was bound to happen. All that was lacking was the necessary spark to set things off. When the pachucos and servicemen passed each other on the streets, many times hard stares gave way to outright insults hurled by both: "What're you doing for the war effort, spic?" and the baiting response, "Keeping your girlfriends happy, puto."

By 1943, nearly all of the Hispanic gangs were confined within the boundaries of East L.A. Some had been there for decades, e.g., Maravilla, White Fence, and Temple Street, to name a few. For the most part, criminal activities were limited to burglaries, petty theft, car stripping, gang fights, and possession of *mota* and *chiva* (marijuana and heroin). Fighting between street gangs was frequent, the weapons of choice being chains, clubs, and knives. Other than an occasional zip gun, firearms were rarely seen.

On the evening of June 3, 1943, a group of sailors who had been out drinking and looking for women stumbled into a gang-controlled East L.A. barrio. Startled gang members and their *jainas* (caló, for girlfriends), lounging around their cars and lawns drinking beer, ordered the intruders out at once. The tipsy seafarers, admiring the dark-eyed girls, told them to go to hell. Gang members shouted to others inside their homes, who began spilling out into the street. As reinforcements gathered, shouts and insults were hurled by both groups. And abruptly the talking was overcome by piercing shrieks and hand-to-hand combat.

The Mexican Americans pounced on the outnumbered sailors, battering them into retreat. The bloodied naval personnel managed to escape, cursing and licking their wounds, but they vowed to return—and in much greater numbers. This hapless incident set off a growing wave of anti-Mexican American sentiment among the populace, which was still seething over the Sleepy Lagoon murder. A home-front war that would pit the military and naval personnel against the pachucos and zoot-suiters was about to start.

The next night, upwards of 200 naval and marine personnel armed themselves with baseball bats, socks weighted with ball bearings, and other handmade impact weapons and swarmed ashore. All available taxis were commandeered to carry the invasion force into the scene of the previous night's brawl. Spotting the first group of zoot-suiters, the screaming sailors attacked with a vengeance, beating and slamming the startled barrio residents into the dirt. Clothing was ripped off and shredded, mixing with the blood and urine pooling on the concrete sidewalks. Doors slammed shut and window blinds closed off the light as people locked themselves inside to avoid the madness. At this point, anyone who ventured outside, regardless of attire, was similarly beaten.

The sailors were consumed with destruction and intensified their rampage, overturning cars and smashing windows and streetlights. And then, in the distance, the wail of sirens pierced the night fog. Shouts arose among the rioters: "We got the bastards good this time, now let's get the hell outta here, the cops are comin'. Let's go, Mac! Fuck these assholes." One Mexican American, lying on the pavement with his head split open like a watermelon, moaned softly, "Why? Why?"

The first cops to arrive cautiously stepped out of their black-and-whites, grateful to see reinforcements of military police and shore patrol personnel screaming onto the scene, which was littered with broken liquor bottles, assorted rubbish, and wounded pachucos, now stripped of their identity.

The newspapers were quick to blame the Mexican Americans. Subversion was implied; some articles suggested the zoot-suiters had been taunting the servicemen by displaying Nazi regalia. Most of the populace agreed. Many of the pachucos quickly got crew-cut hairstyles and dressed conservatively. Others

continued to dress in their zoot suits and swore to avenge their homies. Isolated servicemen were attacked and robbed.

The battle lines had been drawn. Violent skirmishes broke out between the servicemen and pachucos in the ensuing weeks. And it wasn't just confined to L.A. proper. The Venice and Ocean Park piers were the scenes of bloody fighting, as was the Pike at Long Beach. Anywhere the military encountered pachucos, violence followed. The pachucos fought back. They ganged up in the barrios armed with knives, chains, and other homemade weapons, beating anyone who didn't belong. The barrios were becoming well-defended retreats. Outsiders were unwelcome, and this was not limited to the military. *Vatos* from other districts were met with hostility as well. Graffiti staking out barrio boundaries served to warn others that they were venturing into enemy territory.

In the end, Los Angeles was declared off limits to all military and naval personnel. The L.A. City Council hurriedly passed a decree outlawing the wearing of a zoot suit in public.

The pachuco movement, though, continued to expand. Inside the barrios, gang recruitment was stepped up. Male children coming of age had little choice but to gang up; indeed, many looked forward to it. Beer-guzzling *veteranos* continued to show off their zoot suits while bragging to wide-eyed youngsters of their fights with the military, but they rarely ventured out now while dressed down (wearing the stylized zoot suit). Even so, the pachucos and zoot-suiters of the day became the role models for generations of gang members who followed.

The name pachuco stuck. Today, it is a common moniker of many Hispanic gang members. The name is seen frequently in Latino-oriented magazines such as Low Rider and Teen Angels. San Chucos, a derivative, is the name of a multi-chaptered Hispanic gang in Las Vegas. Specialty stores in Los Angeles continue to rent and sell authentic zoot suits to Hispanic low-rider types.

Following the end of World War II, the government began using surplus war materials to erect emergency housing units in order to accommodate hundreds of thousands of

Pachuco wearing a zoot suit as seen on the streets of Los Angeles during World War II.

GANGS AND THEIR TATOOS

returning war-weary service personnel and their families. Other surplus military equipment was showing up everywhere. Among the most sought-after items sold by army and navy surplus stores was the military clothing that could be purchased for a fraction of its original cost. Gang members were quick to seize on this. Razor-creased, oversized khaki pants and shirts, navy P-coats, bomber jackets, sleeveless T-shirts, and highly polished jump boots became the uniform of choice for many of the Hispanic gangbangers.

During the next two decades, construction of new homes reached an all-time high. Veterans could buy a home for next to nothing down. Communities sprang up like mushrooms throughout southern California. Families reached out to the suburbs. Hispanic gangs, long entrenched in East L.A., were no longer confined to that sector. Graffiti began to appear in the outlying communities. El Monte, Covina, Pomona, Riverside, San Bernardino, and other cities to the east were now experiencing gang activity for the first time. Each gang staked out its turf by spray-painting its *placa* on any flat surface, e.g., El Monte Flores (EMF); Cherrieville (CVL) of Pomona; Perris Maravilla (PMV) of Riverside. Rivalries between gangs escalated. Sadly, firearms were becoming the weapons of choice. Previously, knives and chains had taken their toll during gang fights, but with few fatalities. Now gunshots were slaughtering the nation's young. The entire Hispanic gang scene had entered a new era—an era swimming in blood. It was all about ganging up to protect your barrio—often nothing more than a run-down apartment complex—and being bigger and meaner than your opponent.

The Aztec Connection

Many Chicano gang members born in the United States are proud to say they trace their distant lineage back to the pre-Columbian Aztecs, who were fierce warriors and practiced bloody human sacrifices. Tattoos, drawings, and literature used by many of today's gangsters reflect this racial pride. The Aztec

eagle and snake, borrowed from the Mexican flag, along with other depictions of Aztec culture, are seen with increasing frequency. In the 12th Century A.D., the Aztecs inhabited an area in the northern plains of Mexico called Aztlan. Aztlan was a lush area abundant with fishing, hunting, and harvesting. A complex of deep caves situated on the rim of a large lake provided shelter for the Aztec tribes. Sometime during this period, the tribes became nomadic and began to wander southward. It had been foretold that they would wander for decades until finally arriving at the place of their destiny. It would be in a valley that contained an immense lake, which supported a series of islands. This is where they would settle and establish an empire that would become one of the greatest in all of the Americas. The discovery of this site was to be revealed to them by the appearance of a sign.

As foreseen, in 1325, after their arrival in the Valley of Mexico where they discovered the predicted lake and islands, the sign they had been waiting for appeared: an eagle perched on a prickly pear cactus and feasting on the heart-shaped fruit of the plant (not a venomous snake, as substituted by the Spanish conquistadors two centuries later). The generations-old migratory existence had ended.

Within a century, the Aztecs would become master architects and builders of magnificent temples and sacrificial altars, along with awe-inspiring pyramids and palaces and floating gardens. Talented artisans worked gold, silver, and jewels into thousands of religious and ceremonial objects. Others harvested cotton that was woven into defensive shields for the warriors; high-quality, brightly colored clothing; and other materials. Featherwork was another craft. Within the government the emperor ruled, and below him sat the military, intellectual, and religious leaders. Rank was marked by clothing and adornments. Day-to-day events were recorded on pictographs and codices. An advanced system of irrigation and sewage disposal was developed. The Aztec capital was given the name Tenochitlan, which means "place of the cactus." Tenochitlan was situated on the present-day site of Mexico City.

As it expanded, the empire would eventually extend from the Pacific Ocean to the Gulf Coast and from central Mexico to what is now the Republic of Guatemala, and in the Americas would be surpassed only by the empire built by the Incas in Peru.

Despite their highly evolved government and advanced technology, the Aztecs were also fearless warriors who practiced human sacrifice on a scale unsurpassed in history. During prolonged ceremonies, thousands of sacrificial victims were slain and offered to the gods. The sacrificial victim was not looked upon as an enemy, but rather a messenger being sent to the gods. During a typical sacrifice, the victim, assisted by the priests, was forced to climb more than a hundred stairs to a platform atop a sacrificial altar. Once on top, he was placed face up on a large stone block. Here he was held down by the priests, who then began their incantation offering to the gods. The victim's screams and struggles ended abruptly when his chest was split open by one of those in attendance using a heavy obsidian knife. The still-beating heart was then ripped out and, along with the blood, became an offering to the gods. Body parts were subsequently placed in a giant stew pot where they were cooked and then offered to the Aztec warriors to eat as a source of strength and bravery.

All males within the empire were required to go into the Aztec army at age 10 for military training. The basic army units consisted of squads of 20 men each, which in turn were combined to form larger units of 400 equipped warriors. War was waged continually, not so much to capture more territory but to ensure a constant supply of captives to be used as sacrifices for the insatiable appetites of the gods. It was stressed that captives were not to be seriously injured so as to provide the gods with the most powerful sacrificial victims.

In combat, warriors were awarded medals (ceremonial shields, headdresses, bracelets, and shell or bone necklaces) for bravery in battle and for the number of captives taken. If he survived until the end of his career, the warrior could be awarded either the order of the Jaguar-Knight or the order of the Eagle-Knight,

Flag of the Mexica Movement. The Mexica flag represents the indigenous movement of the people of Anahuac: Mexican, Central American, and "Native American" of Aztlan (the area that encompasses California, Arizona, Utah, New Mexico, Texas, and part of Colorado).

Facing the illustration, the panel on the left is black, the panel on top is red, the panel on the right is blue, and the panel at the bottom is white. The symbol in the center is black and white, as shown, and is representative of the Mexica god Ometeotl. The four colors represent the four directions.

both upper military awards, and be permitted to wear the identifying war costume.

Cortez and the Spanish soldiers arrived on the shores of what is now Vera Cruz in 1519. When they ultimately entered Tenochitlan, they were awed by the splendor of the Aztec capital. Conversely, they were horrified at the Aztecs' practice of mass human sacrifice and set out to systematically destroy all reference to the practice. One of the first things they did was substitute the fruit of the prickly pear (as seen in the pictographs and codices of the Aztecs, which symbolized the heart of sacrificial victims) with the snake, which was the embodiment of evil. Thus, the eagle defeating the snake became the accepted symbol of the founding of Tenochitlan by the Aztecs and the one that is seen on the Mexican flag today.

Many of today's Mexican/Chicano gang members make liberal use of Aztec symbolism as a matter of self-admiration. This is seen in their tattoos, graffiti, drawings, and symbols. Many Hispanic gangs throughout the United States, including the Mexican Mafia, Mi Raza Unida, Mexikanemi, and others, use the Aztec eagle and snake, taken from the Mexican flag, as a symbol.

Many Mexican Mafia gang members in prison have learned the tongue-twisting language of the Aztecs, Nahuatl, and communicate in this tongue to confuse others.

The Mexica Movement

As stated, the Aztec people came out of the northern plains of Mexico from a region known as Aztlan. During the 12th century, for reasons that remain unclear, the Aztec people—known at that time as the Mexica (pronounced May-she-ka) or Tenocha—began wandering south, eventually settling in the Valley of Mexico, where they built a magnificent empire.

The Mexica explored all territories contiguous to their settlement and gave the entire region the name Anahuac, which means "the land between the waters." It is generally conceded that Anahuac stretched from what is now Mexico on down through the Yucatan and to what is now Costa Rica.

The Mexica Movement of today claims to represent "the original inhabitant people of Anahuac," who are the rightful owners of Anahuac as well as Aztlan. This would encompass all of the territory from Costa Rica up to and including the American Southwest, the territory ceded to the United States following the Mexican American War of 1846–1848.

Literature obtained from the Mexica Movement stresses that the indigenous people of Mexican descent, and not the descendants of the Spanish or other European peoples, are the only legitimate inhabitants of this land. They further denounce the terms "Hispanic" and "Latino," contending that these are derogatory terms that refer to Spain and not to the original inhabitants of Aztlan or Anahuac. Moreover, they denounce the term *la raza* (the people, the race), which is persistently used by Mexican

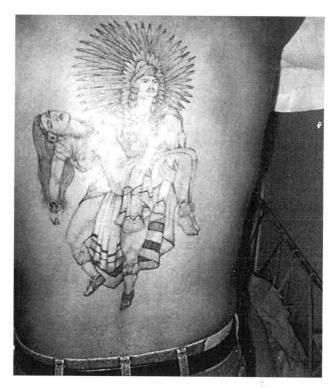

Tattoo on a subject's back depicting an Aztec warrior carrying a maiden.

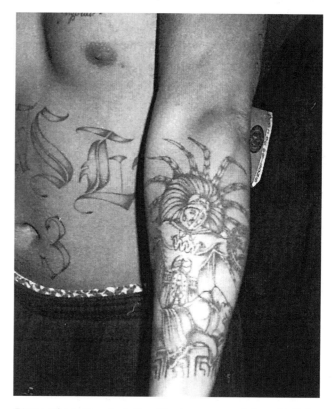

Photo of a tattoo depicting Montezuma, an Aztec chieftain who was the ruler during Cortez arrival in 1519.

American gangbangers and activists to express ethnic pride and solidarity.

The Mexica Movement further encourages Mexican Americans (and other Central American immigrants) to study Nahuatl and to drop their Spanish surnames and adopt names derived from this ancient language.

Many Mexican American gangbangers buy into the rhetoric of the Mexica Movement and have aligned themselves loosely with its cause. Often their tattoos and graffiti reflect this, incorporating Aztec symbolism and images.

- Red represents the east. Name: Tlaloc (Wine of the Earth).
- Black represents the north. Name: Tezcatlipoca (Reflecting Smoke).
- White represents the west. Name: Quetzalcoatl (Feathered Serpent/Precious Twin).
- Blue represents the south. Name: Huitzilopochtli (hummingbird of the south).

Sureños

The term Sureño, once used exclusively by Hispanic gangbangers in East Los Angeles, has since been adopted by tens of thousands of Hispanic gangsters nationwide and has spread well into Central America. Splashed around gang barrios as graffiti or worked into intricate tattoo patterns, the Spanish word means "southern," or "southerner."

Decades ago, when California Hispanics in prison broke off into two opposing factions—the southerners and northerners—and went to war, pressure was exerted against others of *la raza* to align with one group or the other. Sureños were, for the most part, comfortable in a prison-gang environment because the majority of them had been active gangsters in and around the barrios of East L.A. Gang warfare was a skill they'd learned from childhood.

The northerners, though, for the most part, were unsophisticated in gang ways and had values more closely related to agriculture and family. Prior to coming to prison, many had been active as farm workers and seasonal fruit pickers or worked at other mundane occupations. They were derisively referred to by the Sureños as *farmeros*—farmers.

In prison and on the streets, it became common for Hispanics to proclaim their allegiance to the north or south by the tattoos they carried. And through the years, far more Hispanic gangsters were down for the Sureños than for the Norteños. Inevitably, Hispanic gangsters who had never been to California were choosing sides and getting tattoos that read "Sureño," "Sur," or "Sur Califas" (southern California).

Today, some of the most pervasive Hispanic gangs—the 18th Street Gang, the Mara Salvatrucha, Big Hazard, and White Fence, to name a few, claim Sureño. This does not imply that all gangs claiming Sureño are allies. Many of these Sureño gangs are locked into wars with each other. However, when imprisoned, they are expected to unite in support of the Mexican Mafia, which also claims Sureño.

Sureños and the Mexican Mafia

As mentioned earlier, not all Sureños are Mexican Mafia members. In fact, quite the opposite is true. (To be initiated into the Mexican Mafia, a prospect generally has to kill or seriously injure a target selected by the Mexican Mafia leaders. Made mafiosos—including those imprisoned in both the California and federal prisons and those released back to the streets—probably number fewer than 600.) Sureños number into the tens of thousands. And becoming a Sureño is relatively easy. In southern California's gangland, a large percentage of the gangsters are simply born in the neighborhood and naturally follow their brothers (and now sisters), fathers, grandfathers, and great-grandfathers into the same long-standing gang. Others reach the gang by arriving with immigrant families that have relocated to the area. And if the area is southern California, Hispanic gang members will nearly all claim Sureño, as will sympathizers who may not necessarily be active in the gang.

Today, the Sureño phenomenon is no longer limited to southern California. Sureño/Sur/13 graffiti is widespread, and in California it can

be seen as far north as the Oregon border. States extending as far east as Washington, D.C., have reported seeing the same thing. This same graffiti is also seen in Mexico and other Central American countries. Most of these copycats have never been to California, yet by claiming Sureño, they are in effect choosing sides, aligning with the southern California gang scene. In Nevada, most of the Hispanic street gangs claim Sureño, whether in the southern part of the state or in the north. Reno and Las Vegas have scores of Hispanic gangs, most claiming Sureño, and as in Los Angeles, some of these gangs are at war with each other.

Gang members are very vain and deeply supportive of their gang affiliation. One of the best indicators investigators use to validate membership is the gang-specific tattoos seen on active bangers. The following illustrations are a sampling of some of these specific tattoos; however, there are hundreds more.

The 18th Street Gang

The area known to the Los Angeles Police Department (LAPD) as the Rampart Division, where the Santa Monica and Harbor Freeways intersect near 18th and Union, has become a haven for Mexican and other Central American

SOUTHERN HISPANICS

SUR=SOUTH SURENO=SOUTHERNER
KAN=SOUTH (Nahuatl) KANPOL=SOUTHERNER (Nahuatl)

13

THE NUMBER 13 IN HISPANIC GRAFFITI AND TATTOOS STANDS FOR SOUTHERN CALIFORNIA

IT MAY BE SHOWN AS

13
X3
XIII
TRECE
3'CE
CE--YEI (Nahuatl)

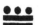

(Aztec Numerology)

Diagram of Sureño identifiers. The number 13 in Hispanic graffiti always indicates southern California. This is because the numeral corresponds to the letter M, which symbolizes the Mexican Mafia, whose founders, for the most part, were from East Los Angeles street gangs. Nahuatl is also used in Hispanic graffiti and tattoos: Kanpol is the Aztec word for Sureño; Kan means Sur.

At the bottom, the three dots above the two bars is Aztec numerology for the number 13.

"SUR" on chest and "Sureño" and "13" on left inner biceps.

"SUREÑOS" tattoo on upper back.

"SUR LS" stands for "Sur Locos." (Thanks Smokey.)

One of the first tattoos an Hispanic gang member gets is the three dots, which mean mi vida loca (my crazy life). These three dots are usually shaped like a pyramid and may be seen anywhere on the body or hands. The "X3" on the earlobe is a 13.

"XIII" on occipital scalp.

F-13 "Florencia," for Florencia 13, one of the oldest street gangs in East L.A

"Temple St." on the abdomen. Temple Street is another long-standing East L.A. street gang.

"WATTS" identifies the south central area of Los Angeles, without being gang-specific. This area was once predominately home to African Americans. Now, many sections have been taken over by Mexican immigrants.

Laying on of hands. This illustration depicts a prison *veterano* sponsoring a prospect (who was with White Fence before coming to prison) into the prison gang.

"WF" stands for White Fence of L.A. and Las Vegas. The gangster's hands are throwing up a W and F. White Fence is one of the oldest East L.A. Hispanic gangs, originating in the 1940s. In an area known as "Blueberry Hill," founding gang members used to hang out in front of a junior high school near where there was a white picket fence. The gang's name was coined from that innocuous white fence. This gang's Las Vegas chapter now has close to 300 members.

"North Town" on the subject's back refers to north Las Vegas without being gang-specific.

The Avenues is a violent East L.A. street gang; 213 is a Los Angeles area code.

Pacoima Pacas is a Hispanic gang in the Pacoima area of L.A., in the northeast San Fernando Valley. Note the variation of the happy and sad faces on the women in this tattoo.

"Califas," as shown on the neck of this subject, always means California and is often seen along with "Sur" or "Norte."

"Hazard Love" designates this gangster as a member of the Big Hazard Gang of East L.A. The emblem is taken from the biohazard symbol. The symbol on the right upper chest is Aztec numerology for the number 13.

"PSSLTS" translates into "Pomona South Side Locotes" (high on drugs) of Pomona, California, and Las Vegas, Nevada.

"BFTH" translates into "Boyz From The Hood," Orange County, California. The five-point star near the right elbow is used by Orange County Sureños. Few Sureños outside of Orange County use the star, which is regarded as a Norteño indicator. The "CE'YEI" is from the language of the Aztecs and means 13.

"PMV" stands for Perris Maravilla, Riverside County, California.

"AM" in script stands for "Arizona Maravilla" (Arizona Street in Los Angeles).

This Maravilla's tattoo includes a unique depiction of an Aztec warrior carrying a maiden, which blends into the eagle and snake of the Mexican flag.

"Chicano" and "Soldier," on each of the subject's arms indicates his status as a Hispanic gang member but does not specify a particular gang.

This tattoo is indicative of a Hispanic gang member from the Lil' Locoz (which may be seen spelled with an S or a Z), a violent Las Vegas street gang. "702" is the area code for Nevada (since split into two areas: 702, southern; 775, northern).

This gangbanger has "Lil' Locos" tattooed on his upper back.

Gang members are known by their monikers, which many proudly display. "Nyte Owl" is a member of the Lil' Locos.

"East Las 13" indicates that the subject is from east Las Vegas and claims 13 (Sureño).

"CVC 13" stands for Crazy Vatos Controllan, a Reno, Nevada, street gang that claims Sureño.

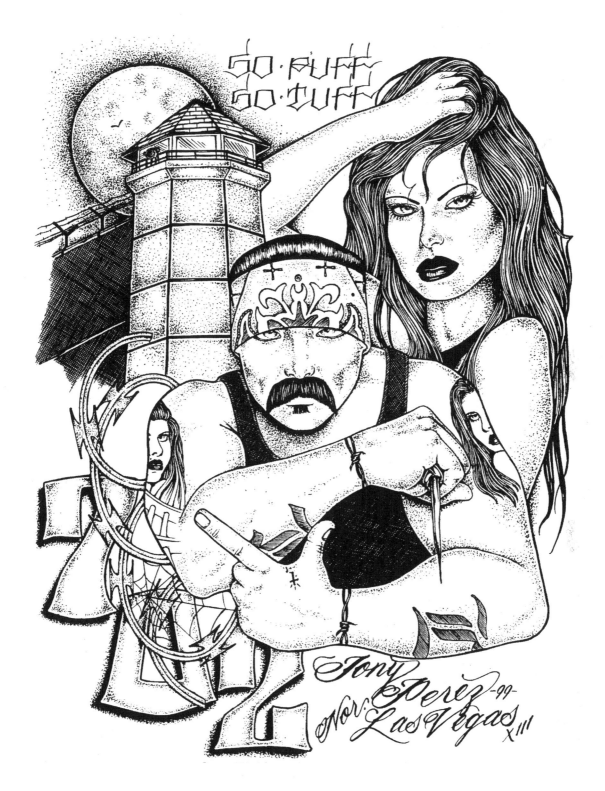

In this **dibujo** by Nyte Owl, prison gun towers and razor wire have not cracked this vato's machismo. Holding a prison-made shank and proudly displaying a pachuco cross tattoo on the web of his left hand, he throws up his placa, the letter L, proclaiming himself a member of a Las Vegas street gang, the Lil' Locos. His woman looks on defiantly and agrees he's "So Ruff, So Tuff."

immigrants. Since the 1960s, thousands of these aliens, many of whom were illegal, have been led to the area by smugglers and family members in search of a better life. Unfortunately, they came under fire from long-established Chicano gangs, namely Temple Street and Diamond Street gangsters, who regarded the *mojados* as prey. The *mojados* were threatened, assaulted, robbed, and forced to pay protection.

Not all of the *mojados* were guileless peasants. Some of these newly arrived aliens were *chilangos*, streetwise bad guys from Mexico D.F. Other bad guys included Salvadorans, many of whom had been part of a bloody civil war—and trained by U.S. Army advisors in demolitions, weaponry, and guerrilla warfare—in their homeland of El Salvador. This nucleus of hardened refugees rallied others to stand up and resist the intimidation handed out by the Chicano street gangs. In time, this new band of gangsters took the name 18th Street and recruited vigorously, strengthening its ranks. Breaking a long-standing tradition of Mexican gang membership in the United States that decreed all gang members had to be of Mexican descent, the 18th Streeters accepted all nationalities, including blacks, whites, Asians, and South Sea Islanders. The 18th Streeters were soon a very large force of their own. Awed by these events, the street gangsters backed off. Eighteenth Street Gang membership continued to soar.

By the 1980s, the 18th Street Gang had experienced such accelerated growth that it claimed four chapters: the Westside 18th, site of the original beginning; the Eastside 18th, primarily in the Hollenbeck District of East L.A.; the Southside 18th, located in the area of Bell Gardens, Huntington Park, and Maywood; and the Northside 18th, located in the San Fernando Valley. And here, again, is where the gang broke a long-standing tradition.

Prior to this gang's expansion, each Los Angeles Mexican American gang was confined within definite turf boundaries. One could drive through gang territory and, if sharp in gang intelligence, always know which barrio he was in merely by reading the ever-present graffiti.

Primera Flats, Gheraty Loma, White Fence, and Big Hazard were in relatively close proximity, each barrio identified by the graffiti. The boundaries were unmistakably marked. To the informed, which included gang members as well as gang cops, the barrio borders were absolute. The 18th Street Gang changed all that. They continued their expansion and prepared to invade other counties adjacent to Los Angeles.

Traditionally, gangsters respected and protected their own barrios. Family home, store, and small business owners; women; and school children moved about without fear of crime from within the barrio. They had only to fear gangsters from other barrios. Away from the barrio, all gang members honored certain unwritten rules: churches, schools, hospitals, and some theaters were considered neutral turf, where all gang members agreed to be nonconfrontational. The 18th Street Gang changed all that, too.

Previously, Hispanic gang members who engaged in gang fights did so in isolated places such as parks, underpasses, or vacant land to avoid disruptions in their own barrios. The 18th Street Gang changed that too, ignoring previous gang traditions. Break-ins, nightly gunfire, assaults and rapes, witness intimidation, weapons, and narcotics increased dramatically in turf under 18th Street control.

By 1990, firearms had become the weapon of choice for most Hispanic gang members. Drive-by shootings became nightly occurrences. Gang crime, once limited to East L.A., had now contaminated all areas of southern California. And the 18th Streeters, whose numbers were approaching 20,000, had established chapters throughout all adjoining counties. Gang investigators could cross county lines and drive hundreds of miles, all the while seeing 18th Street graffiti. Boundaries no longer existed. And law-abiding citizens living in areas dominated by 18th Streeters had become primary victims. According to statistics released by the Los Angeles Police Department, since 1990, the gang has allegedly committed more than 100 murders, far more than any other street gang. In the Rampart division alone, nearly half of all homicides have been attributed to the 18th Street Gang.

Residents living in 18th Street Gang barrios have been intimidated to the point that they are reluctant to testify against the lawbreakers. This situation has created an air of lawlessness in many areas of southern California that may well be spreading to other states.

The hierarchy of the 18th Street Gang comprises the *veteranos*; there is no single absolute leader. The *veteranos* meet regularly to map strategy and exchange intelligence on law enforcement and rival gangs.

The 18th Street Gang Today

The main source of income attributed to the 18th Streeters is sales of narcotics. They have a strong working relationship with the Mexican Mafia. Nonmembers who want to deal drugs in turf controlled by the gang are franchised and forced to pay rent for street corners and taxes on sales.

The gang has become so powerful that it now deals directly with Colombian and Mexican drug cartels. Honduras and El Salvador have reported that 18th Street Gang members deported from the United States have established chapters in Central American cities.

At home, most of the Western states have reported a growing influx of 18th Street Gang members. Las Vegas has a chapter, Oregon reports that the 18th Street is the fastest growing gang in the state, and Utah reports similar activity. The FBI and BATF have created task forces aimed at crushing the 18th Street Gang.

The gang continues to recruit youngsters, striving for quantity rather than quality. During one ceremony, more than 50 street taggers from the Kings With Style (KWS) were "jumped in." This initiation ceremony (read: beating) is said to last 18 seconds for each prospect.

As of this writing, the 18th Street Gang is at war with Florencia-13, a decades-old East L.A. Hispanic gang with 3,000 members, and Mara Salvatrucha (MS), a violent nationwide gang whose members are predominately El Salvadoran immigrants. The Mexican Mafia is trying to achieve reconciliation between these warring gangs.

Mara Salvatrucha

During 1992, the civil war that had raged

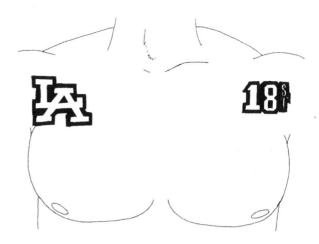

This tattoo, featuring "LA" on the right chest and "18" on the left is the mark of an 18th Street Gang member.

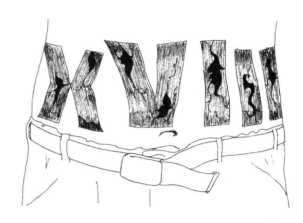

"XVIII" on abdomen, another 18th Street Gang indicator.

for 12 years in El Salvador between government troops and leftist guerrillas played out. But not before 75,000 citizens had been slaughtered by the military, the insurgents, and assorted death squad members. As noted earlier, many of these troops were trained in warfare tactics by U.S. Army advisors and supplied with explosives, armor, artillery, and other heavy and light weaponry. Before a truce was declared, upwards of 1 million Salvadorans had already fled northward to escape the carnage. Many migrated to Washington, D.C., but the bulk of the immigrants settled in California, especially in the Rampart area of Los Angeles (which at that time was overrun with 18th Street gangsters).

Although most were civilian refugees, many new arrivals were veterans of the bloody fighting—both insurgent guerrillas and front-line government troops—who were experienced in warfare and hardened to bloodshed. The 18th Street gangsters were quick to seize on this talent. The recruitment doors opened wide for these new battle-hardened veterans. Many were jumped in and quickly learned the intricacies of gang life American style and were marked indelibly with 18th Street tattoos *por vida*—for life.

Other Salvadorans could see the benefits and profitability of ganging up; however, this group wanted no part of a multiracial gang. They preferred instead to gang up with other homeboys who, like themselves, were veterans of the bloody civil war. And so, Mara Salvatrucha, which translates roughly into "beware of the Salvadorans," was born.

The MS members soon earned a reputation as being very violent bad guys who would back down from nobody, law enforcement included. Narcotics and weapons sales, drive-by shootings, carjackings, robberies and burglaries, extortion, protection, rapes, murder, and witness intimidation became many of the gang's trademarks. In 1992, five MS armed robbers shot and killed a Maywood, California, police officer during a stickup.

The MS gang members regarded themselves as soldiers and resisted all attempts by others, including the police, to control or dominate them. A showdown with the powerful 18th Street Gang (which included other Salvadorans in its membership) was inevitable. And when it erupted, Salvadoran gang members on both sides fought each other in the streets, showing a fierce loyalty to their respective gangs and a complete disregard for human life.

During one of their frequent gatherings, Mara Salvatrucha gang members and families were picnicking in a Los Angeles park. During the festivities, some of the beer-drinking MS gang members burned a Mexican flag in a show of contempt for Mexicans and Chicanos. This act enraged many of the Hispanics living in the L.A. area. The Maravillas, a large Los Angeles-based gang that dates back to the

1920s and has about a dozen chapters, declared war on Mara Salvatrucha in the early 1990s.

This war eventually spread to other cities and continues to be a problem in some areas. In Reno several years ago, a girl of 13 who was near some Maravilla gang members was shot and killed by another teenager who opened fire on the group. The 16-year-old shooter was a Salvadoran immigrant. He received a life sentence.

During 1993, the Mexican Mafia called a series of meetings with Hispanic gangs in the Los Angeles area demanding 10-percent taxes on all illegal street profits. The inflexible MS told them to go to hell. The Mafia retaliated by putting out the green light on all MS members. This battle between Mara Salvatrucha and other Hispanic gangs raged for more than a year. In 1994, the Mexican Mafia, which had a good working relationship with the 18th Street Gang, called a series of meetings. The end result was that the MS agreed to sell the Mexican Mafia drugs, and the 18th Street leaders agreed to call off the war with them. The Mexican Mafia had been so impressed with the mind-set of the Salvadorans that it recruited them to be enforcers and tax collectors in addition to selling drugs. And one of the first targets was the Maravillas, with whom the Mexican Mafia was still at war over their refusal to pay taxes to the Mexican Mafia. The Salvadorans took pride in being tax collectors for La eMe and built on their ruthless reputation. Law enforcement was quick to take notice, and task forces were assigned to bring them down. As a result, many more of the Salvadoran gangsters were swept off the streets and sent to prison. In prison, where their reputation for violence had preceded them, their presence was viewed with caution by prison administrators and welcomed by their countrymen.

The Salvatruchas Today

The MS claim 13, or Sureño. Strong indicators of MS affiliation include tattoos (e.g., MS 13, the words "Mara Salvatrucha" or "Salvadoran Pride," or the cryptic "Mara with a Shotgun") and the MS hand sign (a clenched fist with the index and little fingers extended).

Hundreds of Salvadorans have found their way into U.S. jails and prisons, where they band together. When released, the illegals are deported to their native country, where they continue their gang ways learned in the United States. At home, they find eager recruits among the impoverished youth. This has caused a new kind of war in El Salvador—gang warfare with skills perfected on the streets of the United States. Eighteenth Street gangsters and Mara Salvatruchas, former rivals in the States, continue to battle at home over drug profits and other illicit activities. Graffiti depicting both gang cultures is pervasive in the capital, San Salvador, as well as in the peasant villages. To compound the problem, surplus military weapons are sold openly on the black market. It is not uncommon to see gang members of these two main groups attacking each other using grenades, automatic weapons, and antitank guns. And the sharp rise in capital offenses, such as murder, kidnapping, rape, robbery, and related crime, have been attributed to the return of the deportees. The newly formed—and undermanned and underarmed—Civilian National Police have been notoriously ineffective in suppressing the gang activity, causing the populace to form vigilante committees known as death squads.

Two of these death squads are the Black Shadow and the Lightning Command, the ranks of which are staffed by Salvadorans exhausted from years of bloodshed and turmoil. These death squads operate much like specialized military units that seek out and destroy the enemy. By and large, these vigilantes are supported by a populace weary of civil disorder. In 1994, when three men with ties to the Black Shadow went on trial in San Miguel for the murder of three MS gang members, the mayor of the city explained to the jury that crime was "devouring" the city, and he recommended a not guilty verdict. The three were hastily acquitted. Most Salvadoran gang members in the United States fear deportation because of the presence of the Black Shadow and the Lightning Command death squads.

Salvadoran intel sources indicate the gang members have established alliances with

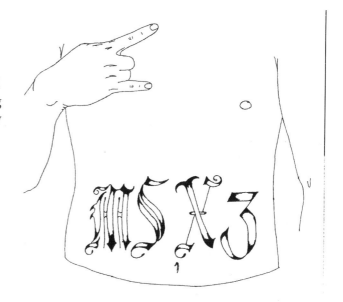

The MS X3 tattoo identifies this gangster as a Mara Salvatrucha of southern California.

organized drug cartels from Columbia and Mexico and have opened drug routes that are used to supply the United States and neighboring countries.

The MS will now accept members from Belize, Ecuador, Guatemala, Honduras, Mexico, and some of the other Central and South American countries if the recruit shows promise of strength and resolve.

The California Department of Justice estimates that MS gang membership may swell from 5,000 to 20,000 members early in this new millennium. Alaska, Florida, Georgia, Illinois, Maryland, Nevada, New York, Oklahoma, Texas, Virginia, Washington, D.C., Wisconsin, and Quebec have all reported Mara Salvatrucha presence in their cities.

Norteños

The Norteños make up the bulk of membership in the hundreds of street gangs in nearly all major cities in northern California. At one time, the line dividing north and south was generally regarded as Bakersfield. This is changing. The Sureños have continued to push north, so that now it appears Fresno has become the line of demarcation. The reader

should be advised, however, that these lines of battle are gray areas at best. Sureño graffiti has been seen as far north as Washington State, and Norteño graffiti is appearing in San Diego to the south.

Despite their common Norteño denominator, many of these street gangs continue to war against each other on the streets of northern California. However, when members of these at-war gangs go to prison, they must lay aside past differences and unite as a matter of self-protection against their southern enemies. The most hard-core of these Norteños in prison, in all likelihood, become affiliated with either the Northern Structure/Nuestra Raza and/or the Nuestra Familia, both violent prison gangs.

Identification of the Norteño is relatively easy. Norteños identify with the color red and the number 14, which corresponds to the letter N, the 14th letter of the alphabet. This letter represents the words *Norteño* and *norte* (north). These two words and the number 14 will be seen in Norteño graffiti, literature, and on the gangbangers' shoes, hats, and clothing, as well as in their tattoos, which serve as the single best gang membership identifier.

East Palo Alto

The California Chamber of Commerce proudly promotes the Silicon Valley, a high-tech, wealthy region that lies along the San Francisco peninsula. This region is home to the nation's top computer-generated industries, as well as some of the most prestigious universities, which makes it an easy sell to successful companies looking to relocate. Where the Chamber encounters difficulty, however, is in trying to promote a 2 1/2-square-mile section in the heart of the valley, an impoverished, crime-ridden incorporated city called East Palo Alto (EPA).

EPA, which lies in San Mateo County, has a population of roughly 23,500 (although census reports are questionable). Although the city makes up only 3.5 percent of the county's population, 25 percent of the county's welfare caseload goes to EPA residents. Eighty percent of EPA's school children qualify for free lunches, and more than 60 percent have only a limited grasp of the English language. Half of the students come from a single-parent home, and many of these are being raised by someone other than a blood parent. Estimates place the high school dropout rate at 50 percent.

Ethnically, the population is about 40-percent Latino, of which a large percentage are illegal aliens. Another 40 percent is African American, with the remaining 20 percent of the population split evenly between Asian/Pacific Islanders and whites or "others."

Few of the community's residents have the skills to enter the surrounding high-tech employment pool, and since the cost of living and property values are inordinately inflated, many of EPA's inhabitants turn to crime. Gangs of all ethnicities abound, hard-core Norteños among them. In addition to the local talent, transient gang members such as those from Mara Salvatrucha and 18th Street in Los Angeles have moved into the area to set up their own regiments. Curiously, the 18th Street gangsters, who have definite roots in the L.A. area, nevertheless claim norte while bangin' in EPA.

Nearly a third of those who call EPA home are aliens, the majority of them from Mexico. After surviving the perilous trip to get there, most of them are frightened and bewildered by what they see—a ragtag community populated by black- and brown-skinned peoples of all kinds. The older immigrants, nevertheless, are usually able to find menial work. A large percentage of the youngsters, however, may take to the streets, where sooner or later they hook up with local Norteno gangs.

At night, the city crawls with ethnic gang members. Gunfire is sporadic, as are robberies, burglaries, drive-by shootings, mayhem, and murder. The overstretched and underfunded police department, with backup from San Mateo deputies, must prioritize the calls, giving preference to the most serious. They don't want a repeat of 1992, when 42 homicides earned the city the dubious distinction of being named "murder capitol of the United States."

A few hours east of EPA lies Reno, Nevada, with its placid mountains and desert and its

unequaled nightlife centered around the downtown hotel-casinos. "Hot August Nights," a six-day event featuring classic cars and music from the 1950s, has become the city's most important tourism event, drawing hundreds of thousands of visitors. During this event in 1998, gang members from EPA, San Mateo County, Hayward, Sacramento, Concord, and other northern California regions, converged on the city in record numbers.

For the first few days, everything proceeded smoothly with few problems. However, as the event began to wind down on Friday evening, the California Norteños, who'd dressed down in red (Forty-Niner jerseys, red bandannas, etc.), began to cluster around the Virginia Street hotel-casinos, bumping into and elbowing the pedestrians. Sporadic fistfights broke out. To make things worse, virtually all of the Hispanic gangs in Reno claim Sureno; hence, they identify with the number 13 and the color blue. When off brands venture into the area and flag red, it's the same thing as coming in to cross out (puto mark) the local gang members' *placas*.

The next night, a full-scale riot erupted. Police estimated as many as 2,000 California gang members crowded Virginia Street, intimidating passersby and fighting among themselves. Troublemakers, gang members, police, and innocent people were caught up in a series of destructive melees that seemed to travel from intersection to intersection. Storefront windows were shattered, robberies abounded, and cars were overturned. The unrestrained street violence perpetrated by California gangbangers included stabbings and a drive-by shooting that sent seven people to local hospitals. All of the city's 300 police officers, including the reserves, were on duty, but as the violence escalated, they found themselves badly outnumbered. They fought back. When they took somebody down, the person went down hard. Cries of police brutality rose above the clamor. Suddenly, gang members forgot their rivalries. Attention turned to the cops. Shouts of, "Get the pigs!" arose from the troublemakers. Along with insults and

challenges, they now pelted the police with beer bottles and cans. A passerby commented that every tenth kid on the street was taping the action with a video camera.

Late Saturday night, the Reno officers, along with deputies from the Washoe County sheriff's office and troopers from the highway patrol, joined forces to take back Virginia Street. Riot-equipped officers, along with mounted police and K-9 units, began to sweep the streets. Casino security personnel were deputized and ordered to keep customers inside during the street cleaning. Crowds outside who refused to disperse were broken up by police using tear gas and batons. Inevitably, the streets were cleared.

Sunday morning, the Washoe County Detention Center's drunk tanks and other holding areas were packed with more than 200 validated California gang members and other assorted hoodlums and troublemakers. Three of those arrested were wearing bulletproof vests. In all, the Reno police had arrested 452 persons and had issued 149 citations. The Sparks police department had 46 arrests, and other supportive agencies had 32.

In the aftermath, the city fathers mapped out strategies to avoid a repeat of the gang-perpetrated violence. The California Norteno gang members either made bail and left town or, if unable to bail out, went to court, served jail time, and returned to the California communities that had spawned them.

There are hundreds of northern California street gangs, too many to list in this work. However, consistencies abound. Virtually all Norteño gang members get inked up with the name or initials of their gang, along with other generic Norteño tattoos. In addition to their gang name, look for the words "Ene," "Norte," "Norteño," and the number 14, which may also be written "XIV" or "X4." There may also be a star or teardrop tattoo. Along with the specific tattoos, the Mexican flag and Mexican stereotype figures are common, as are guns, knives, prison themes, butterflies, and low-rider cars and figures. However, these, along with the teardrop, are nonspecific and are also used by other Hispanic gangsters.

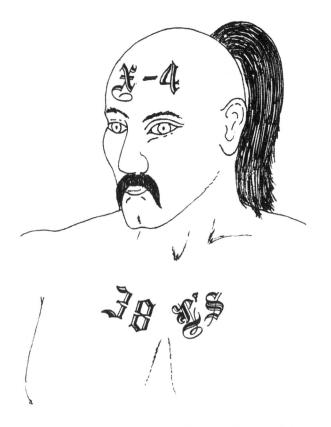

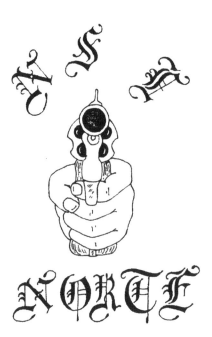

"NSL" stands for "North Side Locos," a San Mateo Hispanic gang. The gun is nonspecific.

The head and face of a Mongolian-type figure, which shows an X4 on the forehead, along with the gang identifier, "38L'S," which stands for 38th Avenue Locos, and East Side Oakland Hispanic gang. Norteños, like Sureños, make liberal use of the term "locos." The symbolic ponytail atop the head points to the north star, another Norteño identifier. The face itself is nonspecific.

NORTHERN HISPANICS

NORTE=NORTHERN NORTEÑO=NORTHERNER

14

THE NUMBER 14 IN HISPANIC GRAFFITI AND TATTOOS STANDS FOR NORTHERN CALIFORNIA

IT MAY BE SHOWN AS:

14

XIV

X4

CATORCE

NORTEÑOS IDENTIFY WITH THE COLOR RED

"ESS" on this subject's lower abdomen identifies him as a member of East Side Stocktone.

Diagram of Norteño identifiers.

Photo of a Norteño with the letter N (in Spanish—***ene***) behind his ear.

"114% Norteño" tattoo.

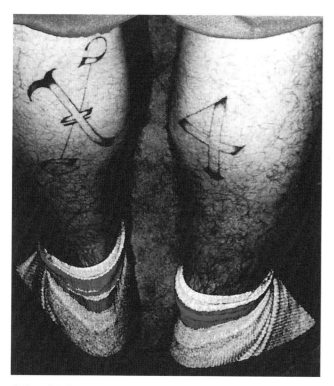

"X" and "4" on the subject's lower legs. The band on the socks is red.

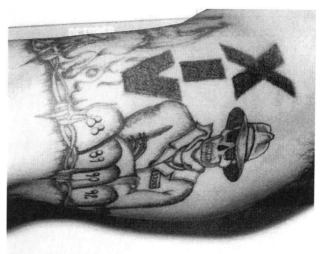

"XIV" on the subject's inner biceps. The numbered tombstones indicate the years he has been imprisoned.

"ESO" (East Side Oakland) along with the word Norteño.

At first glance this tattoo on a prison inmate appears nonspecific; however, closer scrutiny reveals a tiny 14 inside the bubble near the lower clown's nose.

East Side Stocktone

East Side Stocktone (ESS) is a long-standing Hispanic street gang in Stockton, California, a city 35 miles south of Sacramento with a population of 245,000. Hispanics make up 25 percent of the population. Authorities have identified at least 140 ethnic gangs within the city limits, and upwards of 3,000 gang members. An inordinate number of these street gangsters are under the age of 18 and, in many cases, have followed their fathers or brothers into the gang scene. (*Teen Angels*, a magazine published in Rialto, California, features photos and artwork depicting the Hispanic gang lifestyle. Some of these photos picture infants who are still nursing wearing colored headbands and baby clothes emblazoned with gang emblems. Others show young children, in close proximity to firearms, throwing up gang hand signs.

Crimes common to ESS run the gamut from graffiti and vandalism on up through weapons violations, auto burglary and theft, drug trafficking, extortion, witness intimidation, drive-by shootings, mayhem, and murder.

At one time, the ESS and other Hispanic gangs battled only each other over their unique perception of turf and respect. During the last two decades of the twentieth century, however, Asians began moving into the city in record numbers. By the turn of the century, they represented 21 percent of the population. Today, many of Stockton's Hispanic gangs are in armed conflict with the Asian gangs, whose members, by their actions, have refuted the "model minority" tag placed on Asians by the mainstream populace. (More on Asian gangs in Chapter 5.)

Fresno Bulldogs—F-14

During the early to mid-1980s, the Nuestra Familia struggled to rebuild its criminal activities in Fresno. And a horde of willing street gangsters were there to provide the muscle and intimidation necessary to ensure its success. Chicano gang members claiming Fresno-14 affiliation boasted of integrating hundreds of street thugs in four separate *clicas* (cliques)—East Side, Park Side, Sunset, and Pinedale—under one umbrella. And the

Nuestra Familia was quick to capitalize on this source of manpower.

Select F-14 gangsters were introduced into the businesslike structure and demands of the prison-based gang. Respect remained one of the highest priorities of gang membership; however, the prospects were told that the primary motive of gang membership was the control of all illegal rackets, thus ensuring a constant influx of vast sums of money. To do this, it was necessary to instill fear and intimidation into the persons targeted, most of whom were street-level lawbreakers. Protection, extortion, prostitution, mayhem, murder for hire, witness intimidation, weapons, and drugs became the mainstays of the street gangsters, with added income from auto theft, robberies, and burglaries.

A large percentage of the F-14 members eventually found their way into the Fresno county jails, and from there into the big time—prison. In prison, they were welcomed by the Northern Structure and Nuestra Familia prison gangs, which wanted to put the newcomers "under the bonds." For a while, many jumped in, yet others resisted. This resistant faction of hard-core F-14s looked upon the Nuestra Familia with disdain and regarded the Structure as nothing more than a puppet for the NF. Their choice to retain their own Fresno-14 identity and oneness put them on a collision course with the Structure and Nuestra Familia.

By 1986, in a move to reinforce their Fresno identity, the F-14s in San Quentin adopted the logo of Fresno State College—a bulldog—and the color red. They now regarded themselves as the Fresno Bulldogs (FBD or BDS) and declared war on the Northern Structure, the Nuestra Familia, and the Sureños. With this vast number of declared enemies, the Bulldogs stepped up their recruitment policies, the priorities being quantity first, quality second. Hispanic inmates (which made up more than 60 percent of the inmate population) in the Fresno County Jail were pressured to join up. F-14 gang members on the streets were advised to adopt the Bulldog name and emblem.

Recruitment soared. California Department

Tattoo on the subject's upper right quadrant displaying a bulldog figure holding an automatic weapon.

of Corrections supervisors considered validating the Bulldogs as a certified prison security threat group but decided against it because the gang was primarily an outside organization.

By 1993 the Bulldogs' criminal activities had reached into many other central California cities. Their crimes had become noticeably more violent and pervasive. Stepped-up recruitment in county jails was being reported by detention officers. Chicanos who refused to gang up with the Bulldogs were assaulted and otherwise intimidated. The Bulldogs' methods of intimidating other jail inmates included staying up late at night and "barking" loudly through the cell bars.

On February 15, 1993, inmates claiming Bulldog affiliation rioted in a section of the Fresno County main jail, assaulting a detention officer, taking his keys, and opening up a series of cells on the tier and assaulting other inmates. The disturbance wasn't put down until an assembled force of officers fired rubber projectiles from shotguns at the rioting inmates.

By the time order had been restored to the facility, nine officers had been injured and damages in excess of $30,000 had been incurred.

By 1996, internal fighting resulted in a splinter group's breaking off and forming its own Bulldog organization: the Bulldog Nation (BDN). The BDN wanted a more tightly structured organization with specific bylaws. They also saw the advantage of cooperating with other tight-knit Mexican American gangs (specifically the Mexican Mafia) in drug running and other crimes.

The Bulldogs' (BDS) leaders vowed to resist any efforts toward alignment with other gangs, citing the group's earlier resistance to alignment with the Nuestra Familia. The defectors were labeled traitors, which resulted in the Bulldogs putting out the green light on all members of the new splinter group.

∙∙

Bulldog Indicators

The Bulldog slogan is "Walking Free of Bonds." Bulldog-specific tattoos include the following:

- Paw prints on the left inner forearm (four small riding above one large)
- A bulldog face with spiked collar; a bulldog engaging in prison activities—weightlifting, running, fighting, etc.
- A bulldog carrying or shooting firearms
- Dog collars or dog tags around the neck
- The words (or letters) "BULL DOG," "FRESNO BULL DOGS," "F-14," "BDS," "FBD"

∙∙

Unaffiliated West Coast Hispanic Gangsters

There are also émigrés in the United States with backgrounds firmly entrenched in strong criminal organizations in Mexico. These gangsters have affiliation with neither the Surenos nor the Norteños. They have roots with generations-old crime families from the Mexican states of Durango, Michoacan, Nayarit, and Sinaloa, and, lately, cartels from Juarez and Tijuana. These criminal organizations are building a reputation of unrivaled ruthlessness and savagery. It is rumored that the Mexican Mafia and the Felix Arellano crime cartel out of Tijuana are working together in the distribution of black-tar heroin and methamphetamine in the United States.

There are still other Mexican émigrés— independientes—who have no criminal backgrounds yet are caught up in the distribution of illegal drugs in U.S. cities, as well as the nation's farm communities (e.g., the Border Brothers).

Sinaloan Cowboys

A group of Mexican nationals involved in street crime in the United States is known as the Sinaloan Cowboys. Most of these so-called Cowboys hail from the state of Sinaloa or the surrounding states of Chihuahua, Durango, Michoacan, Nayarit, and Zacatecas. Many of these Sinaloan gangsters are from long-established criminal organizations with close family ties that can be traced back three generations. Because of this close family association, law enforcement has found it very difficult to infiltrate this group.

Most of these gangsters in California have settled in the southeast area of Los Angeles County in incorporated cities such as Bell, Bell Gardens, Lynwood, Compton, and the adjoining cities. This large area serves as a base of operations for the Cowboys, whose criminal activity stretches throughout the western United States. They are independent and shy away from claiming Sureño. They have strong drug connections back in Mexico and, in addition to trafficking in black tar heroin and meth, also deal heavily in cocaine, which is supplied by the Colombian drug cartels. Money laundering is another of their enterprises, done via Cowboy-owned businesses such as used car lots, restaurants, Mexican markets, and related businesses.

Sinaloan Cowboys are very aggressive and violent, especially in dealings with their competitors and with drug users who are

behind in payments. Torture and "overkill" techniques have been used quite effectively by the Cowboys to instill fear and compliance in others. In 1993 as many as 42 homicides were attributed to the Sinaloan Cowboys in the Los Angeles area. They have also exhibited a willingness to shoot at and assault law enforcement personnel. There have been incidents wherein the Cowboys elected to shoot it out with the police rather than submit to arrest.

Sinaloan Cowboy Indicators

Cowboys prefer large 4-wheel drive pickups, which may have a miniature saddle and lariat suspended from the rearview mirror. The truck may have noticeable decals of Brahma bulls, the Mexican flag, or the home state (e.g., Nayarit). Common tattoos include saddles and ropes, heavy pickup trucks, sombreros, and silver-toed boots.

Cowboys like to wear expensive western wear with silver-toed boots, as well as heavy gold jewelry. They enjoy flashing expensive gold- and silver-engraved pistols and prefer to pay cash for all purchases.

Those I've seen in prison have been well groomed and prefer to buy their own designer jeans rather than wear prison issue.

HISPANIC GANGS IN THE MIDWEST

As a general rule, Hispanic gangs in the Midwest developed quite differently from their counterparts on the West Coast. On the West Coast, most Hispanic gang members (with the exception of recent immigrants) are Mexican Americans who can trace their lineage back for generations, to when California was Mexican territory. In the Midwest, on the other hand, Hispanic gangs were first noted during World War II when Mexican and Puerto Rican immigrants migrated en masse toward the large industrialized cities that were working 24 hours a day to supply war machinery to the front lines. Factories were competing for assembly line workers. The pay was exceptional. Military personnel, being paid far less, frequently hurled insults at immigrant workers who would stop at the local watering

hole for a beer after work. On occasion, some of these factory workers were assaulted. The Latinos began to group together for protection. Some of these groups became predatory and stooped to committing strong-arm robberies and other street crimes.

Following the war, thousands of factories shut down. Millions of military and naval personnel were discharged from service. Unemployment and inflation soared. Job opportunities and government-funded higher education were offered to the returning service personnel. Hispanic factory workers who had taken over some of the older housing blocks in Detroit, Chicago, and other midwestern cities now found themselves out of work and in debt. Many gathered up their families and moved out. Others, with little hope of employment, formed into street gangs to deal reefer, heroin, and barbiturates.

These early drug dealing gangs established their own guarded boundaries and fought with others who threatened their territorial business. Probably the most aggressive and retaliatory Hispanic street gang to emerge from this era is the Latin Kings (LKs), which today boasts a membership of tens of thousands.

By the time the Folks and People Nations developed during the 1980s, the Latin Kings had emerged as the largest, most violent Hispanic gang in the state of Illinois. In so doing, they had developed a bloody rivalry with the Black Gangster Disciples, both in prison and on the streets of Chicago. And since the Disciples were the leading force in the emerging Folks Nation, it came as no surprise that the Latin Kings affiliated with the People Nation.

Folks and People Nation Hispanic Gangs

Gang members who had affiliated with either the Folks or People while in prison carried this concept of a multi-gang unification back to their respective street gangs after release. Inevitably, nearly all the Hispanic street gangs in the Midwest affiliated with either the Folks or People. Long-standing street gangs who'd had problems with the Latin

Hooded King Cobra and initials "ISC," which stand for "Insane Spanish Cobras."

Cholo figure with upright pitchforks and the initials "CC," which stand for "Chicano Cholos." The upright pitchforks are a well known Folks Nation identifier.

Kings aligned with Folks, where they felt comfortable. Others, who'd coexisted with the LKs on a relatively friendly basis, followed their example and aligned with People. Logically, the membership of the two nations increased rapidly, along with the hostility between the two.

Each street gang that had become part of the Folks or People was required to pay homage to, if not taxes to, the parent nation. However, each individual street gang maintained its own identity and written constitution, along with its chosen hierarchy. Emblems, tattoos, hand signs, and graffiti used by each street gang remained in place. Each gang, though, was now authorized to use the five-point star if affiliated with People or the six-point star if affiliated with Folks.

It should be noted that the gang scene is in a constant state of flux. There are hard-core gang members sworn to a lifetime commitment. Many others are transients who drift in and out of gangs. Gangs on friendly terms today may become bloody enemies tomorrow. A few street gangs have at one time claimed affiliation with Folks and crossed over to People, and vice versa. Others refuse to align with either. The Hispanic street gangs listed here are rooted in the Midwest. They are the known Chicago-based Hispanic gangs as of this writing. There are countless others outside of Illinois as well.

...

Chicago-area Hispanic Street Gangs Affiliated with Folks

Chicano Cholos
Latin Disciples
 (aka YLO Disciples,
 for Young Latino Organization)
Latin Dragons
Latin Eagles
Latin Jivers
Latin Locos
Latin Lovers
Latin Souls
La Raza
 (Chicago factions: 18th Street, 48th
 Street, 63rd Street)

Latin Youth
Maniac Latin Disciples
Spanish Cobras
 (aka Insane Cobras)
Spanish Gangster Disciples

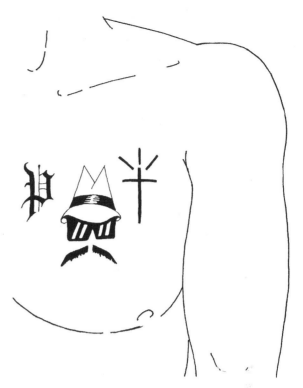

Chicago-area Hispanic Street Gangs Associated with People

Aztec Nation
La Primera
Latin Brothers
 (aka Latin Brothers Organization)
Latin Counts
Latin Dragons
Latin Kings
 (factions include Bush Boys,
 Young Bloods, Party Players,
 and 16 others)
Latin Homeboys
Latin Saints
Mexican Kings
Pachucos
Puerto Rican Stones
Spanish Lords

Vato's face with hat and mustache, the letter "P," and the rayed cross indicates a Pachuco (also called Latin Pachucos) gang member.

The Latin Kings

 In a 1985 report issued by the U.S. Department of Justice, the Latin Kings (People) were described as the most violent of all Hispanic gangs. Once limited to the Midwest, the Latin Kings now command a portion of the crime in many major cities coast to coast. They have also evolved into a powerful security threat in many U.S. prisons.

 Formed in the period following World War II, The LKs are the oldest Hispanic gang in Chicago. Today they are active in Chicago's metropolitan area as well as on the southwest side of the city. Typical crimes include narcotics sales, murder, robbery, battery, extortion, witness intimidation, and weapons violations. Their destructive, violent activity ranges from widespread graffiti to drive-by shootings.

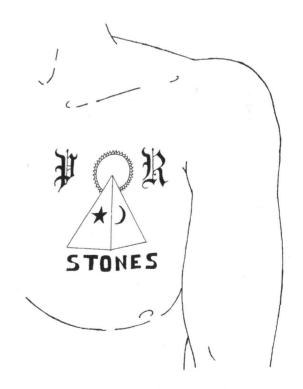

Pyramid with five-point star and crescent moon, along with "P—R" and "Stones," is specific for Puerto Rican Stones.

They've built a reputation for ruthlessness and vengeance. Paybacks are considered essential in order for the group to retain credibility among other gangs. Records are kept of fallen members, and on the anniversary dates of their murders, selected members are sent out to do retaliatory drive-bys.

Membership is predominately Hispanic, with most claiming Central American or Puerto Rican nationality. Whites and African Americans make up the remainder. Total membership is uncertain, but authorities indicate there may be as many as 15,000 Latin Kings doing time in various prisons. They have a *King Manifesto* (a 30-page handbook containing all of the bylaws of the Almighty Latin King Nation) and a fairly good structure with two recognized leaders, both convicted murderers. One leader oversees all activity on the north side, and the other oversees the south side.

The Latin Kings have upwards of 20 factions in the Chicago area. They are also aligned with the Vice Lords and some of the other People Nation gangs. Enemies include the Imperial Gangsters, the Black Gangster Disciples, and their arch-enemies, the Maniac Latin Disciples. The Kings recruit actively in parks and within their own neighborhoods. In the last few years they have been identified recruiting in schools throughout the nation.

Latin King identifiers include the colors gold and black and tattoos featuring a three- or five-point crown, a five-point star, and the letters LK.

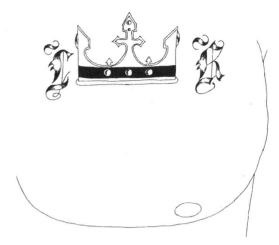

The three-point crown and the letters LK on the left upper chest of a Latin King gang member.

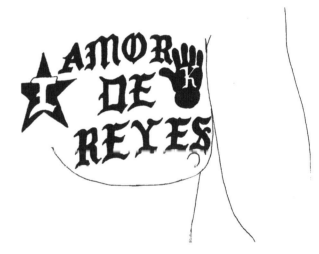

A Latin King tattoo. "Amor de Reyes" translates into "King Love." The five-point star and the "L" and "K" further corroborate gang membership. The upraised hand with five fingers signifies the number five, a People Nation identifier.

CHAPTER 5

ASIAN AND PACIFIC ISLANDER GANGS

Asians and Pacific Islanders have migrated to this country en masse for the past few decades, and the criminal element among them has become a source of dire concern for law enforcement personnel.

Increasingly, businessmen in Asian communities—traditionally secretive and reluctant to ask for help from the police—have become victims of crimes perpetrated by migrant gangsters. To complicate matters, traditionally Asian business communities themselves have been guilty of small-time criminal activity (e.g., gambling and prostitution operations). And many of these "respectable" criminals recruit Asian gangster migrants, whom they employ as muscle for debt collection and other sundry disciplinary measures. Bear in mind that extortion and protection—serious felonies in this country—are widely accepted in Asia as a necessary business expense and, consequently, are rarely reported to the police here. Still, violent crimes such as armed home invasions, murder for hire, and multiple murders, which take place all too frequently in the Asian community, are difficult to keep secret. However, investigating these crimes becomes a demanding job for law enforcement because of the fear of reprisal and distrust of the local police that exist in Asian communities.

In contrast to most ethnic gangs in the United States, the Asians do not confine their activities to specific neighborhoods. They may have a base of operations in a particular city; however, the scope of their criminal activity may range throughout several states. Viet-Ching traveling gangs, for instance, traverse the nation in cars to commit home invasions and other serious crimes within the Asian communities. This type of criminal is difficult to apprehend and is presenting law enforcement with one of its most serious challenges to date. Because Caucasian investigators are immediately viewed with suspicion and distrust, gathering intel from Asian gang members can be a difficult task. The Asians normally maintain a strict vow of secrecy, something that is not seen as often with other ethnic street gangs. Furthermore, Asian gang members are quick to learn. Many are now challenging the police through armed confrontations—and through our own criminal justice system. Some Asian gang members are videotaping traffic stops in an effort to intimidate the police. Others are carrying printed cards outlining their own brand of Miranda, explaining their rights and the expected conduct of the police. The card concludes with the suspect signing a declaration stating he did not give the police the right to take photos of him, nor did he give the police permission to search him or his car.

Many Asian gangsters spend lavishly on

luxury cars, expensive clothing, nightlife, and other indulgences. Because of their outlook on life, most live for today, not caring about tomorrow. To them, their fleeting existence on Earth has been predetermined. The Asian and Western mind-sets differ dramatically. For Asians, time does not flow in a linear fashion as it does for most Westerners. And Asians' belief in reincarnation and predestiny is ingrained in their perspective: "What I do today is predestined; I have no control over it. When I die, I'll be reborn and continue the cycle." Or, "What I do today is the result of past transgressions done against me." Or, "What I will do or will not do 10 years from now affects my actions today." This type of thought effectively removes Asian gangsters from responsibility and accountability for their violent acts. Not only does it ease their path of violence committed against others, it also prepares them to face the inevitable unafraid. An often-seen Chinese tattoo translates into, "I'm not responsible for the life I'm living."

Asian gang tattoos may be significant, but often they reveal little. Most Asians prefer depictions of snakes, eagles, panthers, dragons, and other ferocious animals. But without corroborating identifiers, these tattoos must be regarded as nonspecific. Specific tattoos that may validate gang membership are gang names or initials, e.g., MOD (Masters of Destruction), TRG (Tiny Rascal Gang), ABZ (Asian Boyz), KK (Korean Killers), etc. Along with tattoos, cigarette burns and razor slashes are often seen on the hands and arms of Asian gang members. These wounds (or scars) are usually self-inflicted in the presence of others as a demonstration of the person's ability to withstand pain.

It is not uncommon for those who landed in Indo-Chinese refugee camps following the Vietnam War to have missing fingertips, burns, scars, crude tattoos, and other evidence of prior refugee camp existence and discipline. These toughs are sought after by Asian criminal groups because they have little fear of being sent to the relatively comfortable holding facilities in this country, and they accept killing as a way of survival. They can also be trusted

to maintain silence. Other ethnic gangsters differ from the Asian Americans in that they've never been subjected to the hardships suffered by the camp refugees. To them, the thought of going to prison serves as some measure of a deterrent. To the Asians, the threat of serving time in prison has little effect.

VIETNAMESE IMMIGRANTS

Today's Asian street gang members, whose ages range from 12 to 25, are for the most part the offspring of refugees who emigrated to this country from Southeast Asia after the Vietnam War ended in 1975. Of these, the majority came from Vietnam.

Following the fall of Saigon, thousands of displaced persons streamed out of South Vietnam and took shelter in makeshift refugee camps where, it was hoped, the U.S. military would arrange their passage to the free world. Most of these early evacuees had prior ties to the collapsed government and to the U.S. military and were fleeing to save their lives. Others were corrupt government officials, former military officers, and black market profiteers who had become rich during the long, drawn-out war.

Life in these early refugee centers was brutal. Starvation, assaults, rapes, and lack of medical care claimed thousands of lives. Survival was dependent upon each person's cunning and ability to provide for himself and his family. In April 1975, the first wave of survivors arrived in the United States. Others from the camps reached safety in Canada, Australia, England, France, and Germany. Of those arriving in the United States, the great majority settled in California, where the local and federal government provided financial assistance, along with other generous benefits.

In time, hundreds of thousands more of these "boat people," refugees from the socialist Republic of Vietnam, arrived in the United States.

Many of these later arrivals were cast as Vietnam government "throwaways," hard-core criminals, and espionage agents. Nevertheless, they, like their predecessors, were welcomed

by U.S. authorities. The criminal element among them found acceptance from other Vietnamese criminals who had come before them and from established Chinese organized crime figures, who viewed the new arrivals as collectors and enforcers for the U.S.-based triads (Chinese "secret societies," which are essentially organized criminal groups). Most of these refugees were Chinese/Vietnamese (Viet-Ching) and spoke both Vietnamese and Cantonese-Chinese.

Many of the younger refugees had been torn away from family and had learned how to survive using their wits in the refugee camps. Now, in their newly adopted country, unable to read, write, or speak the new language, they felt awkward and displaced. They moved quite naturally toward association with the Vietnamese gangsters who had begun to prey upon inhabitants of the Southeast Asian communities in this country. Others grouped together in small bands and began moving nomad-like throughout the western United States, committing crimes in settlements populated by other Southeast Asians.

Many times these Viet nomads took women with them on their forays. The women were there to service the men, to hold drugs and weapons, and, most importantly, to gain access to houses that had been selected for home invasion. During these vicious crimes, the woman's responsibility was to knock on the door until someone opened it. Once the door opened, the gangsters, who had been cowering out of sight, jumped to their feet and forced their way inside at gunpoint.

Inside the house, terror reigned. The bandits demanded money, jewelry, firearms, electronic appliances, and any other items of value. And to enforce cooperation from the family, they threatened and tormented the family members, sometimes pistol-whipping them, pouring boiling water over them, tying them up with duct tape, forcing them to drink caustic cleaning fluids, and torturing them in other ways, sometimes for hours. Young girls were sexually assaulted, and in some instances babies were placed in microwave ovens or repeatedly dunked headfirst in a toilet as a way to force the family to give up hiding places of valuables.

When finished, the bandits threatened the family members with swift retribution if they called the police. Then they loaded up all the valuables and raced away to new destinations, sometimes to cities hundreds of miles away. And too often, the devastated families, suspicious of law enforcement, did not report the ordeal to the police. To compound matters, the family was now vulnerable to being extorted further by other gangsters selling protection.

A day or two later, the carload of bandits, now cruising another Asian community in a different city, would commit a similar crime, perhaps an armed robbery or other violent act, always targeting other Asian homes or businesses. Following this, they would make another speedy exit, en route to yet another city where the crimes could be repeated.

These elusive Vietnamese traveling gangs that cross state boundaries have presented law enforcement with a unique challenge in dealing with gang crime. The reluctance of the victimized family members to confide in the police and the mobility and multijurisdictional aspect of crime scenes have made it extremely difficult to prosecute many of these roving Vietnamese gang members. It has become vitally important for law enforcement agencies to identify and track these bandits and, more importantly, to exchange intel through networking at meetings and by computer.

The main reasons so many of these crimes go unreported are as follows:

- Many of these immigrants do not know how or to whom to report a crime. Others equate U.S. law enforcement with that of Southeast Asia, where brutality and corruption are common with uniformed personnel.
- The victims have little knowledge of the English language.
- The victims feel shamed and humiliated. Asians feel strongly about "losing face."
- The victims fear retribution from the criminals. Many Asians do not understand

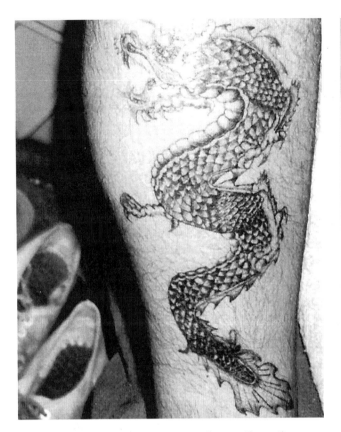

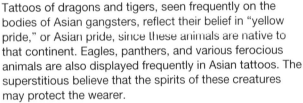

Tattoos of dragons and tigers, seen frequently on the bodies of Asian gangsters, reflect their belief in "yellow pride," or Asian pride, since these animals are native to that continent. Eagles, panthers, and various ferocious animals are also displayed frequently in Asian tattoos. The superstitious believe that the spirits of these creatures may protect the wearer.

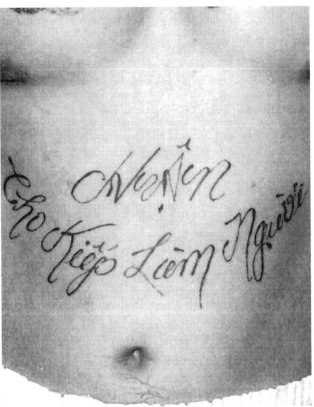

This Vietnamese criminal has writing on his abdomen that translates literally into "Hating Life Makes a Person." This further translates into "Real People Hate Life," or "Hating Life is the Only Way," or "Real Men Hate Life." This reflects his acceptance of the inevitability of his own violent death, an expected event among Asian street gangsters.

our criminal justice system as it pertains to bail. To see a suspect arrested and then released back to the streets on bail can be fear-inspiring to the victims.

Law enforcement officers responding to the scene of a home invasion should be reminded that, once inside, regardless of which family members have been injured or the severity of the injuries, the first person who should be approached is the eldest male in the house. Once accord has been established with him, permission to question the others should be politely requested. If an Asian officer is present, he or she should conduct the interviews; however, bear in mind that not all Asians are kindred. For example, don't expect a

Korean or a Cambodian to establish a good rapport with, say, a Vietnamese or Chinese victim. It may work out, but it may effect the opposite of the desired reaction.

OTHER SOUTHEAST ASIAN CRIME GROUPS

Other Southeast Asian immigrants were soon to follow the Vietnamese who were relocating to the United States. In addition to emigrants from Vietnam, refugees arrived in California from Cambodia and Laos. Today, in California alone, there may be as many as 1 million Southeast Asian immigrants. Of course, only a very small percentage of these immigrants have become involved in criminal activities. As a rule, the

Indo-chinese culture places a lasting value on family structure and diligence as they pertain to hard work and education.

Cambodians

Cambodians, ethnically known as Khmers, fled their country following its takeover in 1975 by the Khmer Rouge, ending a 600-year-old monarchy. Cambodian gangbangers, unlike the Vietnamese, mimic American street gangs in many ways. They stake out their turf using graffiti, adopt the oversized style of dress, and sometimes target other ethnic groups. The Korat Boyz (K-Bs), a Cambodian street gang in Long Beach, California, has been at war with a Hispanic gang, the East Side Longos, since 1989, when the K-Bs killed their first Mexican American during a drive-by shooting.

Laotians

Three groups of people emigrated from Laos: the lowland Laotians, the highland Laotians (known as Hmongs), and the Miens. The Hmong people were the backbone of the CIA's "secret army" during the war, fighting the communists with ferocity. Like Cambodians, Laotian gangbangers in this country do not limit their criminal activity to other Asians as the Vietnamese gangs generally do; they will also victimize other ethnic groups. In Sacramento, Laotian gang members active in street gang crime have targeted blacks and Hispanics during drive-by shootings and other gang activity.

Crimes Committed by Asian Gangsters

- Victimization of Vietnamese immigrants through home invasions, extortion, and protection practiced by Vietnamese gangsters moving over established nationwide routes
- Theft of, and counterfeiting of, credit cards and payroll checks; ID forgeries; and counterfeiting of VCR tapes and CD albums
- Cloning of cellular phones
- Auto theft, chop shops, carjackings "to order"

- Murder for hire by Viet-Ching gang members, said to be operating as nationwide assassination squads working for Chinese organized crime
- Drive-by shootings, weapons violations, drug trafficking, and street crime, including conventional armed robberies and burglaries, by Cambodian and Laotian gang members, many of whom are also heavy drug users
- Smash-and-grab robberies of gun and jewelry stores
- Fencing of stolen property, commonly practiced by older Vietnamese immigrants
- Wholesale computer chip theft
- Auto insurance fraud—phony accidents
- Cigarette smuggling—from the United States to Canada
- Kidnapping for ransom
- Wholesale marijuana cultivation and distribution by Hmongs and Laotians (In Fresno, a multimillion-dollar marijuana field being cultivated by Laotians was discovered interspersed among legitimate crops, complete with gun coverage, night vision equipment and other high-tech accessories.)
- Computer chip thefts, which net Asian criminals millions of dollars a year. (Pentium processors, which are untraceable and carry no serial numbers, are sold on the black market or shipped to the Orient where they are worth hundreds of dollars each.) In the Silicon Valley, manufacturers of Pentium processors have lost hundreds of millions of dollars as a result of sophisticated break-ins and truck hijackings by Asian crime figures. Insurance premiums have skyrocketed, while the Asians continue to amass small fortunes trafficking in these chips, which can bring in more illegal profits than drugs do.

CHINESE ORGANIZED CRIME

The mainstays of Chinese organized crime are illegal gambling and trafficking in heroin (China white). The cultivation and distribution of opium and heroin is the number-one criminal enterprise of Chinese crime figures.

"ABZ"—Asian Boyz tattoo on the subject's upper arm.

One of the tattoos seen frequently among Southeast Asian gangsters is the four Ts. In Vietnamese, this stands for *tinh* (love), *tien* (money), *tu* (prison), *toi* (crime). Occasionally there is a fifth T, which stands for revenge. Three dots in a triangle pattern, copied from the Hispanics, is another common tattoo worn by Southeast Asian gangsters. This stands for "*To O Can Gica*," which means "I Care For Nothing," or (like the Hispanics) "My Crazy Life."

Chinese secret societies known as triads—vast criminal networks represented on every continent—are happy to supply millions of addicts with the poppy's sinister yield. Heroin is rapidly becoming the drug of choice among many of the world's elite as well as street-level addicts. Opium smoking, though still prevalent, is regarded as an old man's aberration. In the United States alone, it has been estimated that heroin addicts spend upwards of $150 billion a year on China white, the end product of the opium poppy. When revenues are calculated on a worldwide basis, the figures are staggering. Medicinal products derived from opium account for approximately 15 tons of crude opium a year. Yet the hill countries of the Golden Triangle produce, in addition to that amount, upwards of 2,000 tons a year, all of which (with the exception of the fraction confiscated by law enforcement) will be slammed into a vein or sucked into the lungs of dreamy-eyed junkies throughout the world. The Chinese triads reap billions of dollars a year from this one criminal endeavor.

Though the Chinese control the major sources and routes of the heroin trade, they fall behind in the street-level distribution networks. They have linked up with other criminal organizations—such as the outlaw biker gangs; the Cosa Nostra; and Iranian, Nigerian, Lebanese, Aboriginal, and Russian Mafias—to fill the gap.

Other criminal activities associated with Chinese organized crime are

- money laundering and loan sharking
- prostitution
- extortion
- protection
- counterfeiting of money, credit cards, CD albums, and software (Expect to see

upgrades of Windows operating systems counterfeited in China and sold worldwide.)

- smuggling of aliens by criminals known as "snakeheads" (As many as 100,000 illegal aliens are smuggled into the United States yearly and forced to work in involuntary servitude for years paying off the debt.)
- carjacking "to order" (The buyer puts in his order, and the stolen car is then shipped to Hong Kong, where it is delivered.)
- illegal fireworks
- life insurance scams insuring babies or others for large sums of money and then arranging their demise
- large-scale weapons trafficking, along with sales of bulletproof vests (When the Wo Hop To [WHT] went to war with the Wah Ching in the San Francisco Bay area, authorities learned the WHT had purchased 300 vests at one time.)

Chinese organized crime figures far outdistance their other Asian counterparts in structure, organization, and the establishment of secret societies. These societies can be traced as far back as 1,500 years before the birth of Christ.

Triads

A more recent development are the triads (a name coined by the British because of the identifying triangular emblem), which go back several centuries. These originated not as criminal groups but patriotic societies that pledged to overthrow the foreign conquerors and restore the Ming dynasty to the imperial throne.

Today's triads are now regarded as entirely criminal organizations and are outlawed in Hong Kong (but not in the United States). Prior to Hong Kong's return to mainland China's rule in 1997, British officials indicated there were at least 50 of these triads operating out of that city, with tentacles reaching worldwide. One of the largest is the 14K Triad, which British intelligence estimates has 30,000 members, with at least 50 subgroups. All told, Hong Kong officials estimate that one out of

every 20 people living in the city—or 300,000 residents—belongs to one of the triads. With this staggering number, it must be accepted that the Chinese criminal network presents a formidable worldwide problem.

Membership in Chinese criminal triads is restricted to Asians—whites are not allowed in. Indo-chinese refugee camp survivors and reliable toughs from street gangs, who may have existing family members who are active within the triad and will sponsor them, may be accepted as initiates. Others with proven skills and backgrounds may also be sponsored by established members. But there are thousands of prospective members who want in but don't have the proper credentials or legitimate sponsors to pull it off. Those who do manage to be selected must go through a rigorous probationary period. Once an initiate is accepted, the sponsor is held accountable for his progression up through the introductory stages.

Triad (*hung mun* in Cantonese) members must keep their affiliation secret. Meetings and initiation ceremonies, therefore, must also be done in secret. Some of the initiation rites that were performed in past generations required the recruit to prove his sincerity and strength through a series of tests, including defending against sword-wielding triad fighters and memorizing the 36 oaths—a document of 36 poems. It was not unusual for these ceremonies to go on for six days, during which time the recruit was constantly threatened with death if he showed weakness or suggested disloyalty.

"Hanging the blue lantern" is a term that describes an initiation into a Chinese triad. Today's ceremonies last no longer than a day. The main part is the reciting of the 36 oaths amid constant reminders that punishment comes swiftly for anyone who betrays the triad. It is loyalty or death. To culminate the initiation, blood is drawn from each recruit, which is mixed togther and consumed by all. The recruits are now blood brothers in a criminal enterprise. However, these triad members are not bound to a lifetime membership in a specific triad. It is not uncommon for a member to jump from one to another if more appropriate opportunities are offered.

Each *hung mun* member is assigned a

Over-the-shoulder tattoos are popular with Chinese gangsters. This subject was validated as a Wah Ching (Youth of China) gang member. The upright wings of the eagle are said to represent the letter W; the serpent's coil, the C.

The Chinese were using hand signs and secret handshakes thousands of years ago. This tattoo, which covers the back of a Wah Ching gang member, depicts an ancient Chinese ruler throwing up a hand sign while protective dragons look on.

number divisible by three and a title denoting rank. The number three is regarded as magical by the Chinese. A typical name and number would be Blue Chief, #219. Members are then always referred to or addressed by number. This routine helps to insulate the member from outsiders and puts an added burden on the police trying to identify triad members. The Red Pole, which is the name given to triad security forces, is responsible for ensuring triad secrecy.

Tongs

Other secret societies that had been in place in China for the past 400 years were known as "tongs," a word taken from the Chinese *tang*, meaning party. Tongs first appeared in the United States in the mid-1880s and, on the surface, were nothing more than meeting halls set up in the various Chinatowns, each with an identifying name and a membership consisting of Chinese immigrants.

Some tongs were based on the immigrants' place of birth. Others were based on the type of work the immigrants were doing. There were laundry tongs, railway tongs, medical (herbal) tongs, meat cutters' tongs, and myriad others. And the tongs were not required to operate in any specific area. The Deep Mine Tong, for instance, had a membership of mine workers from coast to coast.

During the long workday, immigrant laborers, who were viewed with suspicion by the white populace, preferred to keep to themselves and endure the demands of the backbreaking work in the mines and railways, often working 12 to 16 hours a shift. After work, covered with dust and sweat, they would gather in the tong meeting halls where they could sip tea and exchange gossip with their countrymen. Chinese merchants who had emigrated with the laborers and worked small stores offered rice and chicken along with other treats to the weary laborers for a small fee.

To the workers who could afford it, opium pipes, fan tan gambling, and assorted high-mileage prostitutes were available. Chinese hookers could be had for a quarter; white

women a dollar (Posner 1988). Opium, a black, tarlike substance, came in small rectangular brass containers straight from China and was always in demand and sold openly. The merchants who peddled the stuff could never quite grasp the white man's laws that declared this pleasurable substance illegal. To them, a dreamy-eyed opium addict lost in his own murky world was far more tolerable than the drunken, rowdy white troublemakers that would often converge on the Chinese settlements to visit the women, gamble, and smoke opium. Their presence sometimes erupted into drunken brawls, which reinforced the Chinese laborers' belief that the white man was indeed a demon. Yet they welcomed the money spent by the whites, who were making 10 times as much as the Chinese laborers.

Other valuable functions of the tongs included making high-interest loans to the immigrant workers (which amounted to loansharking but was legal in China) and slipping money to local law enforcement officials to keep them from busting up the opium dens and other unlawful Chinatown businesses. This latter practice effectively diverted local law enforcement from the Chinatown settlements and transferred the responsibility of enforcement to the tong officials. And since the Chinese rarely reported crimes, the settlements showed a very low incidence of criminal activity. On paper, everything looked good.

As the tongs became increasingly stronger and more influential, Chinatown businesses were coerced to pay taxes. The brunt was paid by the gambling halls, opium dens, and cat houses, although the small shops, restaurants, and laundries also paid their share. In addition to paying taxes, businesses also bought protection, a practice that was acceptable in China and regarded as a necessary business expense. As the settlements continued to expand, tong officials began accumulating vast sums of money—and hungered for more. It was inevitable that before long the tongs would encroach upon each other's territories. The stronger tongs began preparing to muscle out the weaker ones.

Tong wars broke out nationwide. Major tongs, with branches in many cities, went to war against other tongs throughout the United States. The customary weapons used were large knives and hatchets, and thus the newspapers began referring to the tong wars as "hatchet wars."

Whites, who had been spending large amounts of money in dingy Chinatown opium dens and brothels, began staying away in fear of being caught up in one of these battles. Anti-Chinese feelings among whites mounted.

By the turn of the century, the major tongs had been at war for more than 30 years. Each had its own small army. *Boo how doy*, literally, "hatchet boys," were fighting on all sides. These battle-scarred warriors were the first Chinese street gang members to appear in the United States.

Finally, by the mid-1920s, the tong wars began to abate. But they left a lasting impression on the established white community. Discrimination was at its highest ebb. Chinese immigration was severely restricted. This trend continued until the start of World War II, when a different Oriental became the villain: the Japanese (and, unfortunately, the Americans of Japanese ancestry, the *Nisei*). Signs in the windows of Chinese American restaurants and shops proudly proclaimed, "This place is a Chinese American establishment."

Following the close of World War II, the nation's Chinatowns opened up their doors to the white establishment once again. However, the gambling and other vices had gone underground, their doors open only to Chinese. Bars, restaurants, and curio shops were erected for the benefit of the whites who frequented the areas during the boom years. Behind the scenes, the triads (which, according to the FBI, are the actual controlling voices), called the shots through the tongs (which benefited from an air of legitimacy).

In Gerald L. Posner's well-researched book *Warlords of Crime*, he lists the following five major tongs that exist throughout the United States:

- On Leon, headquartered in New York City
- Hip Sing, based in San Francisco
- Ying On, active in Los Angeles and the Southwest
- Hop Sing and Suey Sing, both of which have offices on the Pacific coast, extending to the east

Initiation into a tong follows similar rites to those used by the triads. The initiate must first be sponsored by a confirmed member. Once this is done, his name is posted for a period of three weeks, during which time all other members have the opportunity to either allow him to proceed further or block his entry into the society. Once he has cleared this hurdle, he is ready to be confirmed. Simply stated, the initiate kneels before a shrine and swears to uphold the tong's precepts under penalty of death. He is then granted membership.

Secret handshakes, hand signs, code words, and other guarded intel are given to the new member, to be followed by additional secret knowledge that he will gain during his lifetime of progression through the tong.

Are the tongs lawful societies or criminal organizations? The issue remains murky to law enforcement. The tongs present a legitimate face to the public by being active in charitable and fund-raising projects in the various Chinatowns—projects that benefit the inhabitants. Do some of their officers have criminal records? Sure, but that in itself does not justify naming the society a criminal enterprise. Many of the meeting halls are multi-level structures. On the main floor, the old men may be seen reminiscing among themselves while sipping tea. Yet it is not uncommon for youthful street gang members to be meeting in the same building on a different floor. Are they connected? Possibly. Are they the enforcers for triads hiding behind the tongs? Quite possibly. But it's difficult to prove. These close-knit organizations are called secret societies for a reason. They keep to themselves and are loathe to cooperate with law enforcement. Because of this, they are difficult to penetrate and their crimes difficult to prosecute.

FILIPINO GANGS

Filipino gangs got their start in the Philippine prisons about the time the islands were overrun and occupied by the Japanese during the early days of World War II. Prisoners, who were accustomed to bleak conditions at that time, faced an even greater threat from the Japanese military. Food, medical supplies, and other necessities became much scarcer, and in many cases only the strongest and shrewdest inmates survived. Grouping together secretly in cliques increased their chances of survival. These cliques did much to strengthen discipline among their ranks—and to punish other inmates suspected of leaking information to the prison's administrators.

Following the war and repatriation, many of the inmates, along with members of these various cliques, were released back to the streets. Having formed strong bonds while doing time, and unconcerned with rehabilitation, many of these former prison clique members ganged up together on the streets of Manila to prey on business owners and to fight with members of other newly formed gangs. Some of these early Filipino gangs were the Sige-Sige, the Oxo, the Bahala Na, and the Tres Cantos. As Filipino immigration to the United States increased, gang members from these organizations inevitably came with them.

English is a required language in the Philippine schools, and since most of the Filipinos arriving in this country speak the language, it has become much easier for them to blend in than it has been for other Southeast Asian immigrants. During the 1970s, California experienced a mass influx of Philippine natives. Many of these immigrants brought with them vocational and professional skills and found employment. Many others, though, were forced to work for minimum wages in the service industries. School-aged youths often were met with derision and aggression at the hands of school bullies and street gang members. Most of these antagonistic gang

"Flip" and "Side" tattoos on the subject's triceps. Flip is a slang term for Filipino, and Flip Side is the name of a Filipino gang.

"BNG?"—Bahala Na Gang. (Sometimes only the question mark—signifying the saying, "What happens, happens"—will be present.)

members were Hispanic and black; however, others—including U.S.-born Filipinos—resented the arrival of the newcomers and targeted them as low-class foreigners. Consequently, the new arrivals soon formed their own groups, or gangs, as a means of self-protection.

Migration into California from the Philippines has continued unabated over the past 20 years. Today authorities in Los Angeles and Orange County have identified more than 50 Filipino gangs within their jurisdictions. The Sige-Sige and Bahala Na, original Philippine Islands gangs, are among them.

The emerging Filipino gangs prefer current clothing fashion; however, when dressed down, they borrow from the "Ninja look"—well pressed, black, baggy outer wear with the name of the gang and the member's moniker affixed to the shirt or jacket in white block lettering. Like the Hispanics, these gangs require a jumping-in ceremony in which the prospect has to fight a group of established gang members to show his skill and courage prior to being accepted into the group. The infliction of cigarette burns on the arms and other parts of the body is practiced by Filipino gang members as a show of toughness and pain denial. Three of these scars in a triangle pattern, copied from the three-dots tattoo used by Hispanic gangs, mean the same thing: *mi vida loca*—my crazy life.

The Philippine culture is strengthened by strong family ties that carry over to the gang life. Members of the same immediate family, as well as cousins, uncles, neighbors, school chums, and so on, may belong to the same gang. And while there may be two or three other Filipino gangs within close proximity, the different gangs do not appear to battle over territory as do some of the other ethnic groups. Surprisingly, though, most street gang activity by Filipinos is directed against others of their own race. And as is so often the case with Southeast Asian criminal activity, much of the crime goes unreported to the police.

Filipino Criminal Activity

Large-scale organized crime, as attributed

to Chinese crime groups, apparently does not apply to Filipinos. Rather, there seems to be a series of smaller, autonomous crime groups operating independently. These groups have a predilection for fraudulent activities, including

- gun running, via strong ties maintained with the Japanese Yakuza (Firearms are smuggled back to the Philippines and to the Orient, where they bring in as much as 10 times what they are worth in the United States.)
- theft and black marketing of U.S. Treasury checks
- theft and black marketing of major credit cards
- fraudulent medical practices (e.g., performing bloodless "surgery" wherein grossly infected organs are supposedly extracted—without ever making an incision—as a way to miraculously cure patients with real or imagined internal organ damage)
- counterfeiting of government documents (e.g., alien registration cards, visas, passports, etc.)
- fraudulent insurance accidents and claims
- counterfeiting of U.S. currency
- extortion/protection
- narcotics
- auto theft and shipment overseas
- drive-by shootings and street crime

TONGAN AND SAMOAN GANGSTERS

Native-born Tongans and Samoans have been emigrating to the United States extensively during the past decade. Like other immigrants, these islanders tend to blend in well while working and establishing homes. The vast majority is quite family oriented, friendly, and outgoing, but as with other ethnic groups, a small percentage also falls into the gang life.

The Tongans and Samoans who became involved with U.S. gangs were initially content to hitch a ride on the prevailing black or Hispanic gangs in their neighborhoods. While

"100% Tongan" indicates ethnicity and is not gang specific. The band on the right biceps reflects an island custom in which 16-year-old male islanders are initiated into manhood. The tattoo is done by an elder who embeds the ink under the skin using a wooden mallet and needle-pointed thorns.

active with these gangs, the islanders learned such essentials as hand signs, street slang, colors, and graffiti. As their numbers increased, many broke away from the blacks and Hispanics and formed their own groups. Interestingly, some of these defectors retained the intimidating titles of their former gangs, i.e., Samoan Bloods, Tongan Crips. And since these two islander groups have a long history of feuding, it was natural that they would choose to adopt opposing gang names and colors.

One thing that does set the Tongans and Samoans apart from other gang members is their ability to converse in their own unique native tongue, which is understood by few nonislanders.

Fights between islanders are fairly common. Islanders that claim Crip regard those claiming Blood as enemies. In Reno, the Tongans have been involved in occasional gang

fights with Hispanics and blacks. The islanders are generally large in stature and relatively good natured. When pressed into a fight, however, they like to go one on one with their adversaries as a show of manhood.

As of this writing, a Tongan native is awaiting trial (his second; the first trial ended in a mistrial on a technicality) locked up in max at the Washoe County Detention Center for the murder of a University of Nevada police sergeant. The suspect has been charged with luring the officer outside of his radio car and then savagely hacking him to death with a hatchet.

Unless specific gang tattoos are noted on the islanders, tattoos are generally not a good indicator of gang membership. In the islands, painful tattoos are applied by the elders to denote various levels of the person's physical and spiritual development.

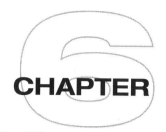

RUSSIAN ORGANIZED CRIME: THE VODKA DONS

Oleg Korataev, a European heavyweight boxing champion from Russia, visited New York's Brighton Beach area in the early 1990s. During a television interview he announced that he wanted to make his home here and go into business. Unfortunately, one night after attending a dinner at the Cafe Arbat, a local hangout for Russian immigrants, he was assassinated by a single bullet fired at point-blank range into the back of his head. The murder remains unsolved.

New York authorities investigating the case said Korataev was a strong-arm extortionist and surmised that his killing was the result of infighting among Russian organized crime groups in this country. The police were also of the opinion that the assassin, a paid hit man, had traveled from Russia specifically to kill the boxing champ and quickly boarded a plane back to Russia once his mission was accomplished.

With the collapse of the former Soviet Union, thousands of new criminal groups have emerged in Russia that not only fight for control of organized crime and sales of military weaponry, but also for control of much of the commerce and banking industries. Poorly paid ex-KGB agents and military defectors, along with myriad other government specialists and former prison inmates, have formed their own criminal organizations known collectively as the Russian *Mafiya* (Mafia) or the Vodka Dons.

Under the guise of allowing Jews to leave Russia, Boris Yeltsin began cleaning out his prisons much as Castro did. The majority of these émigrés, including a host of established Russian *Mafiya* figures, have relocated to America. Probably no other foreign criminal groups have impacted the United States as quickly as have the Russians. Boston, Chicago, Cleveland, Los Angeles, Miami, New York, and San Francisco have all reported a presence of Russian organized crime.

Refugees from the Ukraine, who tend to be blue collar religious types, have settled mainly in Sacramento. The younger criminal element among them has a reputation of being excellent car thieves and chop shop operators. Some of these shops are said to be operating 24 hours a day. Hondas and other Japanese imports are the preferred autos.

Brighton Beach, a working class neighborhood in Brooklyn just east of Coney Island, may support upwards of 100,000 Eastern European immigrants (most of whom have no ties to organized crime) and has come to be known as "Odessa by the Sea," or "Little Odessa." These people, many of them Russian Jews, are tied together by culture, language, and a distrust of governmental political figures. They are keenly mindful of the mobsters among them, and the frequent gang-style slayings, most of which go unsolved, are apparently tolerated

by the tight-knit law-abiding majority. One immigrant explained it by saying, "The bad kill the bad; the good stay together."

Many of the Vodka Dons here are survivors of the brutal Russian prison camps and, unlike U.S. gang members, did not evolve from American-style juvenile street gangs. In this country, they move directly into big-time criminal activities right alongside other ethnically oriented criminal organizations. They find it expedient to get along with Sicilian Mafia figures as well as Asian and African organized criminal groups and Latin American drug cartels. And they have learned that here in the United States, as in Russia, governmental influence can be bought from selective political figures and other persons of authority.

They also quickly learned that lawbreakers in this country are treated with much more courtesy and fairness than they are back home (in Russia there are no Miranda rights, no controls over excessive force, and suspects may be thrown into prison where they languish for years before ever going to trial). And here, friendly civil rights organizations are within easy reach of the nearest phone to ensure that the rights of the arrestees are not being violated.

Russian white collar scam artists target major banks, credit card companies, and upscale department and jewelry stores using counterfeit and stolen credit cards, swindling these establishments out of hundreds of thousands of dollars during a run. But one of the largest scams ever perpetrated by the Vodka Dons is the multimillion-dollar gasoline tax fraud operation. This big-money scam deprives the federal government out of hundreds of millions of tax dollars annually. It is worked with either gasoline or No. 2 oil, which can be converted to diesel fuel or home heating oil.

To pull off the gas tax fraud, the Dons create a string of companies—on paper only— purporting to supply agricultural providers, heating oil suppliers, construction firms, and other heavy industries with road-tax-free gasoline, diesel fuel, and home heating oil. This can only be accomplished by obtaining—or falsifying—a certificate of gas tax exemption

from the IRS. And apparently the Dons have the ability to do this. (In the former Soviet Union, citizens were required to produce official documents when making purchases of cars, trucks, and other major commodities as well as when traveling, seeking medical care, securing employment, and performing myriad other everyday functions. These demands on Soviet citizens spawned a breeding ground of remarkable forgers and counterfeiters, many of whom have emigrated to this country.)

When the Dons obtain the necessary documents, they purchase wholesale fuel from the terminals (storage facilities) by the tanker loads. Next, with forged invoices and secret shipments, they supply hundreds of thousands of gallons of tax-free gasoline and diesel fuel to independent retail outlets run by other criminal associates, who pocket as much as 50 cents a gallon in federal and state taxes paid by the consumer. And frequently, this bootlegged gasoline is diluted with cheaper fuels, a practice known as "cocktailing," providing increased profits to the Dons—and substandard fuel to the consumer. To augment their illegal profits, the Dons sometimes dilute diesel fuel with road-tax-free jet fuel. (The reader is cautioned to be wary when purchasing gasoline or diesel fuel from questionable independent gas stations.)

Traditional New York crime families have been quick to recognize the profit potential of the Russian operation and could not sit idly by without imposing their own mob tax on the Vodka Dons. After a series of meetings, many of which were held in the Russian and Turkish baths on Manhattan's lower east side, it was agreed that the Russians would ante up a cut of each gallon sold in exchange for a hands-off policy from the established crime figures. The Dons regarded this arrangement as a necessary business expense.

Because of the sophisticated structure of gasoline tax fraud and the endless paper trails created by the burn (bogus) companies, it has been difficult for authorities to discover and prosecute the mobsters who are responsible. Too many times, federal authorities would spend months following the trail of bootlegged

gasoline shipments, only to discover that a suspect company never existed. In any one-year period, fuel tax fraud is estimated to have cost the American taxpayers in excess of $1 billion.

In California, on September 13, 1995, 13 Russian Armenian immigrants were charged with racketeering and running a black market fuel network that was supplying gas stations and truck stops in southern California with off-road use gasoline and diesel fuel. The indictments charged the Mikaelian organization—named after its godfather, Hovsep Mikaelian, with racketeering, mail and wire fraud, money laundering, extortion, and narcotics trafficking. According to the U.S. Attorney in Los Angeles, the group had avoided paying $3.6 million in taxes in just one year.

To combat the gas tax scheme, authorities have passed legislation requiring home heating oil to be dyed red, making it easily traceable. And California authorities are now requiring the terminals to collect road taxes on all fuel purchases. Businesses that purchase fuel for off-road use will still have to pay state taxes; however, the Department of Taxation has promised to refund the taxes paid after confirming that the transactions are legitimate. The Vodka Dons continue to work around this hindrance, devising methods to circumvent the newly enacted laws.

Another scam the Dons in New York are involved in is big-money extortion, usually perpetrated in settlements populated by other Eastern European immigrants, including many Jewish businesspersons and professionals. Threats leading up to destruction of property, beatings, torture, and murder are sometimes used to extort these people. One method used is the sending of a ram's leg with hoof, enclosed in a plastic bag, to an intended extortion victim. This is a recognized death threat among the Russian immigrants, who take it very seriously. Other immigrants, who still have relatives in Russia, are told their family members will be murdered unless the Dons are paid off.

Other scams perfected by the Russians include staged auto accidents, false medical laboratory procedures, and inflated billing schemes. In 1994, two brothers, Michael and David Smushkevich, were indicted by federal authorities and charged with using mobile laboratories to perform routine medical testing on unsuspecting patients and then billing Medicare and other insurance companies for millions of dollars of false testing. Michael was sentenced to 21 years for his part; David turned state's witness and received probation. It was estimated that during their criminal tenure the brothers had pocketed more than $50 million in profits.

Other crimes attributed to the Russian *Mafiya* in this country are telecommunications fraud (cellular telephone cloning), distribution of heroin and cocaine, loan sharking, auto theft, money laundering, bribery, witness tampering, and murder for hire. Reports continue to surface that the Dons are also involved in the black-marketeering of human body parts used in transplants. Prostitution is another lucrative business for the Vodka Dons, who smuggle young women into Middle Eastern countries as well as the United States and force them to work as prostitutes.

Back in Russia, the *Mafiya*, working in concert with corrupt government officials, is active in black-marketeering of high-tech military equipment and weaponry, including serviceable aircraft and naval vessels. Uranium and plutonium, along with beryllium (a neutron reflector used to increase the explosive power of a fusion trigger) and cesium (the most electropositive element known, said to be worth as much as $100,000 per kilogram on the black market) are highly sought after on the world market. Countries purchasing these materials on the black market should come under close scrutiny as to their intentions.

On September 7, 1998, authorities in Istanbul, Turkey, arrested eight men for smuggling nuclear-related material out of the former Soviet Union into Turkey, where they hoped to sell it for $1 million. It is a matter of concern that other Russian black-marketeers may have been successful in smuggling uranium and plutonium out of Russia, which they may have sold to unstable rogue nations. According to U.S. intelligence sources, as many

as 3,000 unpaid and disgruntled Russian scientists with expertise in weapons of mass destruction have immigrated to other countries, including those who regard the United States as the number-one enemy.

Under former Soviet control, nuclear weaponry and research laboratories were guarded under the tightest security measures. Today, by contrast, Russian organized criminal figures, working closely with corrupt government officials, are selling this material and related technology to the world's highest bidders. The likelihood of small-scale attacks against the United States by terrorists using nuclear weapons continues to grow.

IDENTIFYING THE VODKA DONS

The Russian Dons are not hard to recognize. They like to emulate the American mobsters of the 1930s, wearing long, dark overcoats and snap-brimmed hats and moving about in expensive limousines. Many have distinctive Russian prison camp tattoos (see examples in illustrations that follow). Their fur-clad women make liberal use of makeup and tawdry jewelry and join the men in partying long into the night in the boisterous night spots along Coney Island Avenue, where sultry Russian dancing girls in native costumes perform nightly for the vodka- and wine-consuming patrons.

Tattoos, hand signs and signals, and, to a lesser extent, scars, facial expressions, and body movements are used by cultures throughout the criminal world as a means of communication. Intentionally inflicted injuries that leave telltale body scars are used by Asian criminals (as in the practice of chopping off a portion of a finger as a disciplinary measure) as well as Russian street thugs. An example of this, as practiced in Russia, is the custom used by Russian pickpockets when schooling beginners. When pupils of pickpocket gangs being put to the test are detected by their victims, other members of the gang may reprimand them by inflicting painful razor cuts on their palms near the thumb. When the cut is healed, a scar forms, which marks the

pickpocket for life. It is not unusual for an accomplished pickpocket to exhibit two or three of these scars, a testimony to his early ineptitude while perfecting his skill. With successive blunders, the pickpocket may lose his thumb.

Tattooing of Russian prisoners, who were generally either political (presumed enemies of the state) or criminal, was practiced extensively. The more convictions an inmate received and the longer the sentence, the more tattooed he became. Many of these tattoos denote rank, criminal expertise, and length of sentence, as well as personal peculiarities. A lifer could be recognized not only by the amount of inscribed ink on his body but by specific tattoos authorized only for a person serving a life sentence. Political prisoners, many m were suspected of being informants, were forcibly inscribed with tattoos denoting collaboration.

A caste system denoting the pecking order of all the inmates was in place in most of the Soviet prisons. Prison inmate *pakhans* (bosses) wore distinctive tattoos that set them apart from other prisoners. The *pakhans* were the undisputed leaders. They made policies and organized the other inmates, and were afforded the power to assign, promote, and discipline the other prisoners. It was also their responsibility to compromise prison officials so that alcohol, drugs, and women could be smuggled into the prison. Below the *pakhans* were the "authorities," also known as enforcers, fighters, or soldiers. At the third level of the prison structure were the "men," who were the drones and usually handled the difficult tasks. Below this level were the "outcasts," undesirables including informants, persons convicted of crimes against children, and sometimes predatory homosexuals.

Pakhans operating outside the prison walls have developed their own cell systems, much as the Colombian drug cartels have. Cell systems are groups of isolated criminals with minimal exposure to other cells. This system minimizes contact between active criminals operating in other cells and, more importantly, serves to insulate the *pakhans* from the main

criminal body. Most *pakhans* have four cells under their control. They further insulate themselves by using a front person known as a "brigadier." The brigadier's responsibility is to supervise the criminals working in the four cells. The brigadier himself is closely scrutinized by spies sent out by the *pakhan*. This system virtually conceals the identity of the *pakhan* from the street operators working under his direct control.

The term *Vory v Zakone* can be translated to "thieves in law." It describes an elder *pakhan*, or godfather, who is the undisputed leader of a Russian criminal organization. This person may generally be identified by specific tattoos (see the following examples). A *Vory v Zakone* is also known as a keeper of the code (*vorovskoaia spravedlivost*), the code being a set of 18 rules to which all Russian mobsters must adhere. Not to do so may mean death to the violator. A *Vor* is a mobster who has not yet achieved *Vory v Zakone* stature. To be promoted to this highest criminal level, a *Vor* must be voted in by other *Vors*.

...

Thieves Code of Conduct—The Vorovskoy Zakon

- Forsake all relatives—mother, father, brothers, sisters.
- Do not have a family—no wife, no children; this does not, however, preclude having a lover.
- Never, under any circumstances, work, no matter how much difficulty this brings—live only on means gleaned from thievery.
- Help other thieves—both moral and material support, utilizing the commune of thieves.
- Keep secret information about the whereabouts of accomplices (i.e., dens, districts, hideouts, safe apartments, etc.).
- In unavoidable situations (if a thief is under investigation), take the blame for someone else's crime; this buys the other person time of freedom.
- Demand a convocation of inquiry for the purpose of resolving disputes in the event of a conflict between oneself and other thieves or between thieves.

- If necessary, participate in such inquiries.
- Carry out the punishment of the offending thief as decided by the convocation.
- Do not resist carrying out the decision of punishing the offending thief who is found guilty, with punishment determined by the convocation.
- Have good command of the thieves' jargon (*fehnay*).
- Do not gamble without being able to cover losses.
- Teach the trade to young beginners.
- Have, if possible, informants from the rank and file of thieves.
- Do not lose your reasoning ability when using alcohol.
- Have nothing to do with the authorities (particularly with the Correctional Labor Authority [ITU]); do not participate in public activities, nor join any community organizations.
- Do not take weapons from the hands of authorities; do not serve in the military.
- Make good on promises made to other thieves.

...

Soviet Prison Tattoos

From the mid-1960s until the 1980s, as many as 35 million persons were incarcerated in Soviet prison camps. Of this staggering number, approximately 20 to 30 million received tattoos from other inmates. The specific meaning of each tattoo was known to all prisoners. To be caught wearing an unauthorized tattoo was a very serious matter. If, for instance, an inmate tried to impersonate a *Vory v Zakone* by displaying an identifying tattoo, he could be put to death by other prison inmates.

Tattooing was done using multiple needles or worked-over electric shavers. The ink used in these prison tattoos was made from soot gathered from burning pieces of rubber and mixed with shampoo and, some sources say, urine. This unsanitary combination caused uncounted cases of systemic poisonings and open sores. Many of those inmates who received tattoos died from complications.

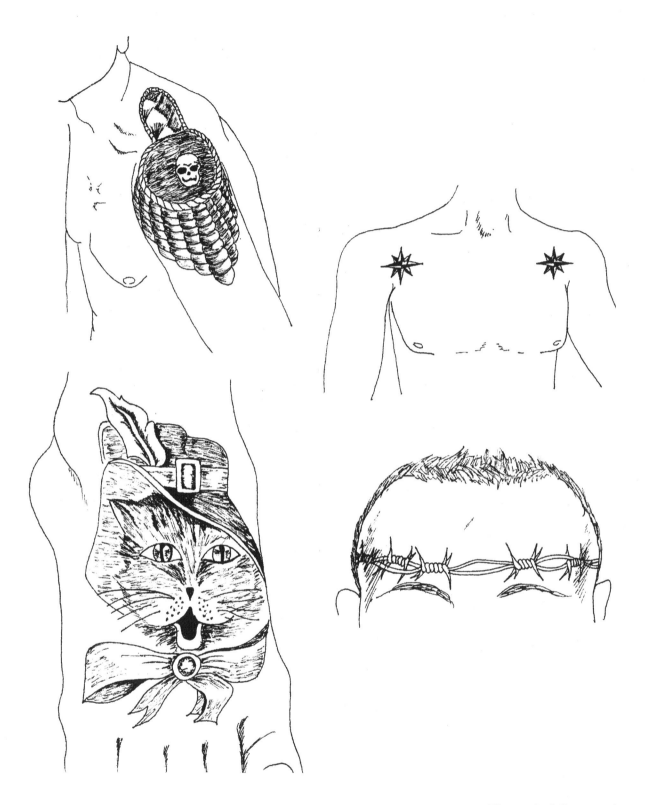

Upper left: Military insignia and shoulder epaulets are popular with Soviet prisoners. Many different depictions may be seen. Skulls usually denote a murderer. Upper right: Eight-point stars at the front of the shoulders denote a *pakhan*, or godfather. The same stars seen on the knees means "I bow to no one." Lower left: A single cat, as depicted on this inmate's foot, denotes a thief who acted alone. Multiple cats means the thief was part of a gang. Lower right: Barbed wire encircling the head means the inmate is serving a sentence of life without the possibility of parole.

GANGS AND THEIR TATOOS

The tattoos displayed here originated in the former Soviet Union and were obtained through intelligence sources in the Middle East. They provide only a sampling of the hundreds that were used for decades in the prison camps. Those depicted here are thought to be reasonably accurate; however, I have been unable to corroborate conclusively the presumed interpretations.

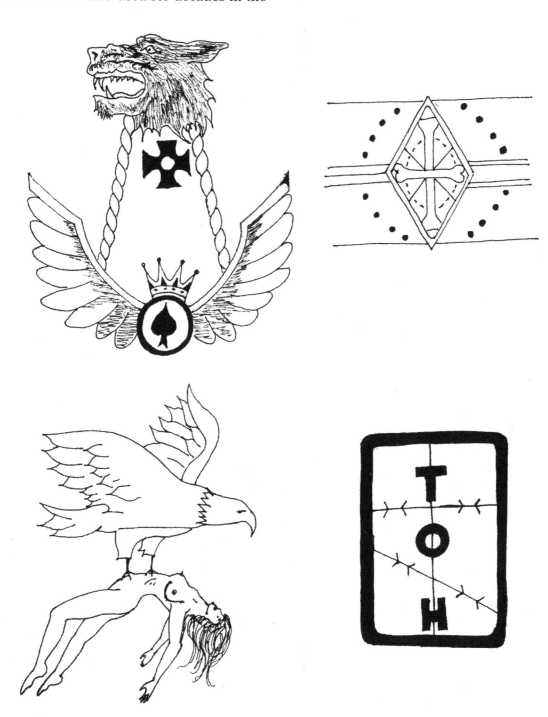

Upper left: Senior criminal authority. Upper right: A tattoo applied forcibly on an inmate to void a prior gang tattoo. Lower left: This tattoo denotes recidivism and identifies an inmate who continues to return to prison. Lower right: This tattoo means the inmate has served time under very difficult conditions.

Upper left: *Vory v Zakone*. Upper right: Criminal group authority. Lower left: *Vory v Zakone*. Lower right: Senior criminal authority. Center: Criminal group authority.

Upper left: Violent criminal. Upper right: Prisoner with a history of armed robbery. Lower left: This tattoo means "I was born free and should again be free." Lower right: Tattoo of a woman holding a flaming sword means "My enemies will be punished."

Upper left: The acronym on the knife means "I am going to kill collaborators with a knife." Upper right: This tattoo is applied forcibly and indicates the inmate is a collaborator. Lower left: This tattoo is applied forcibly and means the inmate has been marked for death. Lower right: This tattoo indicates the inmate was first sentenced to death and later the sentence was commuted to life in prison without the possibility of parole.

Upper left: Criminal group authority. Upper right: This tattoo, which may be found on many parts of the body, means the inmate is letting it be known that he intends to continue living a life of crime. Lower left: This cynical tattoo means "The Constitution of the USSR Human Rights." Lower right: Stalin, "The Leader of the Socialist Camp."

Upper left: Caucasian prisoner, specifically characteristic of Chechnya. Upper right: Characteristic of criminal of Ukrainian background. Lower left: Drug supplier. Lower right: Drug user.

Upper left: 1930s Sicilian Mafia figures are popular tattoos with some of today's Russian organized crime groups. Upper right: *Vory v Zakone*. Lower left: *Vory v Zakone*. Lower right: Tattoos of American currency are seen frequently on Russian organized crime figures.

Upper left: Homosexual ostracized by other inmates. Upper right: Tattoo near the penis denoting an active homosexual, often applied forcibly. Lower left: Passive homosexual, often applied forcibly on the buttocks. Lower right: Passive homosexual, often applied forcibly on the buttocks. Center: Tattoo applied on the buttocks of a passive homosexual.

Soviet Prisoners' Sign Language

As stated previously, tattoos are one way criminals communicate nonverbally. Whereas tattoos are relatively permanent, sign language is fleeting, yet can convey information, announce affiliation, transmit orders or messages, issue challenges, and warn others of impending danger. The hand signals shown on these pages have been validated by Middle Eastern sources as being some of those used in the former Soviet prisons. Whether or not they are still being used by street-based Russian *Mafyia* members today has not been established.

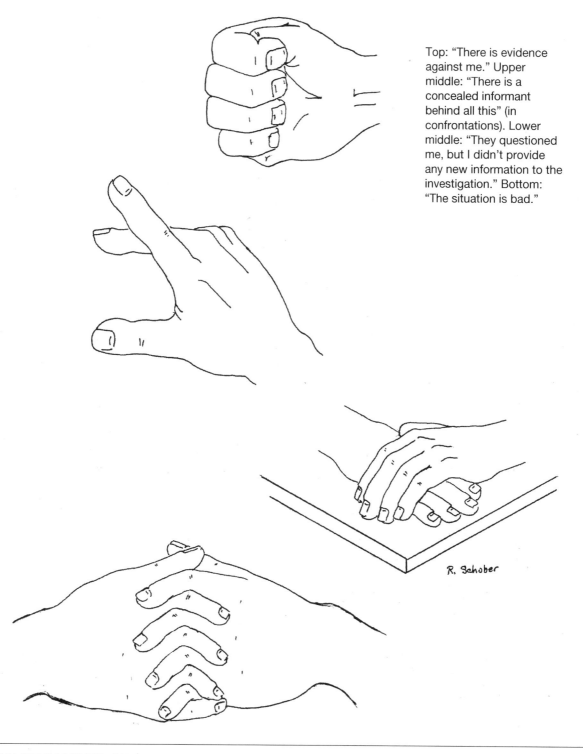

Top: "There is evidence against me." Upper middle: "There is a concealed informant behind all this" (in confrontations). Lower middle: "They questioned me, but I didn't provide any new information to the investigation." Bottom: "The situation is bad."

R. Schober

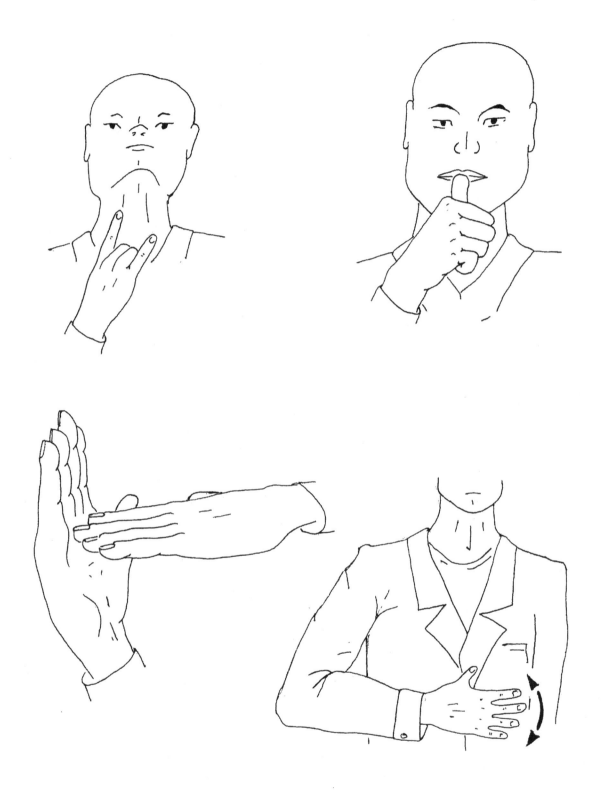

Upper left: Sign of danger. Upper right: "Shut up!" Lower left: Heavy accusation. Lower right: Order not to disclose important facts (in confrontation).

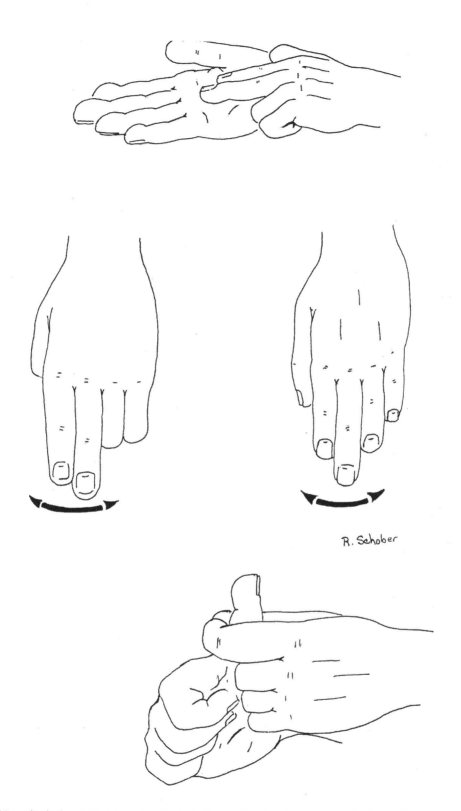

R. Schober

Top: Command to write it down on paper. Center left: Suggestion to share responsibility on the case. Center right: Not sure of something. Bottom: Heavy accusation.

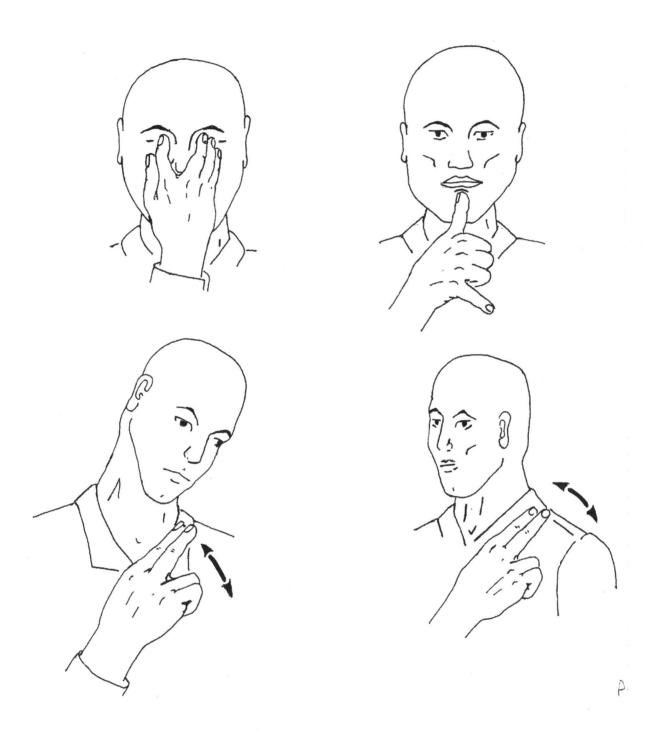

Top left: Sign that there is a policeman in the area. Top right: Invitation to smoke hashish. Bottom left and right: Signs that there is a policeman in the area.

GANGS AND THEIR TATOOS

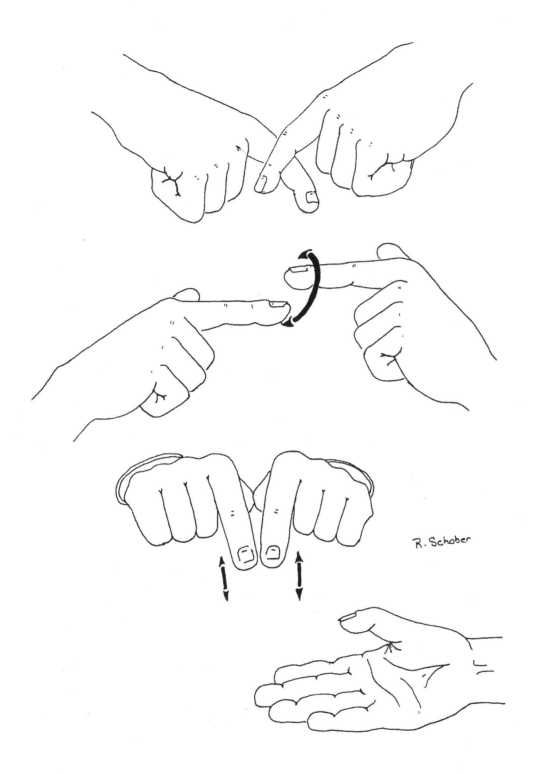

R. Schober

Top: "Don't believe what I'm saying." Upper center: Not sure (in confrontation). Lower center: sign of agreement or approval. Bottom: "I'm telling the truth."

CONCLUSION

Today, when as many women as men are getting tattoos, there is still an antiauthoritarian appeal inherent in the practice. No matter how trendy and "mainstream" the current fad may become, the public continues to associate tattoos with prison inmates and gang members. And rightly so: few persons released from prison will come out skin clean. In fact, it is not unusual for inmates who have spent decades behind bars to have more than a hundred tattoos.

Throughout the U.S. prison system, all too many gang leaders continue to call the shots for their counterparts on the outside. Bank robberies, counterfeiting, drug and weapon sales, and contract murders are all planned by gang leaders behind the walls and carried out by subordinates on the streets. In prison, where the art of tattooing is a centuries-old custom, correctional officers who routinely strip search inmates have the best opportunity to photograph and track gang-related body ink. The perceptive officer can use this opportunity to help establish evidence of gang hierarchy, rank, the scope of criminal activity, enemy gangs and alliances, and volumes of corroborative evidence. Because tattoos are the single most accurate method of gang membership validation, the ability to interpret them and the willingness to share this intel with outside law enforcement are imperative. I cannot stress enough the importance of this responsibility.

The compilation of gang intelligence presented in this book represents years of face-to-face contact with prison inmates and data garnered from officers in the trenches who have unselfishly made this information available in the hope that it will be of benefit to law enforcement and concerned citizens in a combined effort to take back our streets. Ordinary citizens, who are unfortunately caught up in the wave of lawlessness, must arm themselves with a knowledge of graffiti, clothing/colors, and other identifiers. Only by doing so can they accurately report to law enforcement those who are transforming once peaceful neighborhoods into battle zones. By using illustrations that replicate specific tattoos to supplement detailed information on the various categories of gangs, this book exposes citizens to the inner workings of gangs and other subversive groups, providing them with intel previously available only to law enforcement.

It is my hope that this work will be of benefit to law enforcement as well as to lay people in the identification and tracking of illegal gangs, a problem that continues to escalate throughout the nation despite the millions of dollars poured annually into defeating the phenomenon.

And to the thousands of gang intelligence officers out there on the front line, I offer my respect and admiration for the outstanding job you're doing against overwhelming obstacles, many of which are entrenched within our own criminal justice system.

BIBLIOGRAPHY

Abadinsky, Howard. *Organized Crime*. Chicago: Nelson-Hall Inc., Publishers, 1990.

Badey, James R. *Dragons and Tigers*. Loomis, CA: Palmer Enterprises, 1988.

Bing, Leon. *Do or Die*. New York: Harper Collins Publishers, 1991.

Carrasco, David. *Quetzalcoatl—And the Irony of Empire*. Chicago: University of Chicago Press, 1992.

Dunston, Mark. *Street Signs*. Powers Lake, WI: Performance Dimensions Publishing, 1992.

Earley, Pete. *The Hot House: Life Inside Leavenworth Prison*. New York: Bantam Books, 1992.

Gonzalez-Wipper, Migene. *Santeria: The Religion*. St. Paul: Llewellyn Publications, 1998.

Gruzinski, Serge. *The Aztecs: Rise and Fall of an Empire*. New York: Harry N. Abrams Inc., 1992.

Leon-Portilla, Miguel. *The Broken Spears: The Aztec Account of the Conquest of Mexico*. Boston: Beacon Press, 1992 edition.

Jackson, Robert K., and Wesley D. McBride. *Understanding Street Gangs*. Placerville, CA: Custom Publishing Company, 1986.

Morales, Gabe. *Varrio Warfare: Violence in the Latino Community*. Seattle: Tecolote Publishing, 2000.

Novas, Himilce. *Latino History*. New York: Penguin Books, 1994.

Posner, Gerald L. *Warlords of Crime: Chinese Secret Societies—The New Mafia*. New York: Penguin Books USA, 1988.

Ridgeway, James. *Blood in the Face*. New York: Thunder's Mouth Press, 1991.

Rodriguez, Luis. *Always Running—La Vida Loca: Gang Days in L.A.* New York: Touchtone, 1993.

Shakur, Sanyika (aka Monster Kody Scott). *Monster: The Autobiography of an L.A. Gang Member.* New York: Penguin Books USA, 1993.

Smaka, Frank and Gary Nicol. "The Cuban Freedom Flotilla: From Mariel Harbor to Las Vegas." Las Vegas Metropolitan Police Department report (16 June 1983).

Steward, Samuel M., Ph.D. *Bad Boys and Their Tattoos*. New York, London: Harrington Park Press, 1990.

Valdez, Al. *Gangs*. San Clemente, CA: Law Tech Publishing Company, 1997.

ABOUT THE AUTHORS

Sgt. Bill Valentine was a line officer for the Nevada Department of Prisons for 20 years, retiring at the end of 1997. For many of those years, one of his primary responsibilities was the identification and tracking of all suspected gang members at the Nevada State Prison in Carson City.

In September 1995, he published his first book, *Gang Intelligence Manual* (Paladin Press, Boulder, CO). In February 1998 he produced a two-part video, *Reading Gang Tattoos*, which is currently being distributed by Calibre Press (Northbrook, IL). Sergeant Valentine has been a featured speaker at many gang investigator seminars and has written numerous articles on the subject.

This, his third work, is the culmination of countless hours spent attending gang seminars in many states and, more importantly, working face to face with prison inmates inside the walls over the past 20 years. It is his expressed desire that the information contained herein will benefit the valiant efforts of others who are laboring to hold the line against the menace posed by gangs and their accompanying weapons and drugs—one that threatens to overpower our American way of life. Sergeant Valentine continues to live in Carson City, Nevada, with his wife, Jessie, of many years. They have three grown children and numerous grandchildren. Sergeant Valentine is active in writing and working as a consultant on gang identification and management in the home and workshop.

The illustrator and coauthor of this book, Correctional Officer Robert Schober, has worked on line at the Nevada State Prison for the past eight years. As long as he can remember, he has always liked to sketch. He was the illustrator for *Gang Intelligence Manual* and has done many other gang-related drawings that Sergeant Valentine has used in his presentations before law enforcement agencies.

Correctional Officer Schober has lived in the Carson City area for the past 13 years with his loving wife and four children. He looks forward to continuing in this endeavor.